THE
WILDLIFE & NATURE
PHOTOGRAPHER'S FIELD GUIDE

THE
WILDLIFE & NATURE
PHOTOGRAPHER'S FIELD GUIDE
MICHAEL FREEMAN

CROOM HELM
London & Sydney

Contents

© 1984 Michael Freeman
Croom Helm Ltd, Provident House, Burrell Row,
Beckenham, Kent BR3 1AT
Croom Helm Australia Pty Ltd, GPO Box 5097,
Sydney, NSW 2001, Australia

British Library Cataloguing in Publication Data

Freeman, Michael, 1945-
 The wildlife and nature photographer's
 field guide.
 1. Photography of animals
 2. Nature photography
 I. Title
 778.9'32 TR727

 ISBN 0-7099-1025-8

Designed by Mike Rose and Bob Lamb

Illustrations originated by Anglia Reproductions,
Witham

Printed and bound in Spain by Printer industria
gráfica sa. Sant Vicenç dels Horts, Barcelona
D.L.B. 2982-1984

Introduction

Successful wildlife and nature photography fuses together three skills – the ability to see pictures, to handle a camera .quickly and confidently, and to find and approach the subject. These skills can be developed by almost anyone, given patience, time, and some very specific information. What this book provides is the information.

This is one of the most practical of all fields of photography, because it can only be practised by going out on location, fully prepared. It is definitely not an armchair activity, and this book, unlike most that contain large pictures and little real information, has been designed to be used in the field rather than skimmed through casually at home.

To this end, the kind of information and the way it is presented has a particular slant. The ruling principle has been to include all the *useful* information that can be fitted into a volume small enough to be carried in the field. If you simply read it first and then leave it

behind, you will not be allowing this book to do its job. Like any other field guide, it is a piece of outdoor equipment. Every standard situation, from choice of lenses and film to tracking and map-reading, is covered. The inessentials have been cut out to make way for the things that you will need to know at the time when you are out with a camera.

Nor are the photographs that follow chosen just for decoration or eye-relief; they have been included for the information that they can give, whether for comparison with the scene in front of you or to show you what to expect in unfamiliar conditions.

The photographs in most books are collected after the text has been written, from picture libraries and other occasional sources. Not surprisingly, very little is known about the conditions under which these photographs were taken by the people who design such books, and the caption information is correspondingly thin, or even fictitious. Yet, it is

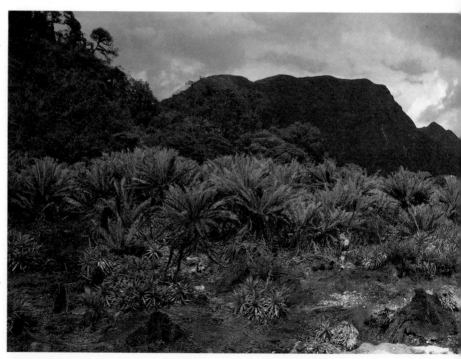

exactly the how and why of the photography that is important to anyone using a camera; this includes not merely the basic technical information such as the focal length of lens and type of film, but the decisions that the photographer had to take on the spot. If this were a book about animals, plants and landscapes, this would not be an issue, but as the real topic is the photographs of these subjects, we have gone to some lengths to make sure that the essential information is here.

In many cases, the camera settings may be obvious and subsidiary factors in a photograph, and there is little to say about them. Nearly all SLR cameras have through-the-lens metering, and in many this is automatic, so that in a conventional situation, aperture and shutter speed are taken care of as a matter of course. However, it is the uncertain occasions, the ones that call for the photographer's judgement, that often hold the potential for the most exciting pictures – an animal bursting from cover, or a flock of white birds flying against dark stormclouds. At these times, only experience with the settings and facility with the controls will guarantee good results. If you rely heavily on the automatic capabilities of your equipment, you may have little opportunity to develop good technical judgement for the occasions when you need it.

There are three major sections, the first dealing with camera-related techniques, the second with field skills, and the third with specific natural environments. Most of the photographs were taken in the last year specifically for this book, on a series of field trips in Britain, Europe, the United States, India, Sri Lanka, Tanzania and South-east Asia that were planned to give a fair sampling of wildlife and nature subjects. They were taken with the problems and opportunities of photography in mind, and their captions have been written from a photographer's point of view.

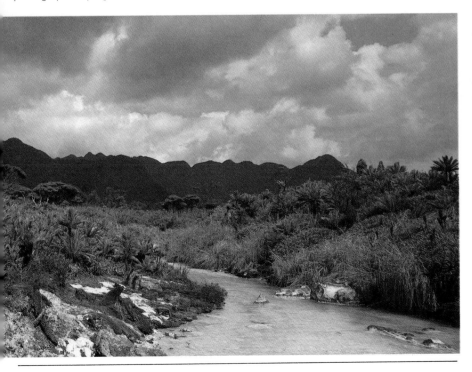

Section 1: Photographic Technique

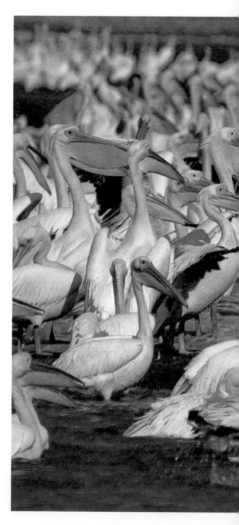

Wildlife photography is being transformed by the new technology of cameras, lenses and film. Equipment and materials have been improved more in the last few years than at any other time in the growth of photography. Color films are faster, processing more consistent, lenses give brighter and sharper images, and cameras are moving from the mechanical to the electronic. Because wildlife subjects are more often than not elusive and difficult, the effect of all these improvements has been to extend the range of possible subjects and to open up much of this rewarding field of photography to non-specialists. The increasing sophistication and complexity of the working areas of a camera or a chemical process are now being matched by simpler controls for the user.

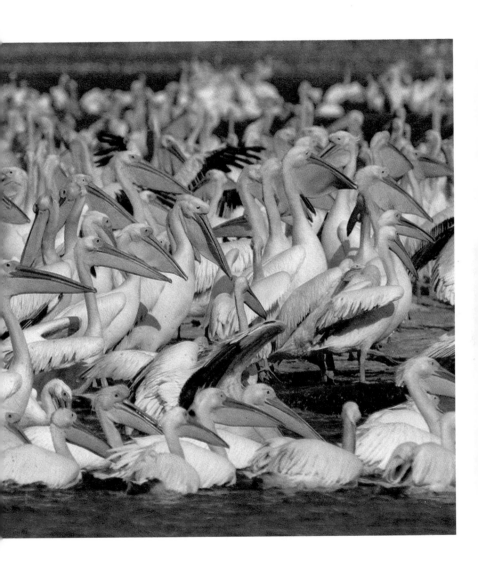

The Choice of Equipment

As photographic subjects, wildlife and nature differ in their equipment needs. Nature photography, by definition, is fairly general in scope, allows considerable room for personal interpretation, and so is not usually very demanding in terms of cameras and lenses. Landscapes, for example, can be approached in as many ways as there are photographic styles, with whatever equipment you care to use. What counts as suitable equipment depends much more on your preferences than on the subject itself. Wildlife photography, on the other hand, is dominated by the problems of getting technically competent pictures of subjects that are either difficult to approach or difficult to find in the right situations. For personal safety most animals prefer to keep their distance, and many of their most interesting activities, such as mating, are conducted under conditions of great privacy. As far as camera technology is concerned, these difficulties have the effect of stretching the capabilities of cameras and lenses to their limits, and so wildlife photography leans very heavily on equipment.

In any field of photography there is equipment that is ideal and equipment that can simply be made to do the job, more or less. In much wildlife photography the limits of what is just satisfactory are quickly reached. If, for instance, you ought to have a 600mm lens in order to fill the frame with a distant animal, but actually have only a 200mm lens, then you *may* be able to overcome this disadvantage by

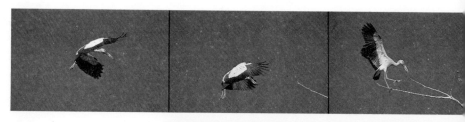

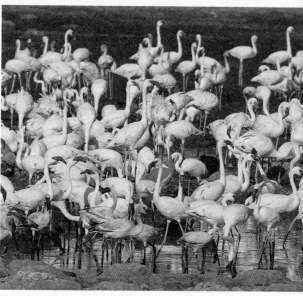

In fast-moving action sequences, such as a bird making a landing approach, a motor drive is ideal. Either choose the best frame of the series, or keep the sequence intact.

Motor drive

Battery pack

greater effort (such as by building a hide (blind) or using remote control) or else accept a poorer photograph (enlarging from a smaller image to produce a picture that is less sharp). To photograph a bat in flight, however, *only* a high-speed flash linked to a sensitive trigger will do the job. Equally, a moving animal at dusk, that would need a shutter speed of 1/125 sec to give a crisp image, can only be photographed at that speed if the film you are using is fast enough and the maximum aperture of your lens wide enough. Although this may seem harsh advice, in wildlife photography you must work within the limitations of your equipment.

There exists today such a variety of specialized photographic equipment that every imaginable facet of wildlife behaviour can be photographed. There are ultra-fast super-telephoto lenses, sophisticated remote control devices, and scanning electron microscopes that can image even bacteria with good depth of field, and ideally every wildlife photographer should have the right piece of equipment for the subject at hand. Practically, however, this is often not possible, for reasons such as cost, weight or bulk. In each section of this book the best equipment is shown in case you have access to it, but also described are techniques to help you use more modest cameras and lenses to their fullest. While it is pointless to attempt a photograph with a piece of equipment that is wholly unsatisfactory, some subjects can be handled creatively in different ways. For example, if you cannot approach a herd of animals close enough to show individual animals clearly, you could instead make the herd a key element in a landscape photograph. This is, in effect, re-defining the purpose of the shot to overcome a technical problem.

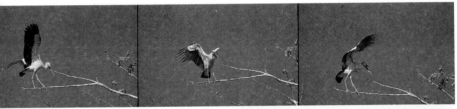

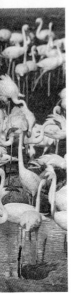

Massed shots such as this view of flamingos in an East African Rift Valley lake are only possible with a super-telephoto lens. The compressed perspective shows just how dense the flock is.

600mm (4°)

Although the telephoto lens used for these elephants was not quite powerful enough to fill the frame, re-composing to include the forest setting was a reasonable solution.

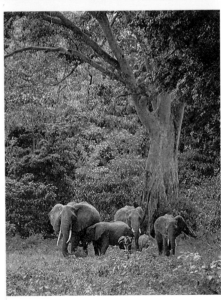

Camera Types

Cameras are normally grouped according to the size of film they use – 35mm, rollfilm or sheet film – because this more than anything else determines the size of the camera, the design of lenses it can accept, and the way it can be used. The 35mm film is sprocketed and in most cameras produces a picture measuring 24mm x 36mm (although it can also be used in some panoramic cameras to produce longer images). Rollfilm, for pictures nearly 6cm in width, is usually carried on a tough paper backing, but some cameras also accept a sprocketed version known as 70mm film. Picture size varies much more than it does with 35mm film and 6 x 6cm (2¼ x 2¼ inch), 6 x 7cm and 6 x 9cm are all common. Sheet film is used in view cameras and is available in several sizes, 4 x 5 inch and 8 x 10 inch being the most popular.

Although there are film sizes smaller than 35mm, nothing less is capable of giving what is generally considered a high quality image at moderate enlargement, such as an 8x 10 inch print. Because most wildlife subjects need the magnification of either a long focus lens or a macro lens, non-reflex cameras are of little use, as accurate sighting over a long distance is difficult, and parallax problems are severe at close range. The standard 35mm camera for wildlife and nature work is the single lens reflex (SLR). Almost all makes have interchangeable lenses (which are virtually essential in most habitats, where a wide variety of subjects can be found) and most have built-in exposure meters that measure the precise image that will be recorded on film. Although rollfilm or view cameras are better suited to certain subjects, and preferred by some photographers for their particular style of work, the 35mm SLR is on most counts the best for wildlife and nature photography.

The biggest advantage of the 35mm SLR is the range and sophistication of the equipment that can be used with it. It is popular in general

For active wildlife, and especially when stalking, the 35mm SLR has no serious competitors. An encounter like this normally leaves only a few seconds in which to shoot, and a larger format camera would almost certainly be too slow to use.

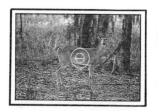

For more considered photography, where composition and image quality override speed of operation, a medium format camera using rollfilm has advantages. The larger film size can, if used well, record extreme detail and a wide range of tones. With a look-down viewing system, as shown here, the image is reversed left to right.

photography because it is portable and easy to handle, and this popularity has stimulated camera manufacturers to place their main effort in research and development against this format. Most of the improvements in lens design, metering and camera functions – all needed more in wildlife photography than in most other fields – take place in 35mm camera systems. For rapid use, as in stalking, this camera size is ideal, while the small picture size, for reasons described later, gives images with greater depth of field. Improvements in film have largely removed what was once considered the major drawback of 35mm – its lack of sharpness at reasonable enlargements. Nevertheless, given the same type of emulsion, the larger the picture area, the better the quality of the image, and where the situation allows, rollfilm and view cameras may be better. Rollfilm cameras are much bulkier and heavier than 35mm models, but they still allow the film to be advanced fairly rapidly while giving a larger negative or transparency. A 6 x 6cm (2¼ x 2¼ inch) picture has nearly four times the area of a 35 mm frame. Although at their best in the studio, where portability and rapid fire are less important, rollfilm cameras can be very useful for landscapes and trees.

View cameras, despite their extreme bulk, and although they are very slow to use, have the obvious advantage of giving a large negative or transparency, of a quality that is unrivalled. More than this, because they retain the traditional features of moveable film back and lens panel, they make it possible to alter the image in many interesting ways – by changing the distribution of sharpness so that close and distant objects can be focused at the same time at full aperture, or even by altering the shape of the subject. One of the classic traditions of photography has been the large-format landscape image, and for this the view camera has a strong place in nature photography.

For still subjects, that can be photographed unhurriedly, view cameras are extremely versatile. The most popular film sizes – 4" x 5" and 8" x 10" – are so much larger than either 35mm or rollfilm that image quality is of altogether a different order. Without special attachments, however, viewing is inconvenient, with an upside-down and dim image.

The camera shown here is a mahogany-and-brass field camera weighing little and designed to fold up for outdoor use. The tilting back puts both foreground and horizon in focus at a wide aperture.

Selecting Lenses

More than anything else, the lens determines the quality and the proportions of the image. When choosing lenses, assess and use them on these four criteria; their design, quality of manufacture, light-gathering power, and focal length.

Design

Although few photographers consider the optical design of the lenses they buy, it is essential for such special uses as close-up work. Most design innovations are concerned with such basic matters as improving the image quality, making the lens lighter and cheaper to produce, and so on. However, no lens can be expected to perform equally well in all conditions, and for general photography lenses are designed to perform at their best in the way that most people use them – that is to say, pictorially rather than scientifically, in daylight, and at distances of more than a few feet.

For specialised use, lenses can be manufactured that work well in one situation but only moderately well overall. Some lenses, for instance, produce an exceptionally flat, undistorted image, while others, with specially ground front surfaces, give glare-free images of naked lights. In wildlife and nature photography, the need to work frequently in close-up makes macro lenses an important special design. Unlike most other lenses, they are manufactured to be sharpest at close distances.

Quality

All lenses suffer inevitably from a variety of optical faults know as aberrations. However, by constructing a lens from several elements, each ground to a different shape, and by using different types of glass, most of these aberrations can be overcome, even in mass-production. Additionally, by coating the many surfaces of a modern lens extremely thinly with metallic oxides, flare can be reduced drastically.

Nevertheless, the very highest quality in resolution, good contrast, freedom from distortion, is possible only on small production runs, and by using expensive materials such as rare earth glasses. Long focus lenses are particularly difficult to make to very high standards, so that the best are extremely expensive.

On a 35mm camera, a 20mm lens gives a sweeping panoramic view of the landscape, roughly equivalent to the full view of our own eyes.

From the same viewpoint, a standard, 50mm, lens gives a normal perspective.

Light-gathering power

The more light that a lens can collect to form an image, the faster the shutter speed that can be set, and in wildlife photography this can be crucial. To freeze the image of a moving animal or bird, a fast shutter speed, such as 1/500 sec, is necessary. What determines the light-gathering power is the maximum size of the aperture – the greater its diameter, the more light enters. Two things, however, set a limit to this. One is that aberrations increase towards the edges of a lens, and a wide aperture reveals more of these; the other is that the longer the focal length of the lens, the less light actually reaches the film. Very wide maximum apertures are easiest to build into lenses that are of close to standard focal length (such as 50mm for a 35mm camera), and most difficult for super-telephotos. Fast lenses invariably use more glass, and so are relatively heavy, and depth of field is shallow at maximum aperture.

Focal length

From a user's point of view, the most important difference between lenses is focal length, as this determines the magnification of the image and how much of the scene in front of the camera is covered. Technically, focal length is the distance behind the lens at which an image is focused when the lens is set at infinity. A standard focal length gives an image that is similar in perspective to that seen by the unaided eye – what can loosely be called a normal view. Measured as the diagonal of the film format, for a 35mm camera it is, strictly speaking, 43mm, although by convention 50mm is considered normal. For the 6 x 6 cm (2¼x 2¼ inch) rollfilm camera it is 80mm, for 6 x 7cm 90mm, 4 x 5 inch 150mm, and so on. A focal length shorter than this gives a wider angle of view, while a longer focal length magnifies the image from a narrower angle of view.

The most useful focal lengths for each specific field of wildlife and nature photography are listed in the appropriate section, but for most wildlife work the one essential piece of equipment is a long focus lens. Exactly how long depends on the size of animal or bird, and how closely you can approach it, but the basic quality of a long focus lens – its ability to magnify the image – makes it the wildlife photographer's first choice.

A medium telephoto lens – in this example, 180mm – gives the kind of magnification that the human eye achieves when it concentrates on a detail of the scene.

A 400mm lens reveals details that the unaided human eye would miss. Most valuably for wildlife photography, it permits close views from a distance.

Viewing and Focusing

The viewing system in any SLR is straight-forward and uncomplicated, despite being mechanically sophisticated. The view through the eyepiece shows the image – at maximum aperture – that will be projected onto the film. Most cameras display slightly less than the full picture area (often about 90%), to compensate for users' mistakes in framing.

Being visual, SLR focusing is natural, needs no calculations, and causes few difficulties. However, if the lens is being used at less than its maximum aperture, you are not seeing exactly the image that you are about to photograph: there will be greater depth of field than you can see. This can be important when, for instance, you are relying on shallow depth of field to throw foreground branches out of focus, or when you are using it to blur a fussy background in a close-up shot. You can usually check the precise effect by pressing the camera's preview button.

In some SLR cameras the focusing screen can be changed, and there is usually a good choice of different designs. Even among SLRs with fixed prism heads it is often possible to order a camera fitted with the screen of your choice, or to have one altered later by the manufacturer. Because of the special demands of much wildlife photography, ordinary general-purpose screens are often not the best.

Under special conditions, visual focusing may not be possible, and some supplementary method has to be used. In wildlife photography this may occur in night stalking and in certain types of remote control work where you may not know the exact distance of the subject. See Night Photography on page 131.

Focusing aids for SLR screens

Although it is possible for the eye to focus on an image projected in mid-air, it is very difficult, and the basic surface used for focusing in a ground glass screen. The roughened surface makes it easy for the eye to stay focused on the same plane. However, the view of a ground glass screen appears unevenly lit, with a central 'hot-spot' directly in front of the eye. To even out the brightness, a Fresnel screen is normally sandwiched to the glass: its thin concentric rings act as a condensing lens and give a bright, even image.

For people who find it easier to focus by matching two straight edges, a split prism can be set into the screen. The image, seen through two small prisms, appears divided except when it is in focus.

A similar focusing aid is the microprism – a grid with many three-sided or four-sided prisms that 'scramble' the image except when it is in focus. Unlike split prisms it can be used with subjects that do not have an obvious edge.

The mechanics of focusing

The traditional lens focusing system is helical – turning the focusing ring moves the outer barrel backwards or forwards like a screw. On long focus lenses this can be a disadvantage; apart from sucking fine dust into the lens like a pump, it moves the entire lens, which is inconvenient if you are resting it on a bag or similar support. A new system, used on the better long focus lenses, is internal focusing, in which the outer barrel does not move; only lens elements inside shift position.

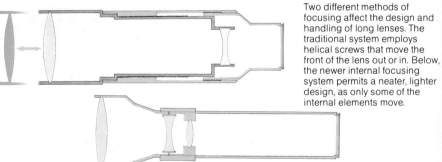

Two different methods of focusing affect the design and handling of long lenses. The traditional system employs helical screws that move the front of the lens out or in. Below, the newer internal focusing system permits a neater, lighter design, as only some of the internal elements move.

General-purpose screens

These focusing screens incorporate a mixture of viewing and focusing aids, so that at least one will serve for most types of photography. At the same time, however, one or more element may be a hindrance for certain shots. Notably, split prisms do not work with long focal length lenses, and give a distracting black semicircle which can, for instance, make it difficult to focus on a moving animal.

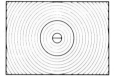

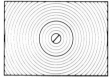

Fresnel with split prism Clear and easy to focus with standard and wide-angle lenses.

Fresnel with angled split prism. Similar to the screen at left.

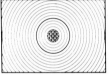

Fresnel with microprism An alternative to the two screens above.

Fresnel with split prism and microprism. A compromise between the two systems.

Screens for landscapes

As composition is frequently critical in landscape photography, particularly with wide angle lenses (which can give an angled image of the horizon unless used with care) a grid is a considerable advantage.

Fresnel with grid The etched rectangular grid makes alignment and judging proportions easy.

Fresnel with grid and split prism As above, but with a split prism.

Screens for long focus lenses

Since split prisms are unstisfactory with long focus lenses and for close-up extensions, a better screen for general use is a simple, unadorned Fresnel. As much wildlife work calls for concentration and fast camera handling, the less distraction the better.

Screens for close-up

Because depth of field is extremely shallow in close-up photography, critical focusing is the main need. Split prisms do not work at any significant extension.

Fresnel A plain Fresnel, as recommended for long focus lenses, is the most generally useful.

Plain ground glass Although the 'hot-spot' effect makes an overall view of the image difficult, a plain ground glass screen allows very critical focusing.

Ground glass with clear centre Similar to the screen above, but with a completely clear glass centre. The image in the centre is very bright, which is useful at long extensions (which reduce the light) and with practice it is possible to focus on this aerial image. The cross-hair helps to stop the eye's focus from drifting.

Clear with graduated scales This screen is designed for high-magnification photography, and needs a very specialized technique known as parallax focusing. By moving the eye slightly the image also appears to move, except when properly focused. The cross-hair helps the eye to focus.

Screens for low light levels

At dusk, in deep shadow, or in other dark situations, a large microprism grid is considered by some people to be the easiest focusing system. In failing light, however, a supplementary rangefinding system may be better (see Night Photography pages 104-5).

Fresnel with large microprism The structure of the grid must be matched to the focal length of the lens you are using, and is usually available in several models.

Full-frame microprism Although distracting under normal lighting conditions, this screen allows any part of the image to be focused.

Controlling Depth of Field

If you focus on a single subject – say, a deer standing 50 feet away – parts of the scene closer to, and farther away from, the camera will be less sharp. Exactly how unsharp depends on the depth of field. Shallow depth of field means that only a thin plane in front of the camera will appear in focus: broad depth of field means that most of the scene will appear sharp, from foreground to background. Being able to control this depth of field, and make it work for you, is an essential photographic skill. There are occasions when you have no alternative, such as when the light is poor and you need to use a long focus lens at maximum aperture. In this case you must accept a shallow depth of field. On other occasions, however, you can choose the extent of the depth of field, so that you do need to consider its effect.

Traditionally, sharpness throughout the picture has been highly valued in photography. Most landscape work, for instance, still follows this ideal. However, shallow depth of field also has its uses. At both extremes of distance, when using long focus and macro lenses, subjects are often caught up in tangled, complicated surroundings. A bird perched in a thicket, with branches all around, or an insect crawling amid leaves and stems, would both make a confused image if everything appeared sharply focused. The value of a shallow depth of field is that it can isolate a subject from its surroundings, throwing the background into a more evenly-toned blur. Fortunately, in these two types of situation, the depth of field is usually shallow in any case, unless you take special precautions to overcome it.

A special advantage of extreme lack of depth of field, particularly useful when stalking, is that you can throw the foreground so far out of focus that it is hardly visible. For instance, some leaves that might be between you and a bird, and which you can use to help stay concealed, may have virtually no effect on the image.

What controls depth of field?

Briefly, depth of field depends on how close you are to your subject; the focal length of the lens; and the aperture. Because sharpness is a subjective quality it is difficult to give hard figures, and the best definition of depth of field is the zone within which the image appears acceptably sharp. Obviously, the more critical you are, the sharper the depth of field in any

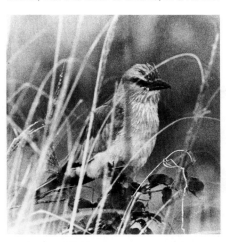

In the first of this pair of photographs, the aperture was set at f16. The bird is partly obscured by grass.

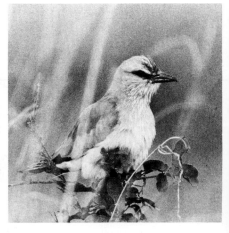

Using the same long telephoto lens at its widest aperture – f4 – throws the vegetation conveniently out of focus.

particular photograph. You can control it in the following ways.

Distance to subject The closer the camera is to the subject, the less the depth of field. As a result, it can be a real problem in close-up work.

Focal length Long focus lenses have shallow depth of field, wide-angle lenses have great depth of field. If you use a very long lens, such as 600mm, the depth of field will be so shallow that there is hardly ever any point stopping the aperture down.

A side effect is that, as 35mm cameras use shorter focal length lenses to give the same type of image as rollfilm or view cameras, the depth of field in a small format image appears greater.

Aperture Depth of field is greater with a small aperture, so that stopping down is the usual way of increasing sharpness throughout the image. One of the drawbacks of a fast lens is that, when used at its widest aperture, its depth of field is very shallow.

Measuring depth of field

Under normal circumstances the best check is a visual one, achieved by pressing the preview button on an SLR. The image is darker, but the appearance is exact (shade your eye if necessary, to make the view seem brighter). Alternatively you can read the depth of field scale engraved on most lenses. These show, for any given aperture, the nearest and farthest points on the distance scale that will be in focus. Depth of field tables published by lens manufacturers are too slow to use in most circumstances, although they can be useful in close-up photography.

Hyperfocal distance

In quite a number of situations you may simply want to keep the horizon, and as much else as possible, in focus, This is frequently a need in landscape photography. If all you do is to focus on the horizon, then you will just be wasting half the available depth of field (the half that lies behind the point of focus). Rather than do this, you should focus on what is known as the hyperfocal distance – the point at which the horizon lies at the farthest edge of the depth of field. For any scene, the hyperfocal distance depends on the aperture. To find it, look at the scales on your lens and set the infinity mark against the depth of field indicator for the aperture you are using. The lens will then be focused on the hyperfocal distance. If you have to widen the aperture, recalculate.

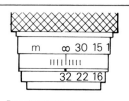

Focusing on infinity wastes some of the depth of field. Here, at f32, only the distance beyond 30 metres will be sharp.

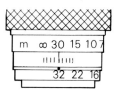

By focusing slightly closer, so that infinity is at one edge of the depth of field, the sharply focused area is brought closer.

With a 20mm lens focused as close as possible. Only the immediate foreground is sharp at the maximum aperture of f3.5, despite the inherently good depth of field of a wide-angle lens.

At the same wide aperture, much more of the scene appears sharp when the lens is focused on infinity, but the foreground is out of focus.

At the smallest aperture of f22, and focused on the hyperfocal distance (see left), practically all of the scene appears sharp. The only significant problem that stepping-down creates is a slow shutter speed, in this case ¼ sec.

Photographing Movement

In practice, most wildlife photographs are taken with the fastest shutter speed that the lighting and film will allow. This is not only as a precaution against camera shake when using long focus lenses, but also to make sure that as much as possible of the animal's movement is frozen. Generally, there is less creative scope for handling movement in wildlife photography than in many other fields. Occasionally, deliberate blur from a long exposure can be made to work in giving a sensation of speed, but more often than not the accepted ideal is a sharp image of the whole animal or bird.

One field where a slow shutter speed can be very useful, however, is landscape photography, particularly where there is flowing water. A fast shutter speed (say, 1/500 sec) that can freeze every drop of spray may be less effective than a longer exposure (1/30 sec or slower) that gives a smoother, more delicate result. The best result is a matter of personal taste.

Camera handling

Panning is the technique of following the image of a moving subject with the camera, and is so natural and obvious that it does not have to be learned. For steadiness it is better to turn your body from the waist up rather than twist just your arms and neck. Also, as there will often be obstructions such as trees between you and your moving subject, it is an advantage if you are able to pan with both eyes open, so that you can anticipate a blocked view. In any case, a running animal may well be heading for cover.

Shutter speed

The shutter speed that you need depends entirely on the animal's movements *as they appear in the viewfinder*. If the animal fills the frame, you will need a faster speed than if it appears quite small, as the pictures below show. Panning, because it keeps the animal's image more or less centred in the viewfinder, allows you to use a slower speed than you

Size in the frame

The larger an animal appears in the viewfinder, the more rapid its movements will appear, and the faster will be the shutter speed needed to freeze them. The red deer, filling the frame, needed a shutter speed of 1/250 second; the elephants, though moving at a similar speed, were smaller in the frame and needed only 1/125 second.

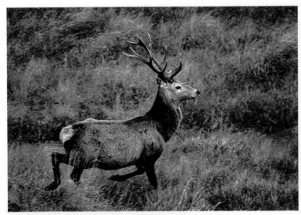

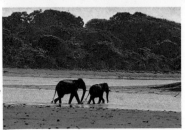

would otherwise, but not by much, as the limbs are moving in different directions. For instance, it is possible, by choosing the right moment, to make a sharp image of a hummingbird's head and body as it hovers by using a speed of only 1/125 second – but to freeze the movement of its wings needs an electronic flash of no slower than 1/20,000 second. The table gives some idea of the speeds necessary for acceptably sharp images of different types of animal.

The shutter speed that you are *able* to use depends on the aperture, and this in turn depends on the design of lens, the lighting conditions and the ISO rating of the film. As light intensity changes noticeably at dawn and dusk, when many animals and birds are at their most active, you may have to be prepared to change quickly to a faster film or a faster (and therefore probably shorter focal length) lens.

Focusing
If an animal is moving across your field of view, then it should not be a problem to keep it in

focus as the distance will change very little. If, however, it is coming towards you, either diagonally or directly, keeping it in focus can be difficult.

One technique that is occasionally possible if your subject is moving on the ground rather than in the air is to choose a reference point that you can expect the animal to pass – a tree trunk or rock, for example – and pre-focus on that; this depends on being able to predict the animal's route.

Exposure
As it moves, an animal or bird may pass in front of a changing background, and may also move between sunlight and shade. In such a case, an automatic camera is not always helpful, particularly if the tone of the background is very different from that of the animal. The best guide is your own judgement, using the exposure techniques described on pages 24-33, but you must work very rapidly.

Minimum shutter speeds
Many animals move at a distinct pace – usually a walk, trot or run – and this can help you assess the required shutter speed. The speeds given below assume that the animal fills the frame, more or less; if it appears smaller through the viewfinder, it will need a proportionally slower speed. However, for safety, it is usually best to use the fastest shutter speed that conditions allow.

	Walk	Trot	Run/gallop
Elephant	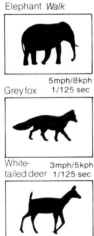 5mph/8kph 1/125 sec	18mph/29kph 1/250 sec	40mph/64kph 1/500 sec
Grey fox	3mph/5kph 1/125 sec	8mph/13kph 1/250 sec	28mph/45kph 1/500 sec
White-tailed deer	4mph/6kph 1/125 sec	11mph/18kph 1/250 sec	35-56mph/40-64kph 1/500 sec
Leopard	4mph/6kph 1/125 sec	11mph/18kph 1/250 sec	50mph/80kph 1/1000 sec

Focal Length

Unless you have very specialized interests, the most important type of lens for wildlife photography is long focus, simply because it magnifies the image. This is the most straightforward way of overcoming the problem of close approach to wary animals. The magnification can be worked out by dividing the focal length (in mm) by that of a standard lens. So, for a 35mm camera, for which a 50mm lens is generally considered standard (giving, in other words, a perspective similar to that with the naked eye), a 200mm lens will magnify four times, a 400mm lens eight times, and a 1000mm lens twenty times.

Choosing the most suitable focal length is critical in wildlife photography as there is usually little time or opportunity to adjust the image by moving closer or further away. The type of subject that interests you most may be a guide: small or medium-sized birds photographed from a permanent hide (blind) will probably need a focal length of at least 600mm (on a 35mm camera) if they are to fill the frame, whereas a 200mm or 300mm lens will probably be the most useful for large plains animals photographed from a vehicle, as in East African game parks.

In field conditions, with a choice of lenses in the shoulder bag, it is important to be familiar with their angles of view. If you can visualize the angle with a particular lens before fitting it to the camera, you can save valuable time. With experience this can become second nature, but there are one or two useful techniques that can help. The photographs show examples of some typical situations. Also, as a quick guide, you can use your hands, or even this book, to estimate the view, as shown.

For non-wildlife subjects, such as landscapes, trees and plants, there is usually more choice between lenses, and the effect that different focal lengths have on the style of image is described in the subject sections later in this book.

Angles of view
Focal length of lens

35mm camera	6 x 6cm (2¼ x 2¼in) camera	Angle of view across longer side
6mm		220°
8mm		180°
16mm		137°
	30mm	112°
13mm		108°
15mm		100°
18mm		90°
20mm		84°
	38mm	76°
24mm	40mm	74°
28mm		67°
	50mm	62°
35mm	60mm	54°
	80mm	41°
50mm		39°
55mm		37°
	100mm	33°
	105mm	32°
	120mm	28°
	135mm	25°
90mm	150mm	23°
100mm		20°
135mm		15°
	250mm	14°
180mm		11°
200mm	350mm	10°
300mm		7°
	500mm	6°
400mm		5°
600mm	1,000mm	4°
800mm		3°
1,000/1,200mm		2°
2,000mm		1°

Estimating the best focal length
Hold your hands, or this book, in front of you
with your arms outstretched. For most people,
the estimates given here are accurate,
although you should check *your* hands and
arms against the view through the camera.

10-12°
35mm camera 200mm lens
6x6cm camera 300mm lens
9x12cm camera 600mm lens

4-5°
35mm camera 400/500mm lens
6x6cm camera 650/800mm lens
9x12cm camera 1,500mm lens

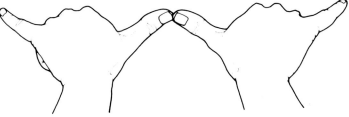

40-50°
35mm camera 50mm lens
6x6cm camera 80mm lens
9x12cm camera 150mm lens

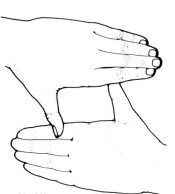

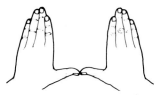

90-100°
35mm camera 20mm lens
6x6cm camera 30mm lens
9x12cm camera 60mm lens

15-18°
35mm camera 135mm lens
6x6cm camera 250mm lens
9x12cm camera 450mm lens

Exposure Meters

Exposure meters measure the intensity of light in a scene. Whether the meter is automatic or manual, hand-held or built into the camera, it is calibrated so that the film, when exposed at the f-stop and shutter speed indicated, will record the scene as an *average tone*. Most photographed subjects – landscapes, people, buildings, animals, or whatever – have a more or less average tone, so that whether they are lit brightly or dimly, they appear most realistic when they have the same average tone in a photograph.

Whatever the mechanics of exposure meters, the only important difference between types is the *area* of the scene in front of them that they measure, as shown in the illustration here.

There are three types of meter: through-the-lens (TTL), hand-held, and spot. The most commonly-used and popular of the three is the TTL meter, built into the camera body. Its obvious advantages are that it takes its readings from the exact scene about to be photographed, and that these readings can be linked quickly and easily to the camera controls. As a result, automatic exposure adjustment is straightforward, and built into many cameras.

Some TTL meters measure a precise area in the middle while others, tailored to the way that most photographers compose images, are biased towards the centre of the picture. The information is displayed in one of several ways, commonly through a moving needle, light-emitting diodes (LEDs) or liquid crystal displays (LCDs).

Hand-held meters can be used for reflected light readings (aimed directly at the subject) *and* for incident light readings (aimed at the light source). They are generally best when you have plenty of time to set up a shot.

Spot meters, which are also hand-held, measure very small areas of the scene with great accuracy. They use a lens and viewer, so

TTL metering

Most TTL meters are biased towards the centre of the picture frame, as this is where most photographers tend to place the centre of interest of an image. The bias also reduces the importance of the top of the frame, so that sky does not adversely affect the exposure reading. Such 'weighted' readings, in other words, *anticipate* average amateur photography, and this often does not suit serious work. Other TTL systems therefore limit measurement to precise areas that are marked on the viewing screen. A few cameras offer the choice of two or more 'weightings' which the photographer can select according to the situation. Make sure that you know how *your* TTL meter takes readings.

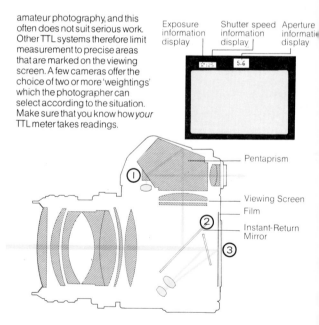

Exposure information display | Shutter speed information display | Aperture information display

Pentaprism

Viewing Screen
Film
Instant-Return Mirror

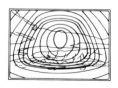

that the scene is viewed in much the same way as with an SLR camera, and the light reading is taken from a small central circle, covering a picture angle of exactly 1°. They are, therefore, not suited to broad sweeping measurements, but they can be used to make an extremely detailed assessment of an image.

Flash meters work in essentially the same way as regular exposure meters, with the single important difference that they respond only to the flash output and not to any other existing lighting. They are hand-held, and most conveniently used for incident readings, aimed towards the flash unit.

Light-sensitive cells
Most of the light-sensitive cells at the heart of an exposure meter are powered by small batteries, and alter the current passing through them to translate light intensity into a reading. Cadmium sulphide, silicon, and gallium cells are all highly sensitive (a range of EV 1 to EV 20

is not unusual) but they may 'remember' very bright lighting and should be allowed to rest for a few minutes after exposure to an intense light source.

The more traditional selenium cells, still used in a few handheld meters, are less sensitive but because they are 'self-powered' they are very reliable, and useful in situations where batteries may fail, such as cold weather.

Types of light reading
The essential exposure information is, in the end, the f-stop and shutter speed, and all exposure meters can convert light readings into these figures. However, a simple notation that is easy to use for comparisons (and is sometimes included on meter displays) is Exposure Value (EV). An EV reading is a single figure that covers *any* combination of f-stop and shutter speed that gives the same exposure, and it alters only with the ISO rating of the film.

Hand-held metering
Hand-held meters generally measure a loosely-defined area. Most have an 'acceptance angle' of around 30°, which is slightly less than the angle of view of a standard lens. Some hand-held meters can be fitted with attachments to reduce this angle so that it corresponds more closely with that of a long focus lens.

By fitting a diffusing cover, usually in the shape of a dome, over the light-sensitive cell, the meter can be used to measure the light source. This is valuable when the subject is much darker or lighter than average, or when the background contrasts strongly. For reflected light readings, aim the meter towards the *subject*. For incident readings, aim the meter towards the *camera*, either from the position of the subject or, if that is inconvenient, from anywhere that is in similar lighting.

Spot metering
The small circle in the centre of the spot meter's viewer covers an angle of 1°. The reading is taken *only* from this area, and the display can be locked by releasing the operating trigger.

Exposure Measurement

When working quickly is important, as it often is in wildlife photography, a TTL meter has no rival. Even when there is no urgency, as with most landscape subjects, a TTL reading may still be the most convenient, not least because the focal length of the lens makes no difference to its accuracy. However, in some unusual lighting conditions, the slower-to-use hand-held and spot meters may be better.

The thing to remember is that all meters give readings that will result in an *average tone* for the images they measure, so the one essential precaution is to aim the meter at the right part of the scene. This in turn means deciding, even if you have to make a split-second judgement, just how light or dark you want the scene to appear. There is no such thing as an arbitrarily correct exposure, although there *is* a fairly narrow range within which an image will appear normal. You may, for instance, prefer a sombre woodland view to remain dark as a picture, or you may want the photograph light enough to show all the details. Accurate exposure measurement means setting the f- stop and shutter speed so that the photograph appears as *you* want it to.

Where the exposure setting is uncertain, and you have at least a few seconds, you can for safety 'bracket' the exposures. This technique, commonly used by professional photographers, involves exposing a number of frames for each subject, some slightly darker and others slighly lighter than the indicated reading. Although this uses more film, if the shot is important the extra cost may be negligible. Bracketing three frames (half a stop under, normal, and half a stop over) is common practice, but five frames (from one stop under to one stop over, in half-stop increments) may occasionally be necessary.

Average reading

In a scene such as this, where there is no great difference in brightness from one part to another, and where the subject is straightforward, an average reading would suit most photographers. A TTL or hand-held meter can be used without any adjustments, except possibly for lightening or darkening the exposure by up to half a stop to cater for individual taste. A spot meter needs rather more care, as it can pick up seemingly insignificant differences. With a hand-held meter you could, alternatively, fit the diffusing dome and take an incident reading, which should in this case be identical to the reflected light reading.

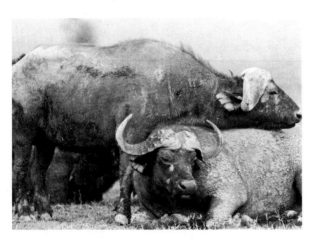

High-low reading

In high-contrast scenes, which have extremes of sunlight and shadow, an average reading may not be accurate. If you want to record as much as possible of the sunlit and shadowed areas together, you can calculate a middle setting by taking two readings, one from a bright area and another from a dark area. Then, select an aperture and shutter combination midway between the two. With a hand-held meter this involves moving in close to each area and making either a direct or incident reading. With a TTL meter, if the reading is taken from just the centre of the viewfinder, aim the camera at the two different areas in turn; otherwise, move in close. A spot meter is ideally suited to this type of reading.

Make sure that the range from high reading to low reading is within the capacity of the film you are using. The 'latitude' of most negative films is around seven stops, while that of most color transparency films is only about five stops.

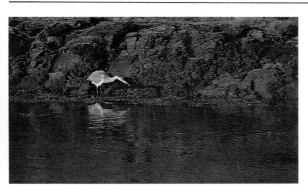

Key reading

There are often situations in wildlife photography where the contrast range is fairly high, but only one tone is actually important. Here, the heron is the subject, although a normal average reading would also consider the darker background. In this case, the reading should be made *only* for the heron. If there was sufficient time, a spot meter would be ideal: a reading could be taken directly from the plumage (the smaller circle marked on the photograph). In practice, there may be less time, but with a TTL meter that measures from a central area, the camera can be aimed at the key subject (here, the larger circle) for the reading and then re-composed for the shot. With a hand-held meter, an incident reading *in the same light* would be accurate.

Exposure Guide

Most modern cameras have built-in light meters, and for most picture-taking situations they are the most convenient method of measuring exposure. Certainly, in most wildlife photography, where decisions have to be taken rapidly, any deficiencies that TTL metering may have are usually outweighed by its simplicity and speed. Nevertheless, there are occasions when it may be difficult to measure exposure – if, for instance, your meter is faulty or its batteries fail. In such a case, it pays to be familiar with the average exposure settings that you would expect in different conditions. The examples that follow have been chosen as typical of many wildlife and nature scenes. In an emergency, compare the situation you are in with these, and choose the most appropriate.

An added important advantage of knowing approximately what the exposure setting *ought* to be is that you need rely less on your meter.

This not only gives you a constant check on the accuracy of the meter; it also makes it easier to pre-set the aperture and shutter speed – an important technique in stalking where it is essential to be prepared for rapid shooting.

The exposure settings quoted are for the most common film speeds: ISO 64 (Kodachrome 64 and Ektachrome 64 transparency films); ISO 125 (medium grain black-and-white films such as Plus-X and FP4); and ISO 400 (high-speed transparency films such as Ektachrome 400 and Fujichrome 400, and fast black-and-white films such as Tri-X and HP5). Working out the settings for other film speeds is straightforward: ISO ratings are on a linear scale, and the list below is in divisions of one-third of a stop. An ISO 100 film, for instance, is two-thirds of a stop faster than ISO 64, and so needs a two-thirds smaller aperture. ISO 25 32 40 50 64 80 100 125 160 200 250 320 400

How weather and habitat affect light
Daytime, ISO 64, typical subjects

	BRIGHT SUN	HAZY SUN	CLOUDY BRIGHT	MODERATELY OVERCAST	STRONGLY OVERCAST
OPEN GROUND	1/250 sec f8	1/250 sec f5.6	1/250 sec f4	1/250 sec f2.8	1/125 sec f2.8
OPEN SHADE	1/250 sec f2.8	1/125 sec f2.8	1/60 sec f2.8	1/30 sec f2.8	1/15 sec f2.8
WOODLAND SHADE	1/125 sec f2.8	1/60 sec f3.5	1/30 sec f3.5	1/25 sec f3.5	1/8 sec f3.5
DEEP WOODLAND SHADE	1/60 sec f2.8	1/30 sec f3.5	1/30 sec f2.8	1/15 sec f2.8	1/8 sec f2.8
RAIN FOREST SHADE	1/8 sec f2.8	1/4 sec f3.5	1/4 sec f2.8	1/2 sec f2.8	1 sec f2.8

///, Colour Cast likely

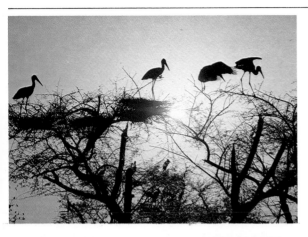

Silhouetted shots against a low sun (here, evening) are usually acceptable over a range of a few stops. A small exposure emphasizes the outline and colour; a full exposure gives a sense of light and atmosphere. This is a middle exposure. For safety, bracket.

ISO 64: 1/250 sec at f5.6
ISO 125: 1/250 sec at f8
ISO 400: 1/250 sec at f14

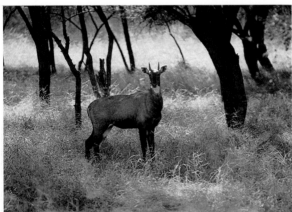

Open shade during the day gives high contrast. If the animal is in shade, give a full exposure or detail will be lost. From an average meter reading, opening up by one stop gives a safe exposure.

ISO 64: 1/250 sec at f2.8
ISO 125: 1/250 sec at f4
ISO 400: 1/250 sec at f5.6

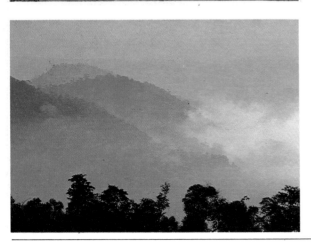

Early morning mist in hills is difficult to judge for exposure, but the setting is not usually critical. From a meter reading of the light, misty area, open up one or more stops. Bracket if possible. If the sun is low, the result will usually be warm.

ISO 64: 1/125 sec at f2.8
ISO 125: 1/125 sec at f4
ISO 400: 1/125 sec at f7

Flare from a low sun in front of the camera, enhanced by dust, is common in plains photographs. For atmosphere, treat as if mist, and give about one stop more exposure than a direct meter reading.

ISO 64: 1/125 sec at f4
ISO 125: 1/125 sec at f5.6
ISO 400: 1/250 sec at f7

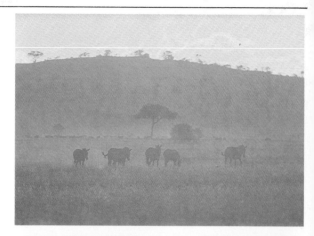

Shooting against the sun in woodland, be careful not to underexpose, or the important shadow detail will be lost. Bracket exposures to include settings fuller than the average reading.

ISO 64: 1/60 sec at f4
ISO 125: 1/60 sec at f5.6
ISO 400: 1/125 sec at f7

Even when side-lighting strikes an animal, it is usually important to preserve shadow detail. In a case like this, the setting can be about half a stop lighter than the shadow reading.

ISO 64: 1/60 sec at f2.8
ISO 125: 1/125 sec at f2.8
ISO 400: 1/125 sec at f.5

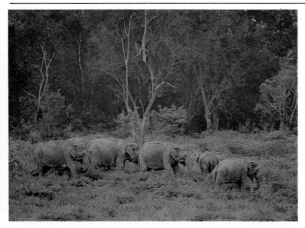

A lightly overcast sky gives low contrast lighting, which is straightforward for a meter, but can confuse rule-of-thumb measurements. Thicker cloud cover gives a similar effect but the exposure settings may be two or even three stops lower than these below.

ISO 64: 1/250 sec at f4
ISO 125: 1/250 sec at f5.6
ISO 400: 1/500 sec at f7

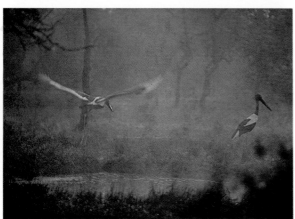

Sunrise in wetlands is often hazy due to rising mist. Light levels change rapidly, but at the point where the sun is sufficiently visible to create noticeable highlights, they merit settings similar to these.

ISO 64: 1/125 sec at f2.8
ISO 125: 1/250 sec at f2.8
ISO 400: 1/250 sec at f5

Rain raises the colour temperature (effectively, adding a blue cast) and has a mist-like effect. It also lowers light levels by up to three stops, as here.

ISO 64: 1/30 sec at f2.8
ISO 125: 1/60 sec at f2.8
ISO 400: 1/125 sec at f3.5

Mid-morning to mid-afternoon are usually fairly predictable lighting conditions. In shade be careful to give sufficient exposure to hold detail, and with colour film be prepared for a blue cast with a clear sky (or add a warming filter).

ISO 64: 1/250 sec at f5.6
ISO 125: 1/250 sec at f8
ISO 400: 1/500 sec at f10

Midday tropical light is, by conventional standards, not very attractive for photography. Under a clear sky, the settings below are about the highest possible under natural lighting.

ISO 64: 1/250 sec at f8
ISO 125: 1/250 sec at f11
ISO 400: 1/250 sec at f21

Full side-lighting in open ground needs considerably less exposure than in colour, where shadows tend to be darker (see page 30, bottom photograph).

ISO 64: 1/250 sec at f4
ISO 125: 1/250 sec at f5.6
ISO 400: 1/500 sec at f7

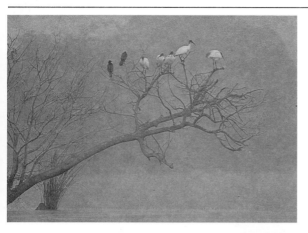

Early morning mist is common in wetlands. Because the contrast range is extremely limited, the exposure setting needs to be accurate: about one stop lighter than the direct meter reading, but bracket.

ISO 64: 1/125 sec at f3.5
ISO 125: 1/125 sec at f5
ISO 400: 1/250 sec at f5.6

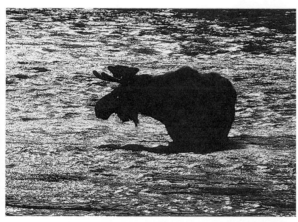

Severe backlighting is usually best served by very small apertures – two or three stops less than would be best for frontal lighting under the same conditions.

ISO 64: 1/500 sec at f11
ISO 125: 1/500 sec at f16
ISO 400: 1/1000 sec at f21

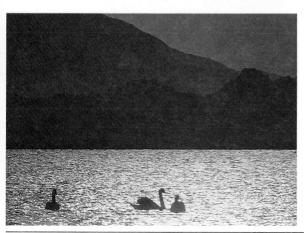

When silhouetted shapes are immediately recognizable (the water surface in this picture is smooth, and the ripples unlikely to interfere with the outline of the swans), these very short exposures are possible, giving strongly defined images.

ISO 64: 1/500 sec at f22
ISO 125: 1/1000 sec at f22
ISO 400: 1/2000 sec at f29

Color Temperature

Color temperature has practical importance in photography, because although our eyes can adapt to color changes to the extent that we do not notice them, film cannot. A subject lit by a setting sun will have an orange cast, and a photograph taken in shade on a sunny day will appear blue. In outdoor photography, the low color temperature at sunrise and sunset is usually accepted for what it is, and considered attractive by most people, but the high color temperature of scenes lit only by blue skylight generally appears 'wrong'. Electronic flash units are designed to imitate 'white' sunlight but some, particularly when new, have slightly higher, bluer color temperatures.

Adjusting Color Temperature

To correct a color cast to 5500 K 'white', or to change it to suit personal taste, a range of color correction filters is available to use over the lens. Yellowish filters (numbers 81 and 85 in the Kodak series) lower the color temperature, while bluish filters (numbers 82 and 80) raise it. In outdoor locations, accurate measurement is hardly ever necessary, and although there exist color temperature meters, the rule of thumb guide below is sufficient.

A low sun, undiffused by clouds near the horizon, has an extremely low colour temperature. Most evident in clear air.

3000 K 4000 K 5000 K

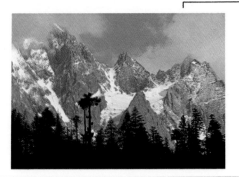

Midday sun gives neutral lighting, without any noticeable colour cast.

Filter guide for altering colour		Use this filter to correct to 'white'
Shade under intense blue sky (as in mountains)	12000 K	85
Shade under blue sky at dawn or dusk	10000 K	85C
Shade under normal midday blue sky	8000 K	81 EF
Overcast sky	6000 K	81 A
Light from orange sun close to horizon (normally no need to correct)	3000 K	80A + 82A

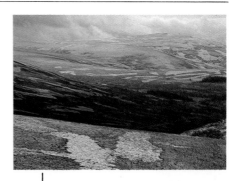

Strongly overcast weather at twilight produces very blue light. This is enhanced by snowscapes.

6000 K　　　　　　7000 K　　　　　　8000 K　9000 K　10000 K　11000 K　12000 K

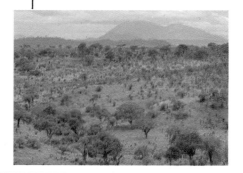

A light covering of cloud diffuses the lighting from both the sun *and* blue sky above, and the result is a slight coolness.

Using Flash

Only a few types of unit are sufficiently powerful to be useful at distances of more than several metres, and most are designed for work at between one and about a dozen metres with medium-speed film and an average lens. For close-up photography, a low-output manual unit is usually best, or a dedicated flash unit if the camera has TTL flash metering.

Most flash units are automatic, and adjust the duration of the flash to give a consistent exposure by means of a light-sensitive cell and fast-reacing circuitry. Dedicated flash units not only adjust the light output automatically, but are linked electronically with the shutter and viewfinder display.

Synchronization
The few cameras that have between-the-lens shutters can be used with flash at any shutter speed, but SLR cameras have focal plane shutters and can only be used at moderate-to-slow speeds.

The 'hot shoe' built into some cameras as a flash mount provides the electrical contact that synchronizes the flash unit with the shutter. Otherwise, a co-axial sync lead from the flash unit can be connected to the 'x' socket on the camera.

When more than one flash unit needs to be synchronized, their sync leads can be connected with a small junction, but this runs the risk of overloading the circuit (see Close-up Flash, pages 116-117). A photo-cell slave trigger is safer.

Calculating exposure
Provided that it has already been tested (see box), an automatic flash unit demands no exposure calculation – it simply needs to be set for the speed rating of the film being used, and the lens aperture set as indicated.

With a manual flash unit, or if an automatic unit is being used at such a distance that its full output will be used, the aperture can be calculated by dividing the guide number for the speed of film you are using by the distance to the subject. For example, if the guide number for your unit is 55 with ISO 64 film, and the animal you are photographing is 20 feet away,

Guide numbers for electronic flash

ASA film speed	BCPS output of electronic flash unit									
	350	500	700	1000	1400	2000	2800	4000	5600	8000
20	18	22	26	32	35	45	55	65	75	90
25	20	24	30	35	40	50	60	70	85	100
32	24	28	32	40	50	55	65	80	95	110
40	26	32	35	45	55	65	75	90	110	130
50	30	35	40	50	60	70	85	100	120	140
64	32	40	45	55	65	80	95	110	130	160
80	35	45	55	65	75	90	110	130	150	180
100	40	50	60	70	85	100	120	140	170	200
125	45	55	65	80	95	110	130	160	190	220
160	55	65	75	90	110	130	150	180	210	250
200	60	70	85	100	120	140	170	200	240	280
250	65	80	95	110	130	160	190	220	260	320
320	75	90	110	130	150	180	210	250	300	360
400	85	100	120	140	170	200	240	280	340	400
500	95	110	130	160	190	220	260	320	370	450
650	110	130	150	180	210	260	300	360	430	510
800	120	140	170	200	240	280	330	400	470	560
1000	130	160	190	220	260	320	380	450	530	630
1250	150	180	210	250	300	350	420	500	600	700
1600	170	200	240	280	340	400	480	560	670	800

Standard portable flash units have automatic or dedicated metering and use AA or NiCad batteries.

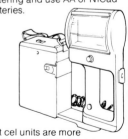

Wet cel units are more cumbersome, but also more powerful. Power supply is permanent.

the aperture should be f2.8 (that is, 55/20). Alternatively, you can use a portable flash meter – an important investment if you use flash frequently

The 'ready' light on most units appears *before* a full charge has been accumulated. Wait for about five seconds before firing, or the output may be only about 80 per cent of maximum.

Flash position

The most convenient place is by the camera, either mounted on the camera's 'hot shoe' or on a supplementary bracket. Visually, however, the results may not be very satisfactory, giving flat lighting, over-exposed foregrounds and under-exposed backgrounds, and prominent eye-shine on people and animals. In most unplanned wildlife photography there is no alternative, but when you *can* make preparations it may be better to place the flash at a distance from the camera and fire it by an extension sync lead or a photo-cell slave trigger.

Checking the flash output

The BCPS and guide numbers claimed by flash manufacturers are not always accurate and are, in any case, calculated for normal *indoor* use, where the reflections from walls and ceilings make the flash seem a little more powerful. A lower guide number and BCPS are usually more realistic outdoors.

To make a practical test, use the unit at full power (that is, at the manual setting on an automatic flash) and with your normal film – preferably color transparency film so that the results will not be confused by printing. Use a person as a test subject, dressed in medium-toned clothes. Make the test outdoors in the evening or at night, when natural light is too weak to have any effect. With the flash mounted on the camera, stand at a measured distance from the test subject and take several exposures, including the aperture recommended by the manufacturer but altering it for each successive shot by half a stop. For example, at 20 feet (6.1 metres) with ASA 64 film and a recommended guide number of 55, make exposures at f1.8, f2, f2.4, f2.8, f3.5, f4, f4.7. Make a note at the time of each exposure. When the film has been developed, see which appears to be the best exposure, and calculate the *real* guide number by multiplying the f-number by the distance. In the example, if the best exposure was the one made at f2.4, then the guide number would be (f)2.4 x 55(feet) = 132.

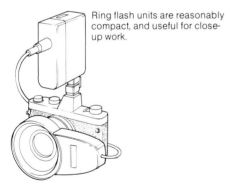

Ring flash units are reasonably compact, and useful for close-up work.

A portable flashmeter is important for critical work, and weighs very little (above right). A photo-cell slave trigger (right) is a useful accessory for firing a second flash unit off-camera – to light a background separately, for instance.

Color Film

Most wildlife photography is in color, principally because coloration is an essential characteristic of the appearance of many animals. The choice between transparency and negative film depends on the final use of the photography: for projection, or for use in magazines, books and other publications, use transparency film; for prints, use negative film. Although prints can be made from transparencies, and slides from negatives, the results are never as good as when the films are used as intended. In practice, most wildlife photographers use transparency film.

Color itself is subjective, and the choice of film from the principal makers shown below usually depend on personal taste. When viewed side by side, competing brands do show differences, but these are small, and among negative films printing variations usually swamp any original differences. Using the summaries given here of each film's performance, test several for yourself. You may prefer the results from one or two; if so, continue to use these and so become familiar with the way they behave in different lighting situations.

The four most important practical qualities of a color film are: color accuracy, speed and graininess, sharpness of image, and richness of color.

Colour films (Transparency)

Kodachrome 25. ISO 25. *The* standard for image quality in colour. No other film approaches its fineness and uniformity of grain structure. Edge sharpness extremely good. Colour accuracy high, particularly for warm hues..

Agfachrome 50 S. ISO 50. A sharp, fine grain film (although grainier than Fujicolor 50 RF and even Ektachrome 64). Neutral and pale colours particularly accurate, and blacks dense. A general purpose film.

Fujichrome 50 RF. ISO 50. Probably second only to Kodachrome 25 overall. Reds richer and edge sharpness slightly higher than Kodachrome 25, finer grain than all other films. A very good all-purpose film except in low light.

Kodachrome 64. ISO 64. Slightly grainier than the two above films, and contrast a little high. Otherwise, an excellent general film, and still the most favoured by professionals. Reds rather too saturated.

Ilfochrome 100. ISO 100. A good general-purpose film, although the speed gain over the films above is not very significant.

Fujichrome 100 RF. ISO 100. Extremely good image quality: grainier than Kodachrome 64, but finer than Ektachrome 64. Contrast higher than the slower films.

Ektachrome 200. ISO 200. A medium-high speed useful for active wildlife shooting in shade and failing light. Grainier than the above films but better than the 400-speed emulsions. Colours accurate, good edge sharpness.

Agfachrome 200. ISO 200. Similar to Ektachrome 200, but colours warmer and edge sharpness not quite as high.

Ektachrome 400. ISO 400. Higher contrast and grainier than Ektachrome 200, but this is an inevitable price to pay for the extra speed. Good edge sharpness.

3M Color Slide 400. ISO 400. A good high-speed film.

Fujichrome 400. ISO 400. Compared with Ektachrome 400, slightly more prominent grain but warmer colour bias.

3M Color Slide 1000. ISO 1000. Extremely fast film that extends the shooting opportunities further into twilight. Good to have at hand in failing light.

Color accuracy

There is no such thing as complete color fidelity because the dyes used are by no means perfect. However, some films are more accurate for certain colors, and all give acceptable results overall.

Speed and graininess

Fast film, which can be used in poor light, achieves its sensitivity by being grainy. This shows up in an enlargement as a speckled texture that breaks up the image slightly. For a fine-grained image, the film must be less sensitive to light – that is, slower. The two Kodachrome films, because of their special process, have particularly fine grain for their film speed. A common choice for wildlife photography is a fine-grained film for most daylight situations and a smaller quantity of fast film for dawn, dusk and poor-weather use.

Sharpness

This is subjective, and depends on resolution, contrast and graininess. For example, Kodachrome 64 is not quite as good at resolving detail as Ektachrome 64, but because it has fine grain and fairly high contrast, it *appears* sharper.

Color richness

Some of the dyes used are stronger than others. Transparency films, if slightly under-exposed (by about half a stop), give more saturated color.

Colour films (Negative)

Kodacolor VR 100. ISO 100. Ultra-fine grain, extremely sharp. Colours accurate and intense, with especially pure blues and rich yellows. Good shadow detail. A good general purpose film when fine detail is important.

Kopdacolor VR 400. ISO 400. Accurate colours, with rich blues and yellows. Grainier than the clower films, but this would only be important at print sizes larger than 8x10 in. A good choice for active wildlife shooting.

Ilfocolor 100. ISO 100. Similar in all basic respects to Kodacolor VR 100.

Ilfocolor 400. ISO 400. Basically similar to Kodacolor VR 400.

Agfacolor 100. ISO 100. Similar to Kodacolor VR 100 and Ilfocolor 100.

Agfacolor 400. ISO 400. Similar to the other ISO 400 films.

3M Color Print 100.
ISO 100. Similar to the other ISO 100 films.

3M Color Print 400.
Similar to the other 400-speed films.

Fujicolor 100. ISO 100. Similar to the other ISO 100 films.

Fujicolor 400. ISO 400. Similar to the other 400-speed films.

Kodacolor VR 200. ISO 200. For a gain in twice the film speed, very little loss in image quality from Kodacolor VR 100: no more graininess and only slightly less sharp. A good all-round film for most nature subjects.

Kodacolor VR 1000. ISO 1000. Less contrast than slower films, and colors more muted also, although greens and reds are good; however, these differences are quite small, remarkable film, particularly if print size is small.

Film Care and Processing

It pays to be careful and demanding about the quality of film emulsion – particularly with transparency film, which produces the final image as soon as it has been processed. The way film is manufactured, stored, used and processed all affect the image, and taking account of this can make a reasonable difference in the richness and accuracy of the colors, the contrast and the film speed.

All film is perishable, but sensible precautions reduce the rate at which it deteriorates. Film which has not been stored or used carefully loses contrast and sensitivity, and color films may develop an overall cast – often green. Apart from age, the chief enemies are heat and humidity. Separately they speed up deterioration but together they are even more harmful. Cold is only a problem when *using* film; for storage it is ideal. For film care under extreme conditions, see the specific habitats in Section 3.

Manufacturing differences
Films are manufactured in large batches, up to tens of thousands of rolls at a time. Despite quality control, film speeds may vary slightly, and the overall color may differ by up to five percent from the standard. The best allowance you can make for this is to buy a large number of rolls at one time, all from one batch. Then, store what you do not immediately need in a freezer.

Some manufacturers produce two kinds of film: 'professional' and 'amateur'. Professional film is made to more critical standards, and is meant to be at its best when fresh. Amateur film suffers no harm at being kept for up to three months at room temperature, as manufacturers realize that it is likely to be stored in less-than-perfect conditions. On long field trips, therefore, amateur film may be the better choice.

Storage
Ideally, film should be stored in a freezer at -18°C/0°F in *unopened packs*. (The films are sealed at manufacture, in conditions of low humidity.) To avoid condensation, allow the packs to warm up naturally at normal room temperature before opening them for use. This will normally take about two hours for 35 mm film and about one hour for rollfilm. When storing exposed film, wrap in a plastic bag with a sachet of silica gel, which will absorb moisture. Time limit: many years.

Good basic storage conditions are at around 4°C/40°F, in a refrigerator. Avoid humidity problems by wrapping as described above. Allow one hour for 35 mm film to warm up: half an hour for rollfilm. Time limit: several years for amateur films.

Minimum storage conditions are, for amateur films, temperature below 24°C/75°F at a relative humidity of 40-60%. Professional films need 13°C/55°F or less. A useful rule of thumb is that every 5°C lower than this *doubles* the life of the film. Time limit: as stamped on the film carton.

Exposed film deteriorates faster than unused film, and so should be processed as soon as possible.

In field conditions, take *any* precautions that keep film cooler and drier. An insulated picnic box is very good for temporary storage. Keep film in shade, and never in enclosed spaces such as locked cars in hot weather. Silica gel is nearly always used for keeping film dry (see pages 176-7 for ways of using and re-using it).

Use
Once the film is out of its protective pack, never allow direct sunlight to fall on it – neither cassettes nor rolls are completely light-proof. Load and unload in the shade. Keep the film compartment of the camera spotlessly clean. If the film is wound over dust or grit, it may be scratched.

If the film seems to have jammed inside the camera, it may not have been mounted onto the spool properly. Remove the film in darkness; if you force the winding mechanism, you may tear the film.

Processing
Although film processes have been standardized and simplified in recent years, quality variations are still possible between different processing labs. For consistency, try to find one that gives you satisfactory results and then use it regularly. On a long trip, if you can store exposed film efficiently, it may be better to take it home to a lab that you know than to experiment with a local one. If you have

to ship film home, use air freight, seal the film in an X-ray-proof bag (available from photographic dealers) and make sure that the shipper marks the packet and documents, 'FILM: DO NOT X-RAY. DO NOT DELAY.'

Kodachrome films can only be processed at certain major Kodak labs, listed below, or at a very few authorized independent labs. (Processing your own film in the field is possible, but maintaining standards of chemical purity and temperature is difficult, particularly for color films.)

Film size

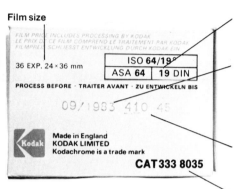

Speed rating: Of the three systems (ISO, ASA and DIN) ASA is the most widely used.

Expiry date: This is the manufacturer's estimate for average use. If you are very particular about the quality, or the film has been badly stored, use well before this date; if it has been deep frozen, it will last much longer.

Batch number: For consistent color, buy as many rolls as you can store efficiently from the same batch.

Catalogue number

Kodachrome processing laboratories

Australia
Kodak (Australasia) Pty Ltd, PO Box 4742, Spencer Street, Melbourne, Victoria 3001
Austria
Kodak GmbH, Albert Schweitzer-Gasse 4, A-1148 Vienna
Belgium
NV Kodak SA, Steenstraat 20, 1800 Koningslo-Vilvoorde
Canada
Kodak Canada Ltd Processing Laboratory, 3500 Eglinton Avenue West, Toronto, Ontario, M6M 1V3
Kodak Canada Ltd Processing Laboratory, PO Box 3700, Vancouver, British Columbia, V6B 3Z2
Denmark
Kodak a s. Roskildevej 16, 2620 Albertslund
France
Kodak-Pathé, Rond-Point George Eastman, 93270 Sevran
Kodak-Pathé, 260. av. de Lattre-de-Tassigny, 13273 Marseille Cedex 2
India
Kodak Limited Colour Processing Division, 483, Veer Savarkar Marg, Bombay 400 025 (Send by registered post)
Italy
Kodak SpA, Casella Postale 4098, 20100 Milan
Japan
Far East Laboratories Ltd, Namiki Building, No. 2-10, Ginza 3-chome, Chuo-ku, Tokyo

Mexico
Kodak Mexicana, SA de CV, Administración de Correos 68, Mexico, DF
Netherlands
Kodak Nederland BV, Fototechnisch Bedrijf, Treubstraat 11, Rijswijk Z-H
New Zealand
Kodak New Zealand Ltd, PO Box 3003, Wellington
Panama
Laboratorios Kodak Limitada, Apartado 4591, Panama 5
South Africa
Kodak (South Africa) (Pty) Limited Processing Laboratories, 102 Davies Street, Doornfontein, Johannesburg 2001
Spain
Kodak SA, Irun 15, Madrid 8
Sweden
Kodak AB, S-175 85 Järfälla
Switzerland
Kodak SA Processing Laboratories, Case postale, CH-1001 Lausanne
Kodak SA Processing Laboratories, Avenue Longemalle, CH-1020 Renens
United Kingdom
Kodak Limited, Colour Processing Division, PO Box 14, Hemel Hempstead, Hertfordshire HP2 7EJ

USA
Kodak Processing Laboratory, 1017 North Las Palmas Avenue, Los Angeles, California 90038
Kodachrome Processing Laboratory, Wilcox Station Box 38220, Los Angeles, California 90038
Kodak Processing Laboratory, 925 Page Mill Road, Palo Alto, California 94304
Kodak Processing Laboratory, 4729 Miller Drive, Atlanta, Georgia 30341
Kodak Processing Laboratory, P O Box 1260, Honolulu, Hawaii 96807
Kodak Processing Laboratory, 1712 South Prairie Avenue, Chicago, Illinois 60616
Kodak Processing Laboratory Inc, 1 Choke Cherry Road, Rockville, Maryland 20850
Kodak Processing Laboratory, 16-31 Route 208, Fair Lawn, New Jersey 07410
Eastman Kodak Company, Building 65, Kodak Park, Rochester, New York 14650
Kodak Processing Laboratory, 1100 East Main Cross Street, Findlay, Ohio 45840
Kodak Processing Laboratory, 3131 Manor Way, Dallas, Texas 75235
West Germany
Kodak Farblabor, 7000 Stuttgart 60 (Wangen), Postfach 369

Long Exposures and Altered Development

Film does not always behave as expected, and under some circumstances can become discolored, more or less contrasty, or lose speed. This generally happens either because of unusually long exposures or when it is developed unconventionally.

Long exposures

With shutter speeds between about 1/30 sec and 1/1000 sec, most films behave normally. At long exposures, however, and sometimes at extremely short ones, they become less sensitive. As a result, they need more light for a well-exposed image – either extra time or a wider aperture. More seriously, color films begin to show a color shift because the three layers of emulsion are affected unequally. Often the result is a greenish or yellowish cast and this needs a filter of the opposite color, such as magenta or blue, to compensate.

This effect, known as reciprocity failure, generally becomes noticeable at about one second with most films, and so is more likely to occur in landscape rather than wildlife photography. Common occasions are at twilight, and when a very small aperture is needed to give good depth of field with a long focus lens. The table shows the extra exposure and filters that each make of film needs at different exposures.

Altered development

Most films can quite easily be given weaker or more intense development, and the motive for doing either is usually to alter the film speed or the contrast. For instance if you mistakenly use a film that is rated by the manufacturer at I S0 200 as if it were I S0 400, then it is a straightforward matter to increase the development to compensate. It can be even more valuable if you plan it deliberately, for any of the reasons suggested below.

Unless you process your own film (in which case, follow the instructions packed with the chemicals), instruct the processing laboratory either to 'push' the film, for increased development, or to 'cut' it, for weaker development, and give the number of stops by which you need it altered. This can be done with every major make of film except, unfortunately, Kodachrome.

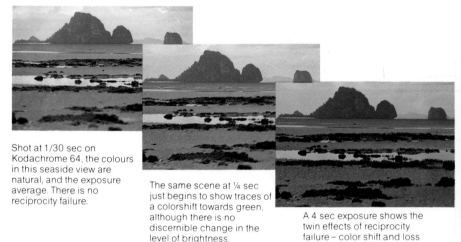

Shot at 1/30 sec on Kodachrome 64, the colours in this seaside view are natural, and the exposure average. There is no reciprocity failure.

The same scene at ¼ sec just begins to show traces of a colorshift towards green, although there is no discernible change in the level of brightness.

A 4 sec exposure shows the twin effects of reciprocity failure – color shift and loss of brightness. To remove both, a CC red filter and double the exposure would be needed.

How to compensate for reciprocity failure (NR = not recommended)

add filtration and increase exposure as follows:

Exposure time	1/10 sec	1 sec	10 secs	100 secs
Kodachrome 25	—	+ ½ stop No filter	+ 2 stops CC10B	+ 3 stops CC20B
Kodachrome 64		+ 1 stop CC10R	NR	NR
Ektachrome 64/ Ektachrome 6117	—	+ ½ stop No filter	+ 1 stop No filter	NR
Agfachrome 50S	—	+ ½ stop	NR	NR
Fujichrome 100	—	—	+ ½ stop CC05C	+ 1½ stops CC10C
Ektachrome 200		+ ½ stop CC10R	NR	NR
Ektachrome 400	—	+ ½ stop No filter	+ 1½ stops CC10C	+ 2½ stops CC10C
Colour Negative Films				
Kodacolor VR 100 and 200	—	+ 1 stop CC10R	+ 2 stops CC10R + CC10Y	NR
Vericolor II and III	—	NR	NR	NR
Kodacolor VR 400	—	+ ½ stop No filter	+ 1 stop No filter	+ 2 stops No filter
Kodacolor VR 1000	—	+ 1 stop CC10G	+ 2 stops CC20G	+ 3 stops CC30G + CC10B

Increasing development has these effects:

Faster film speed: useful, for instance, if you need to use a fairly fast shutter speed for a moving animal in failing light.

More contrast: dull landscapes on overcast days can be made to seem more lively.

Weaker blacks: shadow areas are less dense, which is usually a disadvantage; particularly noticeable on color transparency film.

More graininess: not normally desirable, but useful if you want a gritty appearance (such as for storm clouds).

Color cast: only a problem with transparency film; varies from make to make, but Ektachrome tends to go yellowish, and needs a CC10 Blue filter if you are going to 'push' the film by one stop, and CC20 Blue if by two stops.

Decreasing development has these effects:

Slower film speed: no advantage.

Less contrast: very useful for close views of sunlit landscapes, which usually have intense shadows; helps record more details.

Color cast: Ektachrome tends to go blue or magenta, needing a CC10 Yellow or Green filter if 'cut' by one stop.

43

Black-and-White Film

The choice of black-and-white film is simpler than for color, because the differences between brands are not critical. The essential criteria are speed and graininess, although the fairly recent dye-image films, which use color chemistry rather than the traditional silver development, now offer the possibility of using one roll of film at different film speeds.

Speed and graininess

As with color films, these two qualities go hand in hand: fast films are grainy, fine-grained films are slow. In practice, most film manufacturers produce a range of three emulsions: slow (ISO 25 to ISO 50), medium (ISO 100 to ISO 200), and fast (ISO 400 and higher). Extremely fast films, at ISO 1000 or more, are very grainy indeed.

The choice of developer also affects speed and graininess, but it is pointless to process a fast film in a fine-grain developer, as the effective speed of the film will simply be reduced.

Dye-image films

These relatively new films work on a principle similar to color emulsions, and although the image is recorded and first developed in regular silver grains, these are later replaced by dyes. One result is that all the silver can be recovered, and the graininess is less obvious than with regular films, but the real advantage is that these films are sensitive to such a wide range of lighting conditions that they can be used at speeds from ISO 125 to ISO 1600 without altering the development. Another way of looking at it is that you can under-expose or over-expose, on purpose or by accident, over a range of four f-stops without losing quality. In stalking, when shooting may have to be rapid and a running animal may move in and out of light and shade, this latitude can be valuable.

Processing

By comparison with color, black-and-white processing is extremely simple, and the tolerances of temperature and chemicals much greater. Paradoxically, labs that process black-and-white film consistently and cleanly are relatively hard to find, because color dominates modern photography. Serious black-and-white photographers usually process their own film.

Black-and-White Film

Agfapan 25. ISO 25. Very sharp, extremely fine grain. Good for detailed views with plenty of light or where a tripod can be used, such as landscapes.

Kodak Tri-X Pan. ISO 400. Standard high-speed film, useful for most situations. Many professionals use it exclusively. Can be push-processed satisfactorily.

Kodak Panatomic-X. ISO 32. Essentially the same results as Agfapan 25.

Ilford HP5. ISO 400. Similar to Tri-X.

Ilford Pan F. ISO 50. Similar to the above two films.

Agfapan 400. ISO 400. Similar to the other ISO 400 films.

Agfapan 100. ISO 100. A medium-speed general-purpose film.

Ilford XP1. ISO variable. Dye-image film, replacing silver grains with dye clouds. Can be used at between ISO 125 and ISO 1600, although best results are between ISO 200 and ISO 800. This choice, *without* altered processing, is due to the great latitude.

Kodak Plus-X Pan. ISO 125. Similar in all aspects to Agfapan 100.

Agfapan Vario-XL. ISO variable. Basically similar to Ilford XP1.

Ilford FP4. ISO 125. The equivalent of Plus-X.

Kodak Recording Film 2475. ISO 1000. Grainy and more sensitive to red than regular films, but this film is *the* choice for low-light shooting. Like 3M 1000 in colour transparencies, an important standby when the light is failing.

Film Faults

All photographers are at some time or another unpleasantly surprised by blemishes, scratches or other faults. Most can be avoided by following the camera instruction leaflet, by storing and handling the film with care, and by being meticulously clean. The most important action to take is to identify the cause, in order to be sure of preventing it happening a second time.

Overexposure
Likely causes are the film speed dial wrongly set, aperture diaphragm sticking, shutter sticking, or the film developed too long.

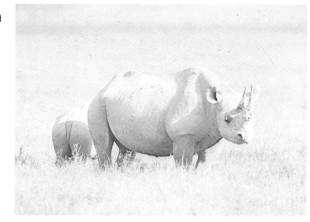

Light leak
The orange streaks in from the film edge show that light has entered either the camera back or the film cassette. Check the fitting of the camera back, and never expose the cassette to bright, direct sunlight.

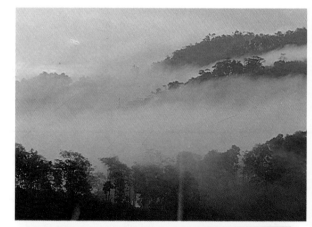

Overlapping frames
This is a mechanical film-winding fault, possibly a slipping ratchet. It needs professional repair.

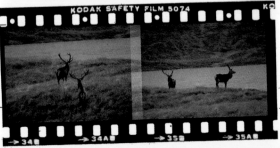

Lens flare
This is not necessarily a fault – if
you like the effect. Reflections
from direct sunlight inside the
lens cause a pattern of shapes
and weaken the image. To cure,
use a lens shade and avoid
direct shots of the sun.

Blur
The definite blurring of this
bustard's leg, and the slight
unsharpness of the neck and
head, are due to a shutter
speed that is too slow for the
action – in this case 1/60 sec. It
is distinguished from camera
shake because part of the
image is sharp.

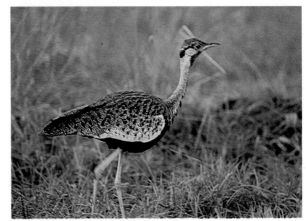

Staining
The magenta blemish is a
processing stain – purely a fault
of the laboratory, although
many will try to avoid liability.

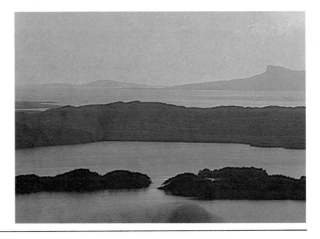

Filters for Black-and-White Film

Some of the filters described for use with color film are equally valuable for black-and-white photography. Most useful are the ultraviolet, polarizing, and neutral density filters. Graduated filters are less necessary, because the same effect can be created with more control during the printing.

The most useful filters for black-and-white film are strongly colored and can control the *tones* in which the different colors in a scene appear. They work by lightening or darkening specific colors. A yellow filter, for example, makes a yellow object appear lighter and a blue object (the opposite color) darker. As black-and-white film is, in any case, overly sensitive to blue so that a clear sky tends to

Filters with black-and-white: uses and exposure increase

Filter	Wratten number	Use	Exposure increase in daylight
Yellow	8	Standard filter for darkening blue sky and slightly lightening foliage. Also reduces haze.	1 stop
Deep yellow	12	'Minus blue'. A similar effect to Wratten 8, but more pronounced, strongly darkening blue sky.	1 stop
Yellow-orange	16	Stronger effect on sky than yellow filters. Reduces skin blemishes and spots in portraiture.	$1\frac{2}{3}$ stops
Orange	21	More pronounced contrast than Wratten 16, particularly at sunrise and sunset darkens foliage.	$2\frac{1}{3}$ stops
Red	25	Darkens blue sky dramatically, deepening shadows and exaggerating contrast. Under-exposure gives a moonlight effect, especially combined with a polarizing filter.	3 stops
Deep red	29	Same effect as Wratten 25, but even stronger. Useful with long-focus landscapes to darken sky close to a distant horizon.	4 stops
Blue	47	Accentuates haze for a sensation of depth in landscapes	$2\frac{1}{3}$ stops
Green	58	Lightens green foliage.	3 stops

Lightening and darkening specific colours

Colour of subject	To darken appearance Wratten numbers:	To lighten appearance Wratten numbers:
Red	58, 47, 44	29, 25, 32, 21, 16, 12
Orange	58, 47, 44	25, 32, 21, 16, 12
Yellow	47, 44	12, 11, 8, 16, 21, 25
Yellow-green	47, 32	11, 12, 8, 16, 58
Green	29, 25, 47, 32	58, 11, 12, 8, 44
Blue-green	29, 25	44, 47, 58
Blue	25, 16, 12, 11, 8, 58	47, 44, 32
Violet	58, 11, 12, 8	32, 47
Magenta	58, 11, 16	32, 47, 25

appear paler in a photograph than it does to the eye, a yellow or orange filter gives a standard correction to most broad landscape views.

Apart form this, as the accompanying photographs show, different filters make it possible to separate tones and alter contrast. When calculating the extra exposure needed for a particular filter, do not rely on the TTL meter, which is not equally sensitive to all colors. Instead, use the table opposite.

The strength of the effect depends on how pure the colors of the scene are. In nature, blue skies and flowers respond very well, but green vegetation reacts disappointingly, as the greens are usually mixed with other colors.

1. *No filter* = blue sky paler than seen

3. *+ 47 blue* = blue in sky invisible, hazy effect

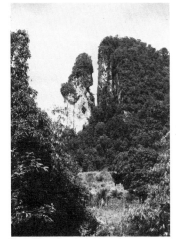

2. *+ 25 red* = dark blue sky, dark vegetation

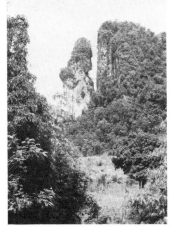

4. *+ 58 green* = vegetation lighter, blue sky pale.

Filters for Color Film

Because most people have definite ideas about 'right' and 'wrong' color, filters are important in color photography – particularly with transparency film, which does not allow easy adjustment later in the darkroom.

Color balancing filters
This set of yellowish-to-bluish filters (numbers 80, 81, 82 and 85 in the Kodak series) raises or lowers color temperature as show on pages 34 -5. As well as 'correcting' a color temperature to standard 'white', they can be used more subjectively – for example to bring warmth to a neutral grey landscape of rocks.

Color compensating filters
This set of filters, in different strengths, is designed to make up for any of the color shifts mentioned so far, including differences between batches of film, reciprocity failure and altered development. There are six colors:

If the film is too green	use a magenta filter
If the film is too yellow	use a blue filter
If the film is too red	use a cyan filter
If the film is too magenta	use a green filter
If the film is too blue	use a yellow filter
If the film is too cyan	use a red filter

The strengths of these filters are marked from CC05, the weakest, to CC50, the strongest. As a rough guide, the effect of a CC05 filter is hardly recognizable, that of a CC10 slight but noticeable, while a CC15 is distinct and a CC20 quite strong.

Ultra-violet filters
These filters, normally colorless but occasionally slightly yellow, absorb the invisible ultra-violet rays that cause a blue cast on color film in distant views and in mountains. They are particularly useful for long-focus lenses, and give valuable protection to the front elements of all lenses if fitted all the time.

Polarizing filters
These dark filters can be rotated in their mounts and according to the angle at which they are set, they can reduce reflections from surfaces such as water, shiny leaves and smooth rocks. They can also, by reducing reflections from small particles in the atmosphere, darken blue skies and cut through haze. The effect is strongest when the surface is viewed at an angle – the exact angle being best judged visually, through the viewfinder. Being dark, a polarizing filter needs an extra 1⅓ stops' exposure, although a TTL meter compensates automatically.

Neutral Density filters
When the film is too fast for the exposure setting that you want, these filters, in different strengths, reduce the light entering the camera. Such occasions are few, but might include, for example, a shot of a sunlit waterfall taken at a shutter speed of about one second for a veiled effect.

Graduated filters
These are among the most useful filters for landscape photography, particularly with transparency film. They can darken skies so that, even on a bright day, details of clouds are as clearly visible as details of the landscape. A typical graduated filter is partly clear and partly dark, with a soft transition between the two. In most photographs, this transition is hardly noticeable, and so appears natural (the exception is a wide-angle lens used at a small aperture, which has such great depth of field that the dividing line appears sharply). If two graduated filters are used together in opposition so that a thin clear gap appears in the middle, this can simulate storm light. Some graduated filters are neutral, others colored. Brown filters can enhance sunrises and sunsets, blue filters can exaggerate a completely clear sky, but most other colors too easily appear false.

Fog and diffusing filters
Slightly cloudy filters give a de-saturated effect similar to fog or mist, while diffusing filters, which are mottled or etched, give a soft, slightly unfocused image.

Special effects filters
A very wide range of trick filters is also available. However startling their effects, very few are successful in landscape photography, where tradition favours a basically realistic approach.

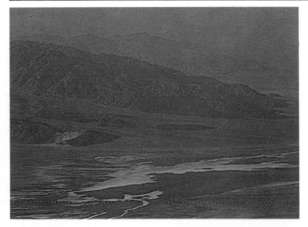

Especially effective over long distances in dry air, a polarizing filter cuts haze very efficiently when the sun is to one side of the camera. The blue cast above is lessened and contrast increased.

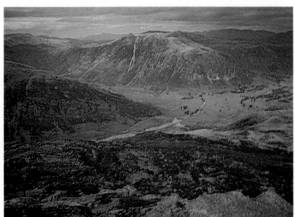

The slightly cold cast of landscapes under cloudy skies (above) can be removed with a slight warming filter such as the 81 B used at left.

High-contrast situations such as the cave above can sometimes be dealt with by using a neutral graduated filter over the lens (left). Angle the filter appropriately.

Camera Care

If camera equipment is used considerately and in normal conditions, it should last for years, and with the present rate of change in camera and lens design, carefully maintained equipment should be perfectly usable even when the model is obsolete. However, the kind of use that it is likely to receive in wildlife and nature photography makes knocks, scrapes and even real damage quite likely.

Particularly when stalking, cameras can receive rough treatment, and when actually shooting there is usually no time to be careful. This makes frequent checking and cleaning all the more important. You cannot expect equipment used on field trips to remain pristine, but external appearance affects only its secondhand value, not its performance. For camera care with this kind of photography, concentrate on maintaining the *working* condition of equipment, during and after each field trip. If appearance bothers you, cover principal parts with camera tape.

Likely damage

This list covers *regular* field conditions only, and nothing more severe than stalking on foot in temperate woodland. For the extreme conditions of heat, humidity and cold likely to be found in deserts, rainforest and snow, see Section 3: special precautions are detailed for each habitat.

Knocks Dropping a camera or allowing it to bang against a rock may bend or shatter external parts and cause internal damage. More often than not, the front of the lens is the point of impact. First make a visual inspection, then gently shake the camera and listen for any rattling that indicates a loose part. Finally operate every control to see if it functions properly. Use the checking procedures illustrated.

Find the point of impact. Damage is likely to be more severe here than anywhere else. If it is the lens hood or filter mount, it may be possible to bend the part back into shape using a small

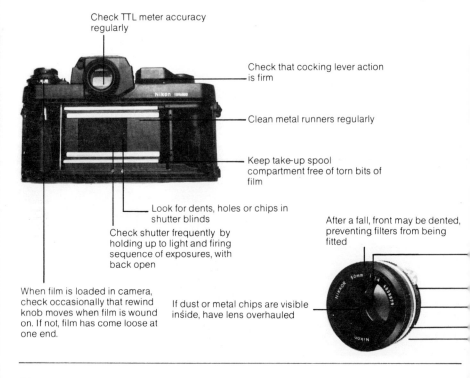

Check TTL meter accuracy regularly

Check that cocking lever action is firm

Clean metal runners regularly

Keep take-up spool compartment free of torn bits of film

Look for dents, holes or chips in shutter blinds

Check shutter frequently by holding up to light and firing sequence of exposures, with back open

When film is loaded in camera, check occasionally that rewind knob moves when film is wound on. If not, film has come loose at one end.

If dust or metal chips are visible inside, have lens overhauled

After a fall, front may be dented, preventing filters from being fitted

wrench or pliers covered with a piece of leather.

The lens is likely to suffer. A scratch may not necessarily interfere with later photographs, particularly if it is off-centre and you use a wide aperture, but on a wide-angle lens the depth of field is likely to be great enough to make it appear as a smudge. Even if the lens *looks* undamaged, an element or two may have been knocked slightly out of place, and after a severe impact it is best to have it checked by a dealer or repair shop when you return home.

Keeping cameras in a shoulder bag is safer than carrying them around your neck, but makes access slower. If the bag is not padded, use pieces of cloth inside or use soft lens cases. Never allow pieces of equipment to rub against each other.

Dust and dirt Keep equipment in a closed bag as much as possible.

Keep an ultra-violet filter fitted to the front of all lenses.

Clean cameras and lenses at the end of each day. See pages 54-5.

Water A few drops of water will not harm a modern camera. Simply wipe off with a clean cloth. Steady rain or drizzle, however, may eventually leak inside the camera and cause corrosion or electrical malfunction. The shutter release is particularly susceptible. Expose equipment to rain only briefly when shooting; at other times keep it either in a waterproof bag or under the anorak or poncho you are wearing.

A peaked waterproof cap may give some small protection when shooting in rain.

If you have to work for some time in the rain, seal the camera inside a transparent plastic bag.

Salt spray is much more corrosive than plain water. Wipe down equipment with a rag and fresh water before drying.

Heat Keep equipment out of direct sunlight as much as possible.

Enclosed spaces such as hides (blinds) and vehicles can heat up much more than the surroundings. Leave equipment in them for as short a time as possible on hot sunny days, and open flaps or windows to give ventilation.

When a camera must be left exposed to the sun, as in certain remote control situations, cover it with a white plastic bag, tied loosely to allow air to circulate inside.

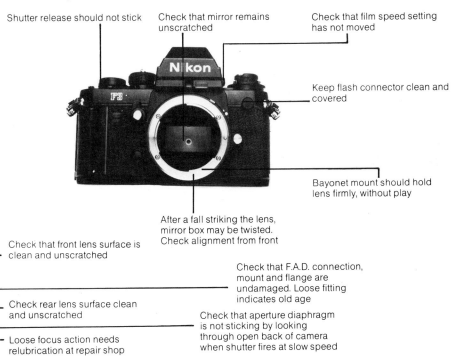

Shutter release should not stick

Check that mirror remains unscratched

Check that film speed setting has not moved

Keep flash connector clean and covered

Bayonet mount should hold lens firmly, without play

After a fall striking the lens, mirror box may be twisted. Check alignment from front

Check that front lens surface is clean and unscratched

Check that F.A.D. connection, mount and flange are undamaged. Loose fitting indicates old age

Check rear lens surface clean and unscratched

Check that aperture diaphragm is not sticking by looking through open back of camera when shutter fires at slow speed

Loose focus action needs relubrication at repair shop

Cleaning Your Camera

Although accidents can be disastrous, the chief enemy of camera equipment on a field trip is simply the slow, steady accumulation of dirt. Because wildlife and nature photography involves fairly rough conditions, there is no way of *keeping* cameras clean while out shooting. The equipment is bound to get dirty and the only answer is regular, thorough cleaning. Large particles, like sand grains, can scratch, and so should be blown off, not wiped. Clean at the end of each day's field photography, and thoroughly at the end of a long trip. Clean the delicate surfaces in this order; blow, brush and finally wipe.

Cleaning materials
The minimum kit is a hand-squeezed blower, a camel-hair brush (or both combined), a toothbrush, soft cloth and cotton buds. For thorough cleaning back at home, add compressed air, an anti-static gun or brush, penknife, eraser, alcohol, lens cleaning fluid and an all-purpose anti-corrosive/lubricant.

Cleaning sequence
Develop a set procedure for your particular equipment, based on the one illustrated here.

Body
1. Separate all easily-removable components.
2. Blow dirt and film scraps from inside the body (film compartments, area around the mirror, and under prism head, if removable).
3. Work around crevices and corners of the outside with a toothbrush. Avoid the lens, mirror and screen.
4. Loosen particles in delicate areas with a soft brush.
5. Use the blower a second time on all areas.
6. Work a lightly moistened cotton bud around crevices.
7. Wipe all parts with a soft, lint-free cloth (not necessarily a special cloth – a well-washed handkerchief is ideal).
8. Use an anti-static gun or brush

on the interior.
9. Operate all moving parts and listen for scraping dust particles.

Lens
1. Treat the lens barrel like the camera body.
2. Having removed the ultra-violet filter, blow the lens surfaces to remove loose particles.
3. Follow this with a camel-hair brush.
4. Use the blower once more.
5. Wipe gently with a clean soft cloth (not the one already used on the camera body), using a circular movement, spiralling outwards from the centre of the lens.
6. Replace the cleaned ultra-violet filter.

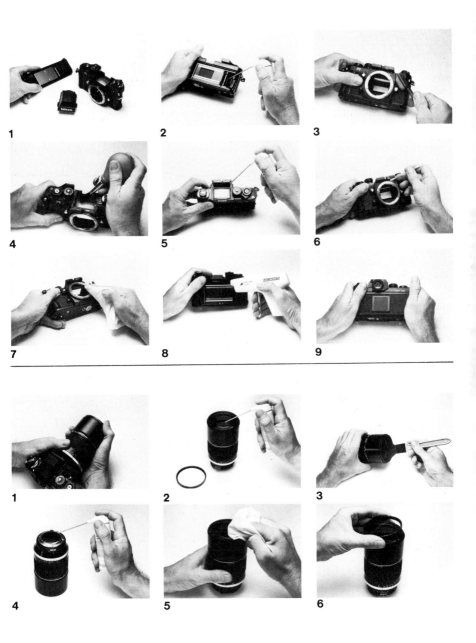

1

2

3

4

5

6

7

8

9

1

2

3

4

5

6

Camera Repairs

Camera mechanisms are intricate, and susceptible to various kinds of damage if treated roughly. This may be unavoidable in field conditions. Because they are so complex, camera breakdowns are safer in the hands of a professional repair shop, but in the middle of a field trip the choice may be between abandoning photography and attempting a repair yourself.

The risk of emergency repair is that you may cause more damage than you started with, so increasing the cost of professional repair later and possibly losing the guarantee protection

on a new camera. However, if it prevents you missing an important shot, it may be worth attempting. Treat emergency repair as a stop-gap measure, and follow up with professional repair when you have time.

Breakdown causes

Cameras stop working for the following reasons.

Wrong use Most 'breakdowns' result from simple failure to follow instructions. Dead or wrongly-loaded batteries are the single most common camera 'fault'. Re-read the instruction

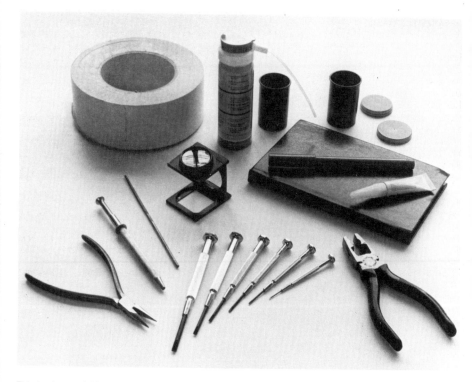

This basic repair kit will serve the needs of most first aid in the field. Camera tape has a variety of uses, and in an emergency will hold broken parts together. Epoxy is even more useful, but is difficult to remove later.

leaflet.

Accident Dropping a camera is likely to break, jar or loosen its components. Follow the procedure on page 52 before opening the camera body. Forcing movements, such as by trying to remove a lens by turning it the wrong way, are also damaging.

Dirt When particles of dust and dirt manage to penetrate the camera mechanism, stoppages are likely. Tolerances in small cameras are very fine, and parts can be jammed by a grain of sand or a chip of film.

Wear and tear Continued use eventually wears down some mechanical parts, particularly those in soft metal, plastic and nylon. Screws can work loose, thereby causing failure in the part they were holding, or themselves jamming some other movement.

Manufacturing defect. Uncommon, and likely to be obvious at the start rather than develop later.

Emergency Repair

Only tackle repairs that you feel are within your competence. If you can avoid attempting them (by using a spare camera), it is better to leave them to a professional repair shop. Try and identify the cause of the problem *before* dismantling anything.

The most important aid is a new camera of exactly the same make. Use this for comparison at all stages – it will show you how the mechanisms *should* look and function.

1. If the camera has suffered an obvious accident, check for damage as described on pages 52-3.

2. If the repair involves bending a part back into shape, use a pair of pliers or a small wrench of appropriate strength, and pad the part with a small piece of leather, and be *very gentle.*

3. Remove the film for access. You may find that it has caused the stoppage, and that freeing it is all that is necessary.

4. Although details vary, most 35mm SLR cameras come apart in similar ways. Access to most of the mechanism is through the top, and the top plate is held in place by the heads of the cocking lever, shutter release, film speed dial and rewind lever, and by two or more small screws. The screws are usually at the sides, but occasionally have to be reached from inside, from the film compartments. The control heads are secured variously by small screws in the side or top, by spring clips, or by a simple central thread.

5. For access to the mirror mechanism in most

SLR cameras, remove the front plate by peeling away the leatherette covering and unscrewing. On some models, sync leads may need to be unsoldered for complete removal.

6. Always keep a record of how you dismantle the camera, so that you can reverse the procedure when you are finished. Keep small parts in dishes on an otherwise empty table in front of you, or place them on strips of double-sided adhesive tape. Group them in sequence as they come off, and either make a series of sketches at each stage or use a Polaroid camera to record each stage.

7. Before anything else, examine the mechanism for loose parts, dirt or film chips that may be jamming some movement. This may be all that is wrong. (Sticking at slow speeds, or a shutter stuck open, may have this as a cause.)

8. If a part has come loose, other components may have worked themselves into different positions. Unless you are familiar with the mechanism, a new model for comparison is almost essential.

9. Epoxy is extremely useful for instant repairs, but it can only be removed later by filing.

How to recognize screws and retaining clips

If you can see a screw in an obvious place, it is likely to be the only means of retaining the part. Use the correct size of screwdriver; too small may strip the flanges, too large may break the head off.

Very occasionally, retaining screws have a left-hand thread, particularly on parts that turn anti-clockwise.

Screws that have two holes instead of a groove can be removed by using the two prongs of a pair of sharp-pointed pliers.

Lens-retaining rings, which have opposing grooves, need a special lens spanner. If you try to use the pliers method mentioned above, there is a great danger of slipping and gouging the glass.

If the head is stripped enough, see if you can file away enough of the surrounding metal to get a grip with sharp-nosed pliers. Headless screws should turn easily.

Remove spring clips by pushing gently on the ends with sharp-nosed pliers, forcing them apart at the same time. Be careful that the spring clip does not fly off and become lost.

If a head has no groove, it *may* unscrew by pressure alone, with a wrench padded with a piece of leather.

Theory into Practice

In nearly every instance, photographing wildlife is more difficult than plain observation; and for several reasons. Most creatures will not tolerate a close approach, and in order to capture a reasonable image a photographer, even with a long focus lens, needs to be closer to the subject than does a watcher with binoculars trying to identify the species. The modern wildlife photographer is also concerned with both animal behaviour and the aesthetics of the image, so that simply lining up the subject in the viewfinder is often not sufficient: the timing of the shot, and its composition, are also important. In addition, photography involves a host of technical restrictions, not the least being that the dimmest lighting conditions in which pictures can be taken are, by normal visual standards, quite bright, and at dusk, dawn and in deep shade it may just not be possible to take an adequate photograph. Seeing wildlife and

photographing it well are often very far apart.

Few activities connected with wildlife and nature need as much planning and skill as does photography. Good wildlife and nature photography depends on three qualities: thorough preparation, sufficient knowledge of the subject to realise what to photograph, and visual ability. The purpose of the large amount of information in this book, straddling both photographic techniques and fieldcraft, is to help equip the photographer with the first two qualities.

The next few pages, however, look at wildlife and nature purely from the point of view of the photographic image. This short section, together with the picture selection throughout the book, is designed to help you plan an aesthetic approach. To be able to make sharp well-exposed photographs is not enough wildlife and nature photography should add to its subject rather than just record it.

While a frontally-lit photograph would certainly show more detail of this wading spoonbill, this backlit late afternoon view takes the opportunity of exploiting an attractive, and not uncommon effect. Using the silhouette against the sparkling reflections of a shallow lake, this shot has strong atmosphere and at the same time reveals the bird's most prominent feature – its spatula-like beak.

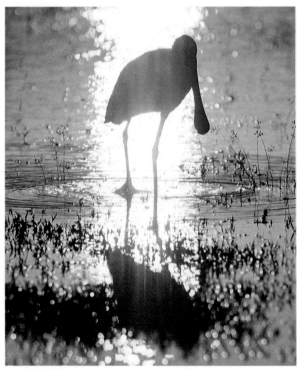

Moments such as this bring
personality to animal
photographs. Here, the sense of
affection is captured through
good timing and flared lighting.

Images on a grand scale are
always prized in wildlife
photography, and few occasions
are better than major migrations,
as here in the Serengeti.

Photographing Single Subjects

One of the most widely established approaches is to cover a single subject – usually one species – as comprehensively as possible. At its most ambitious this can mean attempting to draw a detailed picture of a complete year in the life of an animal or, in the case of some insects, their entire cycle from birth to death. To do this needs time and a fairly intimate knowledge of your subject, but the rewards are high.

Defining the project

The easiest subjects are, naturally, those that are regularly accessible. To photograph the different activities of an animal over a period of time you will have to make a number of visits, so it helps if you can fit this into your normal schedule. Choosing a subject that is close to where you live makes the project easier because you will be able to take up more opportunities at short notice. Even a distant location, however, may not be a problem if you are prepared to stretch the shooting over a longer period of time. If you broaden the scope to include any location where the animal is found, that too will give you more opportunities.

The first step is to set the limits to your photographic coverage – what subject, over what period of time, concentrating on what aspects of its life. You might concentrate all your photography for a season or more on this one subject, or you might be content to build up the story slowly, on occasional visits.

Content

The success of this approach rests largely on being able to show all the important aspects of the animal's behaviour and appearance, at least within the limits that you have already set for the project. You may find it helpful to make out a short-list in advance, amending it as necessary as you go along. Details will depend on the specific subject, but you will almost certainly want to cover the following areas.

Portrait This means, simply, taking at least one clear view of the entire animal. It also means showing the essential field marks and features of interest, although you will almost certainly need several photographs to do justice to everything.

Grouping With gregarious animals, plan shots of a typical herd, flock or other group.

Basic action Running, jumping, flying, or any normal movement, not necessarily related to a specific activity.

Feeding This could include not only gathering food or killing prey, but also, if applicable, bringing back food for young.

Courtship Displays, special colorings or rituals.

Mating

Birth Eggs hatching, new born animals emerging.

Caring for young

Den/nest building

Aggression Threat displays or actual attack, against other individuals of the same species, or against other species.

Habitat Scene-setting shots that show the animal in its environment.

Use this list as a guide only. In individual cases there may be important activities not covered here, such as hibernation or migration.

Visual variety

Deliberately look for more than one way of photographing each aspect of your project. Try the following:

Different scales As well as basic full-frame shots, also consider close-ups of parts of the animal, and more distant views that show it in its setting, against a prominent background.

Massed shots In cases where your subject gathers in large groups, a massed shot, with many individuals filling the frame, can be spectacular. A long focus lens helps to make the most of this effect.

Different lighting conditions Low sun, shade, cloudy weather and all the other varieties of natural light can bring a welcome difference to images.

Different lighting techniques Consider backlighting against the sun or its reflection in water, strong frontal lighting, or artificial lighting as techniques for injecting variety.

Different focal lengths If you are able to approach your subject quite closely you may have the choice of using shorter focal length lenses. The different perspectives from wide-angle, standard and long focus lenses may complement each other.

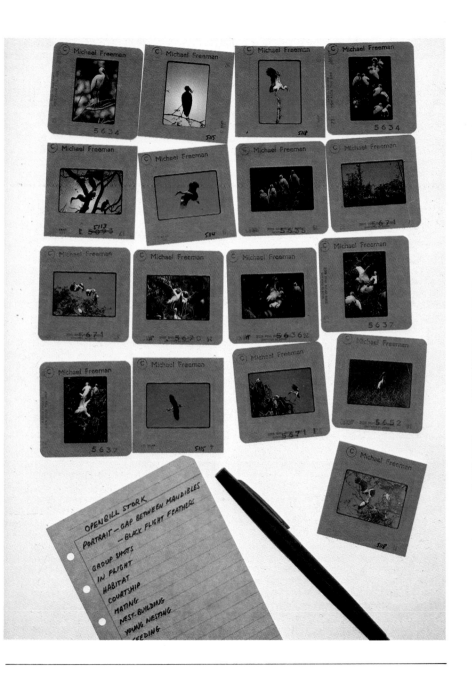

Photographing Habitats

Although it may be a single species that catches your imagination, any location will contain a variety of wildlife. A broad view of the surroundings, taking in life at all levels, creates the opportunity for a varied and interesting set of photographs of the complete habitat. By covering a range of subjects, including large animals, flowers, insects, water-dwellers, and so on, the photography automatically takes on an ecological slant, showing the relationships between creatures and their habitat.

Planning this is not complicated but is necessary, so as to anticipate every opportunity. Most habitats, as the final section of this book shows, contain a wealth of subject matter and of images; so much so that it is often easy to forget some of the obvious or essential shots, such as scene-setting landscapes.

Think of the habitat that you are visiting as a complete unit, with every element, from weather and landscape to plants and insect life, inter-related. The climate and underlying rocks, for instance, largely determine the soil, and all three influence the plant-life. In turn, this supports animals such as browsers and grazers, and their habits determine the kind of carnivores in the area. Through influences such as these, all the parts of a landscape interlock.

This is not just a way of thinking about a habitat; it is an essential key to seeing and photographing it. By understanding how a habitat works you can plan to photograph the highlights of the system. For instance, if you are fortunate enough to see one of the infrequent showers that in some deserts herald a sudden brief blossoming of flowers, then the combination of a shot of the desert in bloom, one of a similar area in its normally parched state, and a broad scenic shot showing veils of rain falling from a rare stormcloud does more justice to the occasion than one single shot.

One habitat may produce individually strong images, but it also gives the opportunity for a coherent set of photographs that work together. A professional photographer would call this a picture essay, because the images are linked and tell a story – here, the relationships between land, weather, plant and animal life.

Content

Before the visit, prepare by reading available books and magazine articles. Look particularly for those that discuss the ecology, and take a mental note of the photographs used to illustrate them. Other people's pictures can give you a valuable preview of the photographic opportunities, even if you expect to be able to do better yourself. From this information, and from park or reserve headquarters, wardens, and guides on the spot, you can make out your own list of things to look out for, on these lines:

What are the animals, plants and landforms that make this habitat special?

What are the species that you are most *likely* to see (that is, are not only common, but visible)?

What are the seasons, times of day and locations that these special and common animals and plants favour most?

What are the most interesting or usual food chains? For example: Foxglove – bumble bee – jay; Seaweed – periwinkle – crab – octopus; Oak leaves – oak beauty moth caterpillar – beetle – shrew – grass snake – fox.

Visual variety

This is much easier to achieve in an entire habitat than with one specific animal, and is not such a problem. With scenic views rather than close-ups of species, however, there is a danger of sameness unless you make a deliberate effort to vary the viewpoint, time of day and lens focal length. And, as the photographs may well be shown together – in a slide presentation, hanging as prints, or in an album – a visual change of pace from shot to shot is important.

These are some ways of injecting variety:

Lighting Particularly for scenic views, shoot at different times of the day, such as sunrise, sunset and twilight; and in different weather conditions, such as fog, rain and bright sunlight. Portable flash for close-ups and for use at night also adds variety.

Different scales Include panoramic landscapes, middle distance shots of single stands of trees or of animals in various settings, close-up shots of individual animals, and close-up photography of insects and flowers.

Different focal lengths Wide-angle, standard and long-focus lenses all give images with a different perspective, and this in itself gives pictorial variety. Briefly, wide-angle

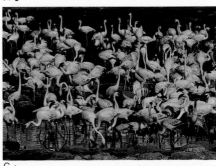

A ▲

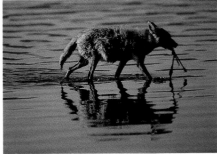

B ▲ ▼E

C ▲ ▼D

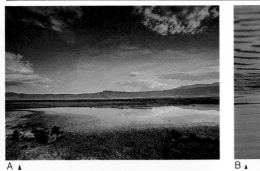

A. Although easy to miss in the hunt for close-ups, an overall establishing shot is essential.

B. Hunting and feeding activity is an important activity, and generally preferable to static shots.

C. Massed shots of groups of animals – here flamingos – gives good visual variety.

D. Family activity is an opportunity for inter-active shots, particularly with young.

E. Small animals give a change of pace in scale. All these pictures were taken in Ngorongoro Crater.

lenses can produce images of great depth, including close foreground and distance in a way that draws the viewer into the scene, while long-focus lenses compress perspective to give a more detailed view in which distant subjects seem to loom large.

Composition As well as conventional ways of framing subjects, try eccentric composition, for example by placing the horizon line very low or very high. Also try compositions that abstract views by concentrating on patterns and by excluding highly recognizable parts of the scene.

Composition and Lighting

Although wildlife and nature photography is dominated by the idea of capturing the subject on film, it would be a waste of an opportunity to ignore the aesthetics of the image or to pretend that they are unimportant. To relegate the photography of animals and plants to the role of plain documentation passes up the chance of creating images that are themselves exciting.

In photography, there are many ways of creating visual interest, some of them quite subtle and individual. Two, however, are of prime importance – composition and lighting. Even under the pressure of trying to approach a cautious animal, or of timing a shot to catch a particular moment, it is usually possible to exercise some choice in the way that the image is arranged, and to take advantage of interesting lighting.

Composition

How the elements of an image – the focus of interest, background, horizon line, and so on – are organised inside the frame strongly influences its aesthetic appearance. Far from being useful only with docile or static subjects that allow time to explore different treatments, compositional skills are crucial when the viewpoint is less than satisfactory. All too often, an animal appears awkwardly placed in a setting, or is too far away to fill the frame satisfactorily even with a long lens. Under these conditions, an interesting composition may save the day.

In most wildlife photographs the components are very straightforward, and normally include a single main subject – that is, one animal. If you are sufficiently close or have a long enough lens for the subject to fill at least two-thirds of the frame, then there is really little choice in the composition – the picture area will appear full. But if the animal is smaller in the frame, *where* you place it is important. The most 'logical' position – in the middle – is usually the least satisfactory, emphasizing the emptiness of the surroundings and often showing a large area of unsharp foreground. A traditionally balanced position is off-centred, by about one-third from the top or bottom and from either side. This works well if the animal is facing into the frame. As well as producing a sense of balance, this off-centred placement also reduces the impression that the animal appears smaller than you would have liked.

Placing the focus of interest very low in the frame emphasizes the surroundings more, so that the subject of the photograph actually changes slightly – it becomes animal-plus-setting rather than just the animal alone. Alternatively, by including a second focus of interest nearer the edge of the picture, composition can point out relationships, such as those between an animal and its source of food. Basically, placing the main subject very eccentrically draws attention to the composition and tends to encourage the viewer to search the image more closely.

Lighting

Because one of the main objects of wildlife photography is to produce *recognizable* images of animals and their key features, lighting that is *efficient* usually has priority – in other words, direct sunlight, frontal or from one side, tends to be favoured. However, what such straightforward lighting gains in giving a clear view it often loses in creating atmosphere. Backlighting and mist, for example, are often more attractive visually, and provided that the *outline* of the animal remains recognizable, may make a more interesting photograph. Aquatic creatures in particular can make strongly silhouetted images against the reflection of a low sun. While there is virtually no control that you can exercise over natural light, search out and wait for any conditions that are even slightly unusual – for example, early morning mist along a marshy river bank.

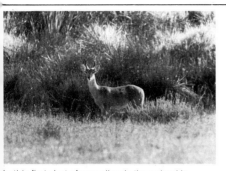

In this first shot of a reedbuck, the animal is centred in the frame; the excess foreground is distracting.

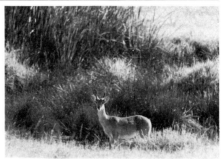

Raising the camera slightly improves the composition by cutting out the foreground.

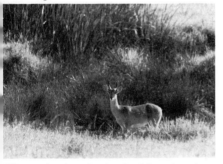

Off-centering the animal so that it faces into the frame improves the balance even more.

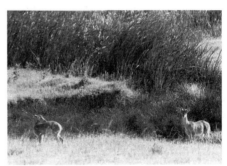

Although smaller, the images of two animals appear to make more use of the frame.

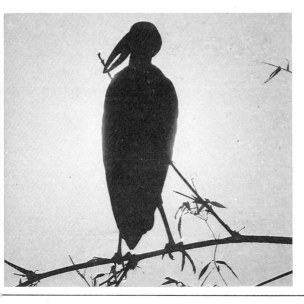

Backlighting can add visual variety, and here serves to emphasize the distinctive bill of the aptly-named openbill stork. Often, as in this photograph, it involves no more than a slight change in the camera position.

Editing Your Work

Although the moment of shooting is the crux of photography, the entire process takes much longer and includes developing the film and putting the pictures to use. Editing is the part of the process in which the freshly developed transparencies or negatives are examined and sorted, and then filed or discarded. If there is any uncertainty about the results, as there often is with wildlife subjects, it is also the moment of truth.

However, what might seem to be just a pleasant hour or two looking at pictures already taken is actually an essential step in the photographic process and can help determine success. In wildlife photography more than in most other fields, many frames often have to be shot for each good image. For instance, when approaching an animal that is still unaware of you, it may be prudent to start shooting early, in case it bolts before you reach your ideal position. Or, when shooting in rapid sequence at an animal running across your field of view, some frames are likely to be spoiled by out-of-focus tree trunks or other foreground objects. In either case, no wildlife photographer would expect all the photographs to be worthwhile. In this kind of situation, many photographers anticipate the editing to come, and defer their final decision on an image until they see the developed film.

Procedure

Negatives should first be contact-printed, but transparency editing is best done on a light-box and with a 'loupe' (a viewing glass) large enough to fit over each frame. Then with all the slides from a single roll spread out together, follow a set procedure. Methods of editing are usually idiosyncratic, but this is a typical sequence:

Discard all frames that are technically faulty – that is, out of focus, wrongly exposed, scratched, or whatever. If you come across a fault that you cannot identify, put the frame on one side and find out later what went wrong (if not, it may happen again).

Mark each slide mount with the information you will later need to identify it. Numbering the rolls and frames and keeping a separate notebook is one method; writing the species, location, date and activity directly onto the mount is another. If any photograph is likely to

be sent away, for example to a book or magazine publisher, also include your name and the copyright symbol ©.

Choose and mark those that you consider to be the very best pictures – your 'first selects'. If you are looking at a sequence of pictures on one subject, in which you were trying to improve the image, try and remember which at the time you thought would be the most successful –the comparison may be interesting.

Divide the remainder into images that are acceptably good – the 'second selects' – and those that for reasons such as composition and interest are competent but nothing special – the 'overs'. Some photographers throw away the overs, others keep them for reference, for example to help in identifying species.

Many sequences in wildlife photography, particularly of behaviour, make a useful *consecutive* series of pictures – an animal drinking, for example, or two cubs playing, or a courtship display. Too often these are broken up into individual images and their value is lost. Now is the time to put them aside and keep them intact.

Once this basic sorting is complete, think of existing sets of photographs in your files to which any of these could be added. For example, you may be building separate collections on subjects such as single species, types of behaviour, similar habitats from different parts of the world, and so on. Assembling such sets can, in its way, be as creative as the original photography.

File the photographs. If you do not already have a filing system, for transparencies the usual alternatives are transparent sleeves on hangers that fit in steel cabinets; shallow cabinet trays that take individual slides; slide boxes, and transparent sleeves in ring-binders. Negatives are best kept in sheets made of acid-free paper or cellulose acetate, that will not affect the emulsion chemically, and then filed in boxes, hangers or ring-binders. Attach contact sheets for easy visual reference.

These consecutive frames of an elephant climbing out of a water-hole have good potential as a sequence. While editing, be careful not to break up useful sets such as this.

Essential editing equipment
includes a light box, loupe,
stamps, protective covers and
sheets for filing.

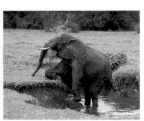
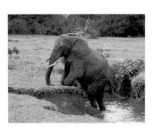
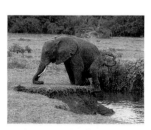

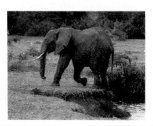
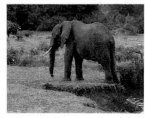

Section 2:
Fieldwork

This second section of the field guide covers the basic situations that you are likely to meet in wildlife and nature photography, and includes both the fieldcraft skills needed by anyone looking for animals, and the several types of photographic approach that are possible.

The extremes of climate and natural surroundings have been left until the end of the book and this Fieldwork section focuses on standard temperature conditions. Nevertheless, the techniques described here are generally operable in most situations, and only when conditions are clearly inhospitable to regular camera equipment, such as in deserts or snow, should you need to look for radical alternatives.

Fieldcraft, loosely defined, is the set of skills needed to deal confidently with any natural environment – being able to move around knowledgeably and unobtrusively, to find the animals and plants that you are looking for, and to anticipate and cope with obstacles and mishaps. This section accordingly gives succinct information not only on how to stalk animals on foot and erect a hide (blind), but also on such ancillary skills as reading animal tracks, judging the weather and finding your way with a map and compass.

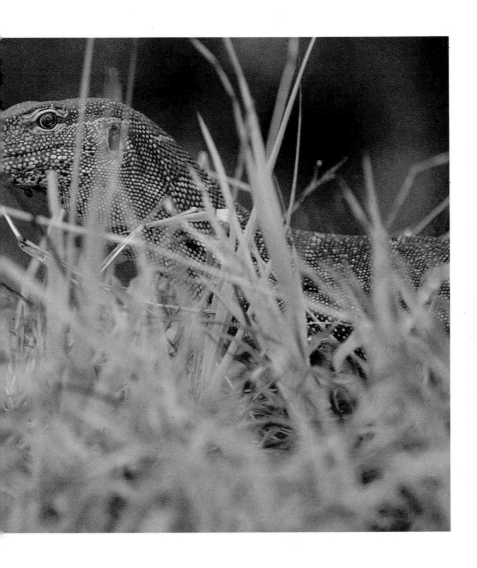

Identifying Animals

At first thought, a camera might seem to be the ideal means of identifying species of animals and birds: fixed on film, the image can later be studied at leisure, apparently removing the need to identify the species at the time. Surprisingly often, however, a photograph actually fails to show the critical marks that distinguish one species from another, similar one; wing markings, for example, may not be visible if the bird is perched. Also, lighting conditions vary, and film does not adapt to changing color temperature as do our eyes. Photographed by the light of a low sun, for example, fine color distinctions may be masked by the orange cast. Yet, for a photographer, identification is especially important. Having a very good photograph, but not being able to give it a basic caption, is extremely frustrating.

Without a doubt, the best method of identifying species is to carry a good field guide, *and* to have studied it in advance. Guides such as those published by Collins in the UK and the Peterson series published by Houghton Mifflin in the USA, preface their lists with clear instructions on identification, and it is best to follow these. Ideally, you should know beforehand which species are found in the location you are visiting, and at the time of year that you will be there. This cuts out a great deal of unnecessary confusion. Then, if you anticipate the more obvious problems of distinguishing similar creatures from each other – greater and lesser Kudu, great and lesser Hack-back gulls, great and magnificent frigate birds, for example – you can be prepared to look for the key features. The basis of rapid identification, used almost universally, is the recognition of 'field marks'. These are the essential markings, normally only one or two, that unquestionably identify species. Among the crow family, for instance, a bare face patch can only mean that it is a rook. The importance of field marks is that by looking only for them, you save time looking at non-essential features. Some species, such as marsh tit and

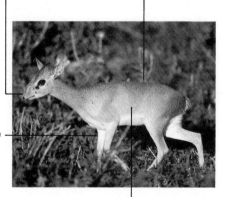

Call of this species is distinctive, but photograph does not help.

Height is useful for identification, but no clues in this photograph.

In original transparency, colour of lower legs would have helped identification. In this as in many field photographs, they are partly hidden by vegetation.

Range and distribution is essential information, but only available if photographer keeps conscientious notes.

willow tit, and many insects, are extremely difficult to identify in the field, but most can be identified, particularly if you know the conditions under which you saw them. Often you can eliminate some possibilities simply because they are not known to occur in the area.

Photographers, unfortunately, are usually in a worse position to pay attention to field marks than other wildlife watchers. If you have only a little time in which to shoot, you will probably be preoccupied with photographic problems. Nevertheless, by practising selective observation, identifying the essential characteristics can become second nature.

There are often occasions when you come across an animal with which you are completely unfamiliar. In such a case try to identify these basic features, and make notes immediately, preferably with a sketch.

Size Compare it with a species with which you are familiar; for example, 'twice the size of a domestic cat', 'slightly smaller than a crow'.

Shape Record your impression of its overall body shape (stout, slender, elongated, etc.) and then, for a bird, the shape of its wings, bill, tail, legs, feet and neck, or, for a mammal, its head, neck, tail and legs.

Color and pattern Assess in the same way as shape, including the color of the eyes, if you are close enough to see. Pay particular attention to the tips of extremities and to strong differences between adjacent colors. Among mammals, the main colors of the upper and lower parts often differ. Watch particularly for patches and stripes.

Movement Find a description for its *general* way of moving, such as loping, hopping, undulating flight, gliding with infrequent wingbeats. Also note any obvious idiosyncracies, for example, the tail held erect, or neck extended in flight.

Calls and song These are more likely to be heard from birds than mammals, but make sure that the bird you are listening to is the same as the one you are photographing.

Tracks If possible, search the ground once the animal has left. Foot prints are particularly useful for identifying mammals, whose feet are usually hidden from view among grass and ground vegetation.

Habitat Record the vegetation and terrain where you made the sighting, and the time of day and date.

◀
In this example, an apparently clear and informative photograph [the original was in colour] does *not* provide all the means for identification. The animal is a Kirk's Dik-Dik, photographed in Lake Manyard National Park, Tanzania, but in the absence of any size reference could be confused with the larger Duiker. Another difficulty not anticipated at the time of shooting was that there are five species of Dik-Dik, mainly identifiable by quite subtle colour differences and by distribution. In particular, the warm colouring of the early morning light makes it difficult to distinguish between the similar Gunther's and Kirk's species.

►
Learn to look at these field marks of birds, and make as close an identification as possible on the spot, rather than wait for the developed photograph.

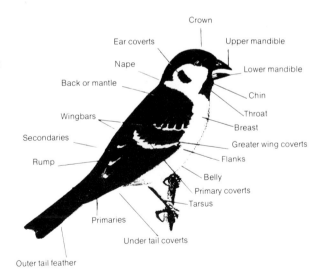

Crown
Ear coverts
Upper mandible
Nape
Lower mandible
Back or mantle
Chin
Throat
Wingbars
Breast
Secondaries
Greater wing coverts
Rump
Flanks
Belly
Primary coverts
Tarsus
Primaries
Under tail coverts
Outer tail feather

Animal Senses

Most wildlife photography involves something of a competition betwen an animal's sensing ability and your skill at concealment. Different species rely on different senses, so it is important to know what abilities you are facing when setting out stalking or working from a hide (blind). Understanding how a particular animal may be able to detect *you* will help in planning the most effective concealment.

As a general rule the kind of territory that an animal lives in, and its habits, give obvious clues to the senses on which it most relies. Species that live in a closed habitat, such as forest, generally need eyesight less than acute hearing and a keen sense of smell, while predators usually do need visual help to make their final attack.

Although some creatures use specialized sensing skills (bats use sonar, pit vipers have infra-red heat-detectors, cockroaches sense pressure differences), most rely on a combination of sight, hearing and smell, with one or two of these predominant. Very few have the same sensory mix as humans, who depend heavily on sight, and it can be a mistake to judge concealment from your own point of view. It is easy to pay too much attention to disguising your visual appearance and insufficient attention to eliminating tell-tale smells.

Mammals

Most have an excellent sense of smell; so much so that it is difficult for humans to

How animals perceive	Sight	Hearing	Smell
Red Fox	very good	very good	very good
Lion	very good	exceptional	good
Leopard	very good	exceptional	good
Cheetah	exceptional	very good	good
Grey Squirrel	very good	very good	good
European Rabbit	good (laterally)	very good	good
Wild Boar	moderate	good	very good
Whitetail Deer	good	good	good
Grant's Gazelle	very good	very good	good
Wildebeeste	exceptional	exceptional	good
Impala	moderate	very good	very good
Ibex	exceptional	exceptional	exceptional
Zebra	very good	very good	good
Rhinoceros	poor	very good	exceptional
Elephant	poor	very good	very good
Baboon	very good	very good	good
Guenon Monkey	very good	very good	moderate
Colobus Monkey	very good	very good	moderate
Heron	very good	very good	poor
Egret	very good	very good	poor
Ducks	very good	very good	good
Hawks	exceptional	very good	poor
Wild Turkey	very good	very good	good
Owls	exceptional (night) good (day)	exceptional	poor

imagine its range and discrimination. A rhinoceros, for example, can detect scent over several *kilometres* under good weather conditions, while the odour-sensitive membrane in an alsatian dog has 50 times more surface area than that of a man. The human body produces mainly butyric, caproic and caprylic acids as odour (quite apart from artificial scent, which is even stronger), and to these a dog is about one million times more sensitive than we are.

Beside smell, the senses of sight and hearing are often less important, but in certain species may be well-developed. Predators usually have good sight, and large ears are usually a sign of good hearing. Few mammals see as well as humans, and few can sense color, but most hear more acutely than we do.

Birds

Sight is generally the most important sense, with the emphasis on detecting movement. Most species have much better sight than humans, and a hawk, for example, has eight times the number of cells in its retina than does a human eye; *and* it has a slightly magnified view. Also, most birds can distinguish color.

Hearing is, on the whole, less important, as sound discrimination in flight is difficult over the noise of air and wings; but it is nevertheless usually better than ours. Smell is poorly developed (except for ground-dwelling species) as scent molecules are very dispersed at altitude.

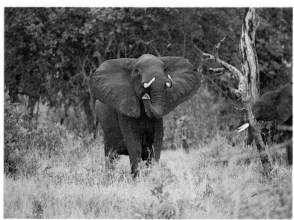

How a hawk sees
The pair of photographs above simulates the difference between a hawk's view and human eyesight. The resolution in the right hand picture is eight times better than in the left.

Elephant waving trunk
Trunk-waving by an African elephant is a way of checking the surroundings. Here, the elephant is trying to locate the photographer precisely, before charging.

73

Animal Tracks and Signs: 1

Animal tracks can help you find their makers in two ways. The first, and more difficult, is by following them in the direction of the animal's movement – tracking, in other words. The second is by using them as evidence that a particular species has been present and may therefore return. To an experienced eye a clear impression of a track can provide a wealth of information – not simply about the identity of the creature that made it, but what it was doing at the time, whether it was foraging for food, fleeing, chasing prey, or just walking. To be able to read tracks in this way, however, takes considerable practice and the purpose of these few pages is simply to give a basic guide to identity. However fascinating the scattered evidence of an animal's passage, a photographer's main interest is having the real creature in front of the camera.

In practice, tracks usually do not appear as clearly as those shown here, for there are very few types of ground that take a good impression. The ideal is a moderately soft, thin covering over a hard surface, and a fresh fall of snow, about one inch thick, on firm ground is nearly perfect. Other good areas are damp, bare earth (immediately after rain), or a sandy beach at low tide. Unfortunately, even these conditions are short-lived and after a few hours the individual prints become blurred with melting, rain, wind and time, while in the more common habitats of grassland and woodland – with a dense mat of vegetation – tracks of all but the heaviest animals are difficult to see.

Except in snow, therefore, your chances of following an animal over any distance in mixed terrain are not high. At a water-hole, however, or on the mud-flats of an estuary, an early morning visit can give you a good idea of what animals you can expect to see arrive.

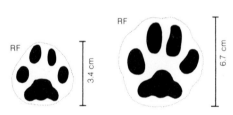

Domestic Cat.
All cat family tracks are similar, and size is the chief distinction

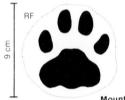

Mountain lion.
(Jaguar slightly larger).

Dog. Size variable.
according to race. May resemble fox. But pads larger and closer together, and claws thicker and blunter

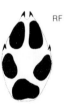

Common Fox

Wolf. Similar to large dog, but claws larger and sharper. Prints on trail usually in straighter line than those of dog

Wolverine.
Thick hair on sole may obscure main pad print, and inner toe impression sometimes indistinct. Usually moves by leaping, so tracks in pairs.

In the next few pages the tracks shown are, of course, only a selection, and have been chosen as representative of the major groups of mammals and birds that you might expect to see. Some of them have also been chosen to point out some of the principles of tracking, for very often the footprint can give you a clue to the creature's way of life, even if you are not sure about the species.

The size of the print is sometimes very important in identification. Those of a domestic cat and a lynx, for example, are almost identical except that the lynx's print is three times larger. To help, a scale is shown against each of the prints illustrated here: compare this with the scale printed along the edge of the last page in the book. If you are interested in photographing tracks, in at least one shot place this scale next to the print for accurate measurement. Tracks show most clearly in oblique lighting, so on a dull day it may be better to use an electronic flash, held at a distance from the camera and close to the ground.

Mammal tracks

These are two main types of print; those made by paws and those made by hooves. Paw prints may be with claws – as in the case of a bear or a wolf, or without – as in the impression of a cat, which retracts them when walking. In the most primitive type of mammal foot, the animal walks on the entire sole, so that the back of the foot shows clearly in a print. Bears, badgers and hedgehogs, for instance, have this type of foot, known as plantigrade, and it is a sign that they have short limbs, move slowly most of the time, and are ill-adapted to running and jumping (although bears can move dangerously fast in an emergency. However mammals that need to move fast, usually tread on the front part of the foot.

The extreme adaptation to fast movement is the hoof, which is, simply, the front toe or front two toes enclosed in a hard covering. The non-cloven hoof of a horse is the third toe (all others have disappeared) while the cloven hooves of deer, sheep, wild boars and others are the third and fourth toes.

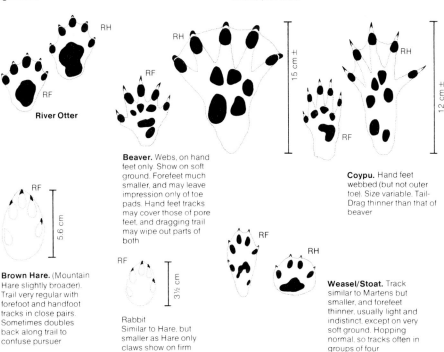

River Otter RH RF

Beaver. Webs, on hand feet only. Show on soft ground. Forefeet much smaller, and may leave impression only of toe pads. Hand feet tracks may cover those of fore feet, and dragging trail may wipe out parts of both

15 cm ± RH RF

Coypu. Hand feet webbed (but not outer toe). Size variable. Tail-Drag thinner than that of beaver

12 cm ± RH RF

Brown Hare. (Mountain Hare slightly broader). Trail very regular with forefoot and handfoot tracks in close pairs. Sometimes doubles back along trail to confuse pursuer

5.6 cm RF

Rabbit Similar to Hare, but smaller as Hare only claws show on firm ground

3½ cm RF

Weasel/Stoat. Track similar to Martens but smaller and forefeet thinner, usually light and indistinct, except on very soft ground. Hopping normal, so tracks often in groups of four

RF RH

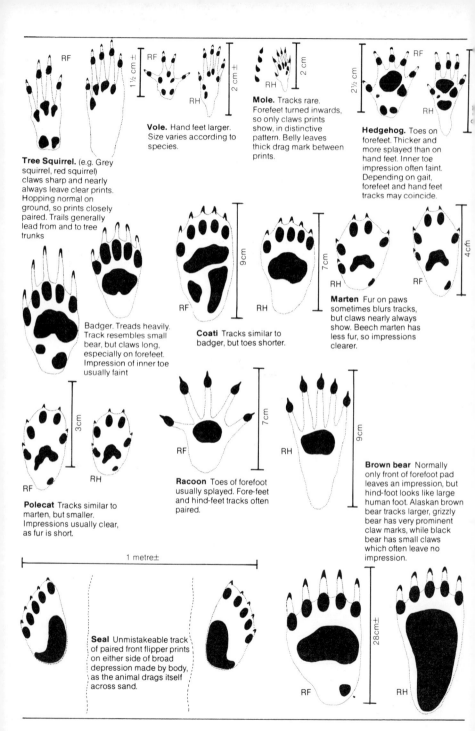

Vole. Hand feet larger. Size varies according to species.

Mole. Tracks rare. Forefeet turned inwards, so only claws prints show, in distinctive pattern. Belly leaves thick drag mark between prints.

Hedgehog. Toes on forefeet. Thicker and more splayed than on hand feet. Inner toe impression often faint. Depending on gait, forefeet and hand feet tracks may coincide.

Tree Squirrel. (e.g. Grey squirrel, red squirrel) claws sharp and nearly always leave clear prints. Hopping normal on ground, so prints closely paired. Trails generally lead from and to tree trunks

Badger. Treads heavily. Track resembles small bear, but claws long, especially on forefeet. Impression of inner toe usually faint

Coati Tracks similar to badger, but toes shorter.

Marten Fur on paws sometimes blurs tracks, but claws nearly always show. Beech marten has less fur, so impressions clearer.

Polecat Tracks similar to marten, but smaller. Impressions usually clear, as fur is short.

Racoon Toes of forefoot usually splayed. Fore-feet and hind-feet tracks often paired.

Brown bear Normally only front of forefoot pad leaves an impression, but hind-foot looks like large human foot. Alaskan brown bear tracks larger, grizzly bear has very prominent claw marks, while black bear has small claws which often leave no impression.

Seal Unmistakeable track of paired front flipper prints on either side of broad depression made by body, as the animal drags itself across sand.

76

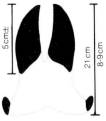

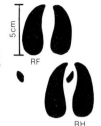

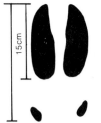

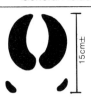

Reindeer (caribou in US)
Distinctive sickle-shaped hoof-prints. Dew claws nearly always show.

Wild boar Distinguishable from deer tracks because dew claws always show, whatever the gait, and they are broadly spaced (that is, not directly behind the hooves). Prints appear turned out. Domestic pig tracks very similar.

Peccary Distinguishing characteristic is that the hand feet have only one dew claw, not two.

Moose (also called elk in Europe). Easily distinguished by size. Domestic cattle have much more rounded hooves and dew claws hardly ever show, whilst moose dew claws normally leave impression.

RF Hind

RF Stag

RF Buck

RF

Red Deer (elk in US) Fairly broad hoof with curved tips that may seem to form semi-circle. When walking, hind-foot track coincides with fore-foot print. Dew claws do not show, except in a jump or gallop.

Fallow Deer Narrower track than that of red deer, with pointed hooves.

White tailed deer Track similar to that of fallow deer, although dew claws occasionally show.

Roe deer Track small, with narrow, pointed hooves. Dew claws only show in a jump.

Muntjac Track very small, and inner hoof usually smaller than other. Dew claws only show in a jump.

Pronghorn RF

Mouflon Long, narrow tracks, hooves nearly always splayed

Domestic sheep Track similar to that of roe deer but more rectangular, and hoof-tips very rounded. Dew claws never show.

Chamois The two halves of each hoof very slender and widely separated; parallel when walking, splayed when trotting and running.

Bison Very large track, noticeably broader than that of moose. Dew claws usually show.

Horse/Zebra/Ass Size varies according to race/species.

Animal Tracks and Signs: 2

In most ground prints three toes point forwards, and with some species a hind toe appears pointing backwards. Despite the greater similarity among bird tracks than among mammal prints, the shape often gives some idea of the owner's habits. Perching birds (passerines) have long hind toes for gripping branches; swimmers have webs; waders have long slender toes, while those of runners, such as grouse, are short and strong.

Bird tracks

Sparrow Slender tracks, normally faint because of bird's light weight.

Pigeon Toes turned inward when walking.

Crow Rough surface of toes gives appearance of distinct sections

Quail Track similar to that of partridge, but smaller

Pheasant Claw marks distinct often follow same well-worn trails

Oystercatcher Toes at large angle to each other. No back toe

Partridge Track similar to that of pheasant, but smaller. In winter, flocks leave trails that weave in and out of each other

Grouse Thick toes, clear claw marks

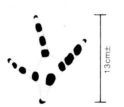

Capercaillie Large broad track, with stubby toes and rounded claws

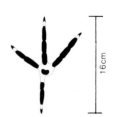

Heron Back toe long, and all claws pointed

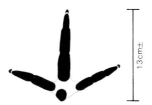

Crane Thick toes but longer than those of a stork. Back toe normally does not show

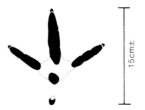

White stork Toes shorter and thicker than heron's and back toe small.

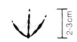

Tern Webs do not reach to claws, which are pointed.

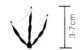

Gull Tracks webbed up to claws, which are pointed. First toe hardly ever shows. Size depends on species (Black-headed Gull 3cm, Herring Gull 7cm).

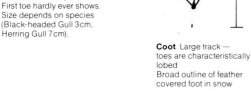

Coot Large track — toes are characteristically lobed
Broad outline of feather covered foot in snow

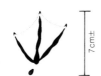

Dabbling ducks Tracks differ from diving ducks in that the small back toe is shorter and more rounded

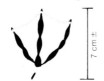

Diving ducks Tracks similar to those of geese but smaller, and toes more slender, the small back toe print is longer than that of a dabbling duck.

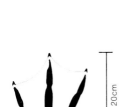

Swan Very large track, webbed right up to claws

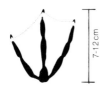

Goose Tracks similar to those of swan, but smaller (size depends on species). Toes thicker than those of ducks

Reading a Map

The key to using a map is an ability to visualize the landscape it represents. It is, in effect, an annotated bird's-eye view, with all the important features identified and measured. The trick is to be able to reconstruct in your imagination the real terrain, and to know which part of the map shows where you are. To a large extent this can be acquired through familiarity, looking at different maps and terrains at every opportunity, and in each case comparing the two. Learning the techniques by rote and by

formula is more difficult and less relevant without this basic appreciation. For example, study and compare the map and photograph below, both of Yosemite.

The ingredients of a map

Whatever the differences in the way maps are drawn, most are basically similar in the kind of information they present. A key somewhere along the margin of the map explains the meanings of symbols, gives the scale and the

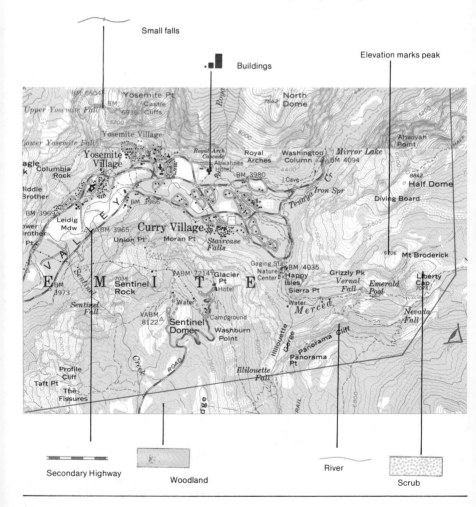

Small falls

Buildings

Elevation marks peak

Secondary Highway

Woodland

River

Scrub

north points, and may also show the accuracy or dates of the surveying. North is at the top, and the overprinted grid is aligned north-south and east-west. Sometimes, grid north, as it is called, differs slightly from True North; if so, the difference will be shown in the margin, but it is usually more convenient to use grid north for normal map work.

Relief is nearly always shown by contour lines, each line joining points at the same height above sea level, and on some maps this

is supplemented by a more realistic shading which strengthens the impression of an aerial view. Cliffs and crags are usually drawn more graphically – look at the key for the symbols used.

The larger the scale of a map, the more detail can be shown of a small area, which is important if you are travelling on foot. For walking, 1:50,000 is about the smallest scale practical; 10cm on the map represents five km on the ground.

Compare this map with an aerial view of the same scene – Yosemite, in California. In a sense, the map itself is also an aerial view, from directly above, and drawn so as to give as much topographical information as possible. Learning to see a map as a bird's eye view is a useful technique of familiarisation, and makes it easier to translate the map to the landscape, and vice versa.

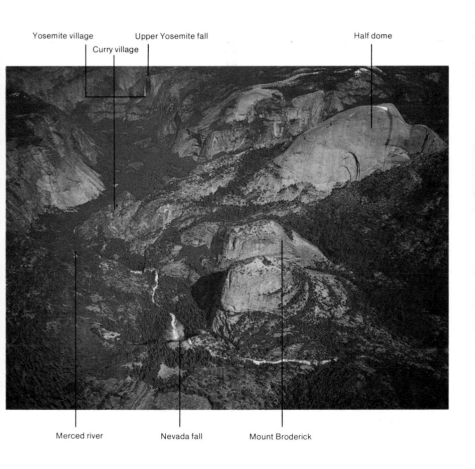

Yosemite village · Upper Yosemite fall · Half dome · Curry village · Merced river · Nevada fall · Mount Broderick

Setting the map

The first step in using any map is to align it with the landscape. If visibility is good, and you can see prominent features like peaks clearly, this can be done by eye. Otherwise, and for complete accuracy, lay the map flat and place the compass on it so that the north-south hairline on the compass is directly over the north-south grid line on the map. Then, rotate the map and compass until the needle points north. Finally, adjust for the magnetic variation.

Magnetic variation

Compass needles point to the Magnetic Pole, which is in northern Canada and moves slightly each year. The variation from True North depends on the location of the area you are in, and is shown on the map. If the Magnetic Pole is to the west of True North (as it is in Europe), ADD the variation to the map bearing. If it is to the east, SUBTRACT it. Reverse these steps when converting compass bearings to the map.

Finding your location

Having set the map, find two or three identifiable features in different directions. Take a compass bearing of each and then, allowing for magnetic variation, align the compass so that you can draw a line backwards towards your location from the feature. Where the lines intersect is your location on the map. This is known as resection, or taking back-bearings. Three bearings are more accurate than two.

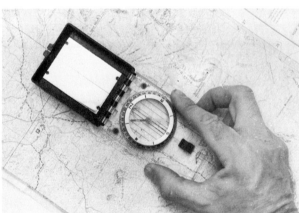

Setting the map 1
A Siva compass makes map alignment easy. Place the North–South hairline directly over the map's North–South grid line.

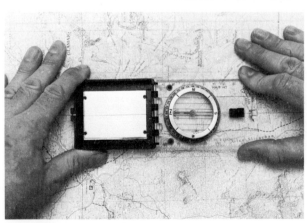

Setting the map 2
Rotate the map and compass together so that the compass needle points North. Except for the allowance needed for magnetic variation (see above), the map is now set.

Walking with a compass

With the map set, draw a line on it from your location to the place you want to reach. Place the hairline of the compass in this direction and take a note of the bearing, in degrees. Follow this.

When sighting with a compass, be careful to stand away from metallic objects. A camera around your neck will deflect the compass needle, as will metal-framed spectacles or sunglasses. In a few locations, the ground itself deflects readings, but such places are usually well-known and maps generally contain a warning.

In practice, a journey normally needs to be broken up into 'legs' so as to avoid obstacles or to reach viewpoints along the way. How long the journey will take depends on the state of the terrain and on the relief, but as a rough guide in planning a route, use Naismith's formula: allow one hour for every three miles plus an extra hour for every 2000 feet climbed. By applying this to each leg of the journey, you can use it as a safety check in bad weather or when you cannot see your objective. You should know roughly when each objective should be reached.

Aiming off

If you cannot see your destination, but it is on an obvious line such as a road, ridge or river, a useful way to allow for any inaccuracies in compass work is to aim off deliberately by a few degrees to the left or right as you approach. By doing this, you will be certain which way to turn when you reach the line. Otherwise, if you aim directly for an objective, but miss it, you may not know whether to go, for instance, upstream or downstream.

Finding your way without a map or compass

If you do not have a map for the area you are visiting, and no compass, here are three alternative means of navigation:

Terrain features Use prominent and unmistakable features visible from a distance as route markers – for instance, a hill, crag or forest watch-tower. For the greatest certainty, plan your journey in legs, walking from one feature to another. Regularly look behind you and memorise the appearance of the route back, for your return.

Position of the sun At midday, the sun is due south in the northern hemisphere and due north in the southern hemisphere. If you have

difficulty in judging its direction when it is nearly overhead, push a straight stick into the ground and look at the shadow. Provided that you have a watch, and know the time of sunset, it is a fairly straightforward matter to work out the direction of the sun at any time of the day. If sunset is at six o'clock, it is in the west; if earlier, southwest in the southern hemisphere, northwest; if later northwest in the southern hemisphere, southwest.

Position of the moon and stars Like the sun, the moon rises in the east and sets in the west. In the northern hemisphere you can find the Pole Star (which stays within 2½ degrees of True North) by following an imaginary line from two stars of the Big Dipper (Ursa Major), as shown. In the southern hemisphere, two stars of the Southern Cross (Crux Australis) show the direction of South.

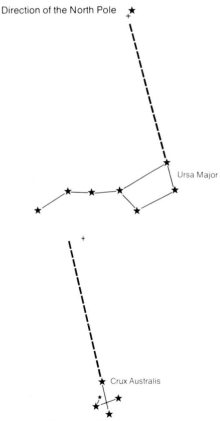

Direction of the North Pole

Ursa Major

Crux Australis

Direction of the South Pole

Understanding Weather

Weather is the day-to-day condition of the atmosphere: climate is the composite total of the weather over a large area. Knowing the climate will give you an idea of what conditions are likely, but the actual weather at any one time is more fickle and likely to vary.

Weather forecasting is difficult even for meteorologists, as so many variables are involved. Nevertheless, weather is so important in wildlife and nature photography that some indication of what conditions may be like in the next few hours or days is valuable. Study weather reports in newspapers when available, listen to those broadcast on radio and television, and ask local advice. Apart from this, the information here will help you to use your own judgement. (Extremes of climate produce habitats so specialized that the weather principles described on these pages do not apply. Deserts, high mountains and polar regions exist under very specific weather controls, and are dealt with later, in Section 3 of this book.)

The elements of weather are temperature, precipitation (mainly rainfall and snowfall, but also hail, fog and mist), winds and atmospheric pressure. These are the four ingredients that make up any particular condition and can, to varying degrees, affect the behaviour of animals and the success of your photography. For instance, the state of the atmosphere controls scent, and so affects the sensing ability of most mammals. High pressure, which often (though not always) brings fine weather

Typical anvil shape of cumulo-nimbus thunderhead

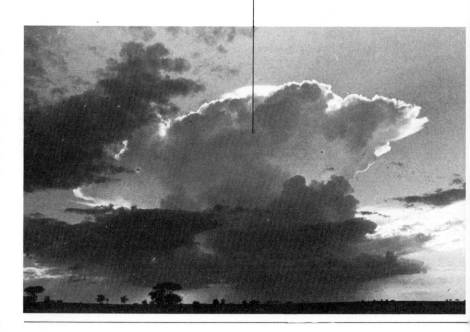

and clear skies, holds down scent molecules, making it slightly easier to stalk animals that rely heavily on their sense of smell. Light steady winds, on the other hand, carry scent molecules far, and damp air, often associated with low pressure, makes scent easier to detect. Many animals are sensitive to impending changes in the weather, and an approaching storm often makes them more nervous than usual.

Even quite crude prediction can be extremely useful when out stalking or planning a session from a hide (blind), and the most important of all weather conditions to be able to anticipate is rainfall (and in colder climates, snow).

Although rain falls from clouds, not all clouds produce rain. Basically, the tiny water droplets that form clouds need to coalesce in order to fall as rain, and what triggers this varies from time to time and from place to place.

However, the type of clouds and the way they form and move can give valuable clues. Air absorbs moisture from the sea, rivers and lakes, in the form of water vapour. The warmer the air, the more water vapour it can take up. Clouds condense from this when moist air rises, and so cools and can no longer hold the same quantity of water vapour.

There are three principal ways in which the enormous bodies of air needed for rainfall are raised. They are not mutually exclusive, and sometimes act together, but each depends on different circumstances:

Convectional rainfall
When the ground is heated strongly, so are the lower layers of air, and they rise rapidly. If already nearly saturated with moisture, they can create vertical storms many miles high, characterized by cumulonimbus thunderheads, often anvil-shaped and containing

wisps of high-level cirrus

woolly appearance of cumulus

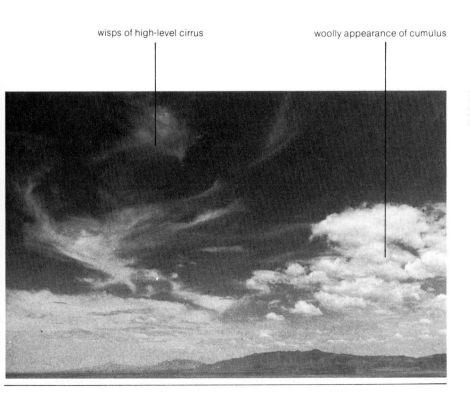

chimneys of violently churning air. The rainfall is usually intense but short-lived, and the static electricity created by the rapid movement of water drops often causes lightning. They are most common in the tropics and over land-locked plains in summer in late afternoon, and usually clear by evening. The broken remains often make sunsets spectacular.

Orographic rainfall
Wind is moving air, flowing from areas of high pressure to areas of low pressure. If hills or mountains lie in its path it is forced to rise, making condensation likely. If the moving air is already nearly saturated with water vapour, as it may well be if it is approaching from the sea towards a coastal range, rain on the upper slopes is likely, although the side of the mountains facing away from the sea, in the lee of the wind, often stay dry (they are in the 'rain-shadow').

Frontal rainfall
Convectional and orographic rainfall are relatively local conditions – the surroundings are mainly responsible for triggering them. Most of the world's precipitation, however, is generated on a larger scale, when two different air masses meet.

Air moves from high to low pressure areas, so that in a low pressure system, or depression, air is drawn inwards, spiralling gently. Because the air comes from different directions, what usually happens is that warm and cold air masses are brought together. The line along which they meet is known as a front, and instead of mixing immediately the lighter warm air rides over the denser cold air. It is this rising movement that creates frontal rain, for provided that the warm air is fairly well saturated, it is cooled as it is forced to rise, and releases moisture.

Depressions often have two fronts – a cold front as the cold air pushes forward like a wedge, and a warm front as the warm air rides over the cold. When one of these fronts catches up with the other, the front becomes more complex, and is called an occluded front.

In western Europe, most of the rainy weather comes in this form, as depressions that have crossed the Atlantic, picking up moisture along the way, move eastward. The illustration above/below shows the typical weather in the path of a depression. Because the air is rising quite slowly, rainfall is usually less violent than in thunderstorms, and lasts longer. Gray skies and drizzle are typical and frontal rainfall is most common in winter.

How frontal rainfall moves across the landscape

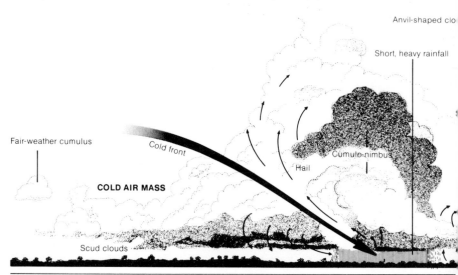

Anvil-shaped clo

Short, heavy rainfall

Fair-weather cumulus

Cold front

COLD AIR MASS

Cumulo-nimbus

Hail

Scud clouds

The approach of a cold front is more definite than that of a warm front, although not always as clearly visible as this.

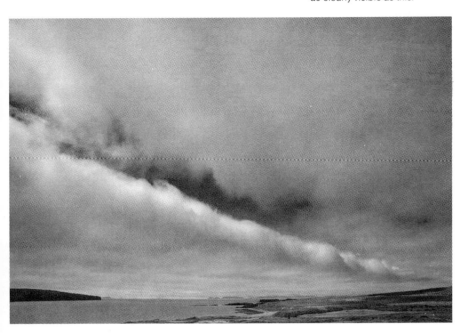

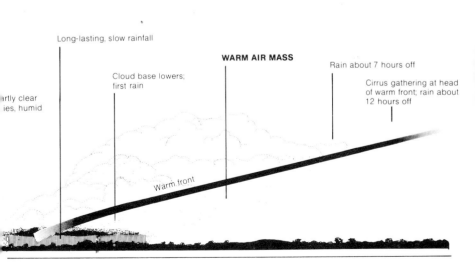

Long-lasting, slow rainfall

Cloud base lowers; first rain

WARM AIR MASS

Rain about 7 hours off

Cirrus gathering at head of warm front; rain about 12 hours off

artly clear ies, humid

Warm front

Dressing for Field Photography

Personal preferences weigh more strongly than anything else in choosing clothing and footwear, but when fieldcraft is involved, and particularly in stalking, there are other important considerations. The illustrations here are no more than examples, but there are some general principles that apply whatever you decide to wear.

Comfort

A day's field trip can be fairly strenuous, making it all the more important to avoid dress that is tight, ill-fitting or made of uncomfortable materials. Choose clothes that are sufficiently loose to allow easy movement even when crawling, and that are also made of an absorbent material (cotton is better than synthetics). Extremes of heat, cold and damp need special clothing and this is dealt with in detail in the last section of the book under each habitat. What is shown here is suitable for what could be called average conditions – the sort of weather you could expect in a temperate spring or autumn, for instance.

Footwear nearly always takes a little time to become comfortable, and putting new boots to immediate heavy use invites blisters and sore feet.

Protection

In typical temperate conditions – say, deciduous woodland and low hills – no special protective clothing is necessary other than a light anorak or poncho in case of rain. At most,

Camouflage

Anything that aids concealment without making clothing more awkward to use is valuable, and some of the military camouflage materials are well worth considering. What may look out of place in a city street can improve your chances of close approach to an animal in woodland.

Most camouflage patterns have two functions: to imitate the general tone and color of the surroundings, and to break up the outline

you might need your jacket and trousers to be tough enough to resist scratches from thorns and branches. Footwear, however, really does need to be strong, with moulded soles that will grip on rocks and muddy slopes. Jogging shoes are light and suitable for delicate stalking, but ankle-high trekking boots give more support and make sprains less likely. Either leather, or a strong synthetic such as Cordura, is suitable for the uppers.

Concealment

As the essence of field photography is to avoid being noticed by wildlife, contrasty and brightly colored clothing is totally unsuitable. At the very least, the color and tone should be drab or neutral, and there is always some advantage in using real camouflage (see box). Also, as many animals can detect motion more easily than shapes, avoid wearing anything that is likely to flap, such as a loose open jacket on a windy day. Military camouflage dress is ideal, and usually inexpensive.

Carrying capacity

Even if you fit equipment into a shoulder bag or some other specially designed container, it may be useful to be able to slip film and some other items into pockets. For convenience, one pocket large enough to take a lens can make it quicker and easier to change focal lengths. One or two spare rolls of film, a filter, cable release and so on, may be more accessible in a chest pocket than in the bottom of a shoulder bag.

Apart from pockets, which should be capable of being fastened, a belt can be useful for hanging things from. Matching 'Velcro' patches on one shoulder and on the inside of a shoulder bag's strap will prevent slipping. But beware of making a large amount of noise.

Most camouflage patterns are designed for temperate woodland, but the one shown at top right was created for tropical forest. Known as 'tiger-stripe', it mimics the effect of a near-vertical sun and high sun. To make the most of camouflage, use it to conceal the give-away features – face and hands, especially. An open-mesh scarf can roughen the outline of the head.

of the wearer's shape. The different patterns shown here reflect not only different designers' ideas about effectiveness, but also different environments. Even drab olive-green, brown or black are much less conspicuous than light colors. Nevertheless, camouflage like this is designed to fool human senses, and few animals rely so heavily on eyesight as we do. Camouflage that may look perfect to you may, to an animal, simply not be as important.

First Aid

The purpose of first aid is to patch up an injury until you can reach professional medical help. It is no more than a stop-gap measure, and if you have an accident, do not concern yourself with attempting complicated treatment. If you are out stalking you will probably be alone, so the advice here is essentially basic self-help for the most likely injuries. Medical problems specific to extreme conditions such as deserts (heat exhaustion, heat stroke), mountains and snow (hypothermia, frostbite) are treated later, in Section 3.

You may well never suffer anything that needs serious medical attention, but you should always be prepared. Carry a small, simple first aid kit in rough terrain and at any distance from help. If you are injured, react quickly but calmly. Never panic – it may encourage you to do things which could worsen the situation.

Wounds

First, stop any bleeding. Although some flow of blood helps to clean a dirty wound, do not prolong it. Wash and clean the wound quickly (there is an automatic anaesthetic effect, but this soon wears off and washing later will be more painful). Be very thorough with a deep wound, which may harbour dirt that can increase the risk of tetanus.

Then apply an antiseptic cream or powder (and an antibiotic ointment if you are going to be in dirty conditions for more than a day) and a sterile gauze dressing. To stop continued bleeding, press hard with your fingers for up to 20 minutes and, if the wound is on a limb, raise it. Never stitch or plug an open wound; at most use adhesive suture strips. Never apply a tourniquet. If the bleeding is profuse, apply more dressings and seek help quickly. Anti-tetanus immunization is a sensible precaution.

Blisters are likely if you use new or ill-fitting boots on a long walk. Avoid them by breaking boots in gradually and by buying the right size, allowing for a comfortable thickness of sock. If you develop a blister, pad the area around it to

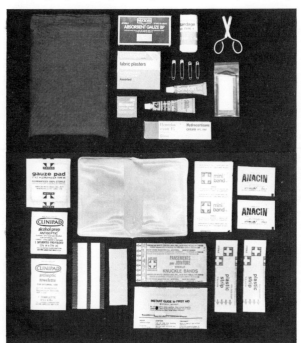

First Aid kit

Adhesive plasters (various sizes)

Bandage

Medium-sized safety pins

Antiseptic cream

Corticosteroid lotion

Antibiotic ointment

Sterile gauze dressings

Surgical tape

relieve pressure (thick corn plasters are useful). The danger of a blister is that, once burst, it can easily become infected. Dress as a wound if this happens.

A bruise is bleeding that seeps into tissues beneath the skin. While not serious in itself, it may mask a fracture. To alleviate pain, raise the limb, rest, and apply a cold compress or ice-pack to reduce swelling.

Sprains

A sprain is an injury to the ligaments and tissues around a joint, and the places most at risk are ankles and wrists. An ice-pack reduces swelling (use snow or immerse in cold stream if the situation allows), but the main action is to bandage the joint firmly. With a foot sprain, loosen the boot but do not remove it – bandage around it.

Supporting a sprain
Follow an overlapping figure of eight pattern when bandaging a hand or foot sprain.

Fractures

Fractures may look like sprains, but are much more serious. Tell-tale signs are when the pain increases if you move or press the injury, and if the limb appears deformed. If you suspect a fracture, *do not move the part*. Call for help or, if you have to treat yourself, immobilize the fracture by bandaging firmly, preferably with a stick as a splint. Use torn strips of cloth if you have insufficient bandage.

Bites and stings

Treat a non-venomous bite as a wound and seek medical advice, particularly about the risk of tetanus or rabies.

If you are bitten by a snake it is essential to identify it; kill it and take it with you if at all possible. Unless you are familiar with the species you will not know whether or not it is venomous; and even if it is, the treatment depends on the *type* of venom. At all costs, *do not panic;* if there is venom in your bloodstream, a high pulse rate will only circulate it faster around your body. The chances are against your having been injected with venom, and even if you have, it may not be serious – deaths from snakebite are rare, even in areas where venomous snakes are common.

Symptoms vary tremendously, but swelling and pain are common. Pit viper envenomation produces these signs within 20 minutes, and usually within ten minutes. Coral snake bites generally do *not* cause pain or swelling, but muscular weakness becomes obvious after some hours.

First, wash the bite and immobilize the area. If you can rest, do so; but make immediate arrangements to reach a hospital that has antivenin. Within the first 30 minutes it *may* help to place a constriction band just above the bite (tight enough to stop the flow through surface veins, but not so tight as to constrict deep veins and arteries). It may also help to make small incisions over the fang marks (no longer than ¼ inch, no deeper than ⅛ inch) and apply suction. However, these measures are risky if you are not medically trained.

Virtually all spiders are venomous, but only a few can cause serious reactions. Treatment depends on the species. As with snakes, find a hospital quickly. For black widow spider bites there is no useful first aid measure, but incisions and suction may help for violin spider (brown or recluse spider) bites.

Bee, wasp, hornet and ant stings are rarely serious. See if the sting remains in the skin; if so, remove it. An ice pack reduces pain, as does an analgesic-corticosteroid lotion.

Ticks embed themselves in skin. Do not pull them, or the head may break off and remain inside. Instead, apply petroleum jelly, oil, nail varnish, alcohol or petrol to irritate it so that it releases its hold.

Centipede bites can be painful, but are not usually serious. Wash and then treat for pain and inflammation with ice and corticosteroid lotion.

Scorpion sting treatment depends on the species, but to be safe find a hospital for antivenin injections. For most North American scorpion stings there is no specific treatment other than ice to relieve pain.

91

Principles of Stalking

Successful stalking depends heavily on your having the knowledge and experience to find the animals in any locality, and to be able to move with sufficient stealth that they are not aware of being approached. In many ways, you are on an equal footing with your subjects and need the skill of a predator to reach them unobserved. Then, to be able to make the best photographic use of your approach, it is important to be so familiar with the camera and its controls that you can react to sudden opportunities instantly and without thinking.

Indeed, the equipment itself can determine whether it is even worthwhile attempting to stalk a particular animal. All creatures set for themselves a limit within which they will not allow a possible enemy to approach. Inside this invisible 'safety zone' they feel secure, but if

If you are particularly dedicated, consider applying military face paint. There is a definite technique in using it, illustrated here. Use the two tones – usually dark and light green – to break up the prominent lines of the face (principally the nose, chin and mouth). Pay careful attention to the eyelids and hair-line. Use the darker tone of paint to mask the highlight areas.

The bright metal parts of camera equipment can easily catch sunlight and give you away at a distance. Use black camera tape to cover them over. It is a sensible precaution and little trouble.

a predator (or photographer), breaches it, they will flee or else react in defence. The size of the safety zone is very variable – a herd of healthy adults, for instance, will feel more confident than a single mother with a newly-born calf, and so are likely to tolerate a closer approach.

Depending on the size of the animal, the focal length of your lens will determine whether or not you can work from outside this safety zone. Generally speaking, the longer the lens the better; but the limit for hand-held photography is set by the film speed, the weight of the lens, and the maximum aperture, all of which affect the all-important shutter speed. As long-focus lenses are constantly being improved, becoming faster and lighter, and as new, faster films are introduced, it becomes practical to stalk even more shy animals.

There are a number of precautions that you can take to make yourself less obtrusive, and most of them are a matter of preparation before setting out on a field trip. Refer first to the section on animal perception on pages 72-3, remembering that what you are trying to conceal yourself from are the *animal's* senses, not human ones.

Appearance
Dress in clothing that blends in with the tones and colors of the surroundings. Specific camouflage (see pages 88-9) is best, but drab colors are normally adequate. Fair skin is highly visible and face, hands and arms are usually exposed to view. If possible cover them, or darken them with camouflage paint or dirt. Even a suntan helps! Remove, or cover with black tape, anything shiny, such as buttons, belt buckle, spectacle rims and the chrome parts of cameras. In the field, avoid sunlight, skylines and open spaces.

Scent
Do not use perfume, after-shave, deodorant, scented soap or any other products that contain strong scent. Clothing restricts the scent molecules given off by your body. A long-sleeved shirt or jacket and long trousers, therefore, are more effective than a T-shirt and shorts. Avoid unnecessary movement, which distributes your scent, and always stay *downwind* of your subjects.

Noise
Do not carry things that rattle. To check, jump up and down a few times before setting off. Keys and loose change, or a camera against your belt buckle, are likely noise-makers. Smooth synthetic fabrics tend to make more noise against branches and twigs than cottons or woollens; they also tend to rustle as you move. Instead of slapping your feet down as

you walk, roll them from the heel to the ball in one smooth, continuous step. Avoid treading on twigs, dry dead leaves and anything else that is likely to snap or rustle. With practice, you can do this out of the corner of your eye.

Movement
Move as little as possible. Movement is highly visible, noisy, and spreads your scent around. If you think that an animal has spotted you or has suddenly become alert, freeze instantly, and stay still for at least a minute. Don't move again until the animal has relaxed. When walking, move only the lower part of your body, in a gliding movement. This is less visible than a normal, arm-swinging walk.

Occasionally spend time just sitting or crouching motionless – observing – without twitching, scratching or making any other unnecessary movement. If you are lucky, animals may leave cover and approach to within camera range. The 'trick' is to allow yourself to become part of the landscape – a strange object perhaps, but one presenting no apparent threat.

Being Prepared

One of the predictable things about stalking is that encounters with animals are likely to come as surprises – to both parties. This constant uncertainty gives stalking some of its excitement, but to cope with it successfully, fast and accurate reaction is important. Always anticipate the conditions under which you might come across wildlife, and check frequently that your camera settings are appropriate. Apart from anything else, this helps you to stay alert.

Before setting out

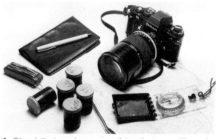

1. Check that you have everything that you will need. Use the equipment list on pages 100-1.

2. See if the camera is already loaded with film. To do this, turn the rewind knob gently in the direction of the arrow; if you can feel tension, there is film inside.

3. If not, load with fresh film, making sure that the film leader is secure on the take-up spool (if the leader slips from the spool, you may not realise for some time that no exposures are being made).

4. Set the film speed dial. You can also use the film carton top as a reminder, which can be placed in the slot in the camera back for convenience.

5. Check that the right filter, if any, is fitted to the lens.

6. Make sure that the lens-to-body aperture coupling is properly connected.

7. Check all the batteries (meter, camera, motor-drive).

8. Have the next roll of film that you will use ready and accessible.

In the field

1. As you walk, anticipate the exposure settings in front of you. There may be two or more – for instance, sunlight, light shade and deep shadow. Set the shutter speed and aperture for one, and remember how many click stops to turn for the others.

2. Also anticipate the focus setting. In woodland, you are likely to encounter an animal at a closer distance than in grassland. Remember which way to turn the focusing ring for nearer or more distant focusing.

3. Frequently check the film counter. If there are only a few frames left, it may be wise to unload and fit a fresh roll. If you are using a motor-drive on 'continuous' setting, you are likely to need about ten frames for an action sequence.

5. In uncertain exposure conditions, bracket quickly when you shoot, moving the lens aperture between half a stop and one stop either side of your estimated setting. This is easiest and quickest if you use a motor-drive. Some cameras have a bracketing control.

4. Regularly check that the control settings have not moved through banging against your body.

6. If you are really taken by surprise, shoot first. With most films (but not Kodachrome), exposure errors of even one or two stops can be corrected during processing (see pages 44-5). If you have just shot an important sequence but are uncertain if the exposure was correct, a useful safety measure is to expose a few frames of a fresh roll, at the same location and with the same aperture and shutter speed that you just used, and have that processed first. The original roll can then be processed accordingly.

Finding the Animals

The easiest way of finding wildlife subjects is to use an experienced local guide. In certain habitats, and with some species, there may then be no more difficulty than walking to a particular site at the right time of day. Really, there is little substitute for local knowledge. Often, however, you will have to rely on your own ability, and for this you will need two kinds of information: a general idea of the behaviour of the animals you are looking for, and some specific clues about the place you are in. Advance research will give you some indication of what is likely; local information will help you put this into practice.

Most animals have a limited number of predictable activities. Some of these are tied to a particular location, time of day or season, and so can be used to improve your chances. The most common are: feeding, drinking, fighting for territory, courtship display, nest building, mating, giving birth, feeding young, repelling or fleeing from predators, greeting, and migration.

Do as much research as possible *before* you set out. As sources, use magazine articles and guide books, and contact local organizations such as conservation departments, national parks headquarters, and naturalists' societies. In the field, recruit the help of park wardens, rangers and guides, or other naturalists with local knowledge.

For many animals, particularly mammals and birds, the most active times of day are early morning and late afternoon. Animals that live in colonies, such as some species of stork, seabirds such as puffins, gulls and terns, and bats, tend to disperse for feeding – leaving and returning at more or less regular intervals. Most small mammals are active only at night, or at dawn and dusk, and this calls for more specialized techniques (see pages 130-1).

Most habitats have a seasonal climate, which controls, to some extent, the abundance and location of food and water. The more seasonal the climate, the more concentrated these become, and as a result they can often be predicted. Seasonal drought, as in savannah grassland, limits water to a few rivers and water-holes, forcing wildlife to concentrate there, usually in late afternoon. In temperate climates the spring abundance of fruit, flowers and berries attracts all manner of insect, bird and mammal life.

Some species migrate to follow food, water and more congenial weather. This sometimes provides an opportunity to see and photograph spectacular concentrations of wildlife – wildebeeste in the Serengeti, geese on the central flyway of North America, caribou in the Arctic or migrant waders in northwestern Europe for instance. Many animals gather in colonies to breed, and spectacular concentrations can be seen at these times. Seabirds, seals and sealions are good examples of colonial breeders.

Weather can affect the behaviour of animals, and your stalking success. An impending storm makes many animals nervous. In rain, most seek shelter. For your own concealment, the fine weather associated with a high pressure system is often an advantage – the pressure holds down scent. Conversely, moist air makes smells easier to detect.

Large predators, never so numerous as their prey, are often difficult to find, particularly as stealth and concealment are their own well-developed skills. One useful tip is to watch the behaviour of the species they prey on; if these are behaving nervously, a predator may be close at hand. For example, when a hunting leopard is near, deer often call to each other in alarm. Similarly, monkeys warn of an approaching tiger. Using the guide on pages 74-9, look for *fresh* tracks and other signs, such as droppings.

If you are not after one particular species, 'planned wandering' is probably the best approach. Try and prepare an approximate route in advance with the help of a map and local advice. Take in *generally* likely places, such as water-holes, and obviously attractive food sources, such as good pasture and fruit-bearing trees. Where two distinct habitats meet (such as woodland and grassland), there is usually a greater variety of wildlife. This is sometimes known as an 'edge-effect' (see Seacoasts, pages 186-93).

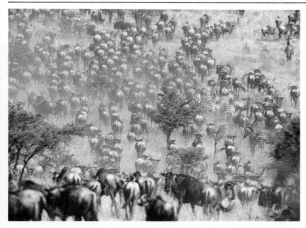

Migration
Seasonal events are often very reliable for photography, especially in habitats that have a very pronounced regime. Here the annual migration of wildebeeste in East Africa's Serengeti concentrates large herds in a relatively narrow corridor.

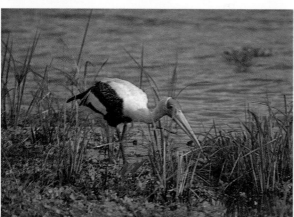

Feeding
Often, the location of food is more predictable than the animals' rearing ground. In Sri Lanka's Yala sanctuary, Painted Storks feed in the wetlands in the early morning.

Water Holes
Wherever there is a dry season, as in the East African savannah, water is limited. Water holes then become highly predictable locations to see animals.

Closing In

The most sensitive part of stalking is the final approach, when you have seen the animal but need to reach a better viewpoint. Because you are increasingly at risk of being spotted by the animal, you will need to exercise both skill and judgement in determining just how close an attempt to make. From the moment the animal decides to flee you will almost certainly have no time to shoot, so you can only expect to take photographs as long as you are in control of the situation. Also, with some species, the loss of a picture is not the worst that can happen; you must check in advance whether any of the animals you are likely to encounter may attack rather than run away.

Within certain broad principles you will only be able to decide how to handle the approach on the merits of the particular situation. In fairly thick cover you might come across an animal at such close range that there is no point trying to move closer. In open woodland you may feel that by moving from tree to tree you stand a good chance of approaching very closely; while in exposed grassland it may be difficult to decide what to try for. How close you *need* to approach will depend on the type of photograph you have in mind, the size of your subject, the focal length of your lens, an on whether the film and lighting conditions will allow you to shoot with your longest lens.

☐To succeed in a close approach, follow these guidelines:
☐Find the animal before it becomes aware of you. If, for instance, you clear a rise to see a herd of mountain goat in the distance already looking in your direction, you are not likely to be able to approach to within a hundred yards.
☐Stay downwind, or at least have crosswind between you and your subject. This will prevent

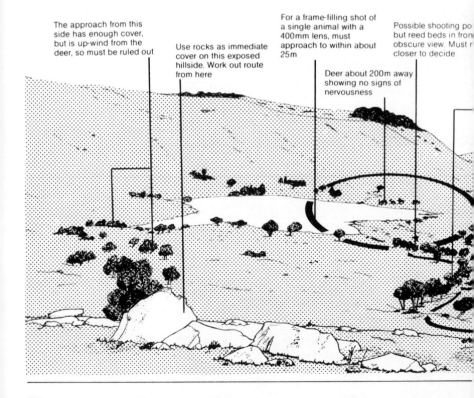

The approach from this side has enough cover, but is up-wind from the deer, so must be ruled out

Use rocks as immediate cover on this exposed hillside. Work out route from here

For a frame-filling shot of a single animal with a 400mm lens, must approach to within about 25m

Deer about 200m away showing no signs of nervousness

Possible shooting po but reed beds in fron obscure view. Must r closer to decide

your scent from reaching the animal, and will also mask noises.

☐Survey the ground ahead carefully, and try to imagine how it looks from the animal's viewpoint. Work out the approach route in sections so that for each leg you have one good piece of cover in front of you (such as a boulder, a clump of bushes or a low rise). Avoid being silhouetted against a skyline, and move in shade rather than in sunlit areas. If the sun is behind you the animal will be able to see less well in your direction, and the shadows you use for cover will appear darker.

☐If there are unavoidable obstacles, such as a river or marshy ground, try to cross them in deep cover and at a distance rather than wait until you are close to the animal.

If the animal seems likely to remain where it is for some time, watch its activity before starting your approach. Most creatures will pause every so often to take stock of their surroundings; many deer, for example, feed for periods of about 20 seconds, looking up in between.

The final stage of the approach can be very difficult and uncertain if you have to use open ground. Nevertheless, you can gain some distance by timing your movement to coincide with the animal's activity. Move when its attention is occupied, and freeze just before you think it will look up. If you are moderately well camouflaged, you may go unnoticed for your lack of movement.

Each time you stop, keep your face turned down and avoid looking directly at the animal. Many creatures are alert to eye contact, as a stare is often a prelude to an attack.

Move as described earlier, on pages 92-3, smoothly and only from below the waist.

Keep your camera up to your chest, ready to use with the least movement. A short neck-strap also reduces the camera's tendency to bounce about as you move.

If the worst happens and you are recognized, it is sometimes possible to retrieve the situation by moving slowly sideways and by looking away, later making another, fresh approach.

In this idealized situation, a small herd of deer has just come into view as you clear the ridge of a low hill. The first priority is to get down and take immediate cover, as at this point you are easily visible. Then, from this position, you must judge the lie of the land and construct a route. Compare *your* assessment of this simulation with that given here, in the captions.

Crawl to right off exposed hillside and make way through copse

uite enough cover,
ound here slightly
and view
ricted

le at this point
er to fork left or right

Choice of Equipment

Just being able to move quietly and easily is a prerequisite in stalking, a certain amount of equipment, securely carried, is also necessary. But beware of over-stocking in an attempt to allow for any eventuality.

Take as little as you think you will need, and carry it in such a way that it does not bounce around or rattle.

Handling a long focus lens

While a long focal length is necessary, a secure support, such as a tripod, is impractical when stalking. Being able to hold a long lens steadily by hand at moderate shutter speeds, such as 1/125 sec and 1/250 sec, extends the lighting conditions under which you can work. Practice using these support techniques.

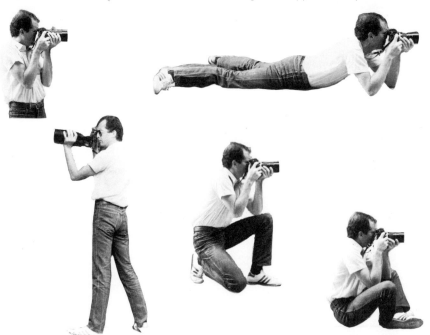

Motor drive technique

A motor drive is useful not only for shooting rapid sequences but also for freeing your hands to operate the other camera controls; your right hand can take the main weight of the camera all the time. Its chief drawback is noise, which may scare an animal more than would the ordinary shutter release and cocking action, but in situations where this is not too important, use it to improve your reaction time. Even when it is set for continuous operation, single frames can, with care, be triggered. Motor drives tend to use up film quickly, and it is easy to finish a roll before you expect to.

Photographic Equipment

Basic
35mm SLR camera
Medium long-focus lens (200mm to 300mm)
General purpose color film (about ISO 64). Minimum quantity 4 rolls.
Fast color film (about ISO 400). Minimum quantity 4 rolls
Spare batteries
Ultra-violet filter
Tape over chrome parts of camera

Optional
Motor drive
Second body (loaded with the fast film)
The longest lens that you can hold by hand, for example 400mm or 500mm
Rifle stock

Camera Care
Small shoulder bag or hip pack, padded to stop rattling.

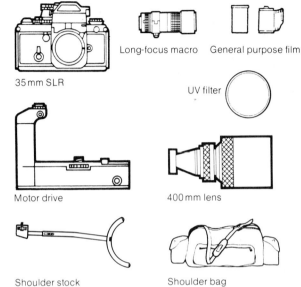

35mm SLR

Long-focus macro General purpose film

UV filter

Motor drive 400mm lens

Shoulder stock

Shoulder bag

Field Equipment

Clothing
Comfortable walking clothes with soft boots or jogging shoes and a light waterproof anorak.
Optional camouflage: paint, face veil, gloves, patterned clothing.

Medical
Simple first aid kit for all-day stalking. See pages 90-1.

Miscellaneous
Knife, such as woodsman's or Swiss Army
Water bottle, if stalking for more than an hour or two
Map and compass for longer trips.
Notebook and pen
Felt-tip marker to identify film

Compass

General purpose knife

Notebook and pen

Water bottle

Photographing Landscapes

A broad, almost panoramic view is often suited to landscapes or a grand scale – open mountain ranges such as the Rockies here in Montana.

By contrast, an intimate treatment that focuses on the close, small-scale detail of plants, frost and spiders' webs, can reflect the packed detail of enclosed landscapes such as this English riverbank.

In most wildlife and nature photography the subjects are specific and simple – an individual plant or animal, or a group of them. The main concerns are getting close enough with the camera and being able to show the subject in an interesting variety of ways. Landscapes, however, present a different kind of subject; obvious and accessible – in fact, unavoidable – but more difficult to pin down when it comes to making an image out of them. Indeed, actually identifying the subject in a landscape is for many photographers the most difficult task. Technically, landscape photography is as straightforward as any field can be, but finding a workable creative approach takes some thought.

A landscape differs from other nature subjects in that it is the total impression made by all the elements of weather, scenery and living things – sky, rocks, hills, plants, animals and so on. Any successful landscape

photograph is less of a factual document than an evocation. Not only is it easier to present a personal view in a landscape than in a wildlife photograph, it is essential if the picture is to have value. Technique is important, but takes second place.

Lighting
The sheer variety and unpredictability of natural light makes it one of the most important factors in a landscape photograph, and perhaps even the most imprtant of all. While there is no way of controlling natural light on a large scale, it is possible to anticipate it, and to be prepared to take advantage of especially attractive conditions.

Low sunlight picks out details and textures, and strengthens the appearance of low relief, particularly among gently rolling hills. It also adds warmth to the colors and, being strongly directional, can be used to give backlit, sidelit

or frontally-lit shots. Sunrise and sunset can produce strong silhouettes and spectacular bottom-lighting of cloud formations. Stormlight is extremely unpredictable, but sunlight breaking through heavy clouds can be dramatic, while banks of mist and fog often give very impressionistic images.

All types of light, however, have their uses. Overcast weather flattens contrast and is good for complicated scenes such as dense masses of vegetation. Hazy sunlight can give a soft, relaxed impression to a landscape while rain, like fog, mutes colors and tones, and can give a strong sense of atmosphere. A high overhead sun gives a harsh light that can complement stark landscapes of rock and sand.

Composition

As the different styles on the following pages show, composition can range from the formal and well-proportioned to the eccentric and eyecatching. The most predictable way of composing major elements such as the horizon is to place them roughly one third of the way into the picture from one edge, but more unusual approaches may better suit some subjects.

☐ A very low horizon emphasizes the sky, and can make subjects on the horizon, such as trees, appear fragile.

☐ A horizon near the top of the frame gives a shielded, less open view, and concentrates attention on details.

☐ A horizontal composition tends to give the most realistic view of a landscape; that is, it is similar to the way we would look at the scene ourselves. A vertical composition does not usually work well with a wide-angle lens, but often suits the stacked, compressed perspective of a long-focus lens.

Variations in Approach

Although there are countless ways of treating a landscape photographically, these are some of the more common stylistic approaches:

Formal In the photographic equivalent of a Constable painting, the composition is ordered, finely balanced, and traditional. This is essentially a straightforward approach that relies heavily on a strong landscape subject.

Panoramic A long frame, generally in the proportions 3:1, enhances the sweeping impression of a broad, open landscape.

Wide-angle One of the most powerful uses of a wide-angle lens in landscape photography juxtaposes close foreground details, such as flowers, with the distance. Generally taken from a low viewpoint, and with great depth of field, this type of approach draws the viewer into the scene.

Compressed distance One of the characteristics of a long-focus lens is that it flattens perspective and makes distant subjects, such as mountains, appear larger. This foreshortening can be very effective from a high viewpoint over a landscape that has distinct layers, such as successive ranges of hills.

Graphic High-contrast views, such as silhouettes, and landscapes that are framed so tightly that they are not immediately recognizable, can appear almost abstract. Essentially, this approach simplifies the image.

Atmospheric Another way of avoiding sharp realism is to give a soft, impressionistic view. Grainy film, flared back-lighting, mist and fog are different ways of achieving a sense of atmosphere at the expense of detail and strong color.

The representative detail Sometimes, a small detail of a landscape, such as the edge of a wave or a single leaf in a small pool, can evoke the feeling of a place more succinctly than a broader, more predictable view.

Compressed distance In this early morning view of tropical mesas in Venezuela's Canaima National Park, a telephoto lens (400mm) enhances the scale by compressing the perspective. The distant cliff seems to loom over the nearer slope, giving a visual clue to its great height.

Representative detail
Where the structure of a landscape – whether rocks or vegetation – is distinctive, a close view may be more effective than a broader treatment. These hexagonal basalt columns give the old lava landscape of northwest Scotland and Ireland its striking characteristics.

Graphic
Silhouettes are a useful option in landscape photography, especially where shapes and outlines are interesting, as in Monument Valley between Arizona and Utah. Dusk and pre-dawn are perfect times of day, provided that the sky is mainly clear.

Wide-angle
Very short lenses, such as the 20mm used here in a view of the Death Valley sand dunes, can give a very involving image, drawing the viewer into the scene. A small aperture and careful control of the depth of field are important.

Choice of Equipment

As there is room in landscape photography for many different techniques, *all* kinds of camera equipment can be used. The three sets shown here are typical, but not essential, for the three main formats.

35mm
35mm SLR body
Wide-angle lens, between about 20mm and 28mm
Standard lens
Long focus lens, from 150mm upwards, according to taste
Lens hoods
Tripod (capable of a low configuration) and cable release
Ultra-violet and polarizing filters
Color balancing and color correction filters, to compensate for skylight color casts and to correct reciprocity failure at slow shutter speeds.
Film choice depends entirely on preference

Rollfilm
Rollfilm body
Wide-angle lens, between about 40mm and 60mm
Standard lens, 80mm or 90mm
Long focus lens, from 250mm upwards
Lens hoods
Tripod (capable of low configuration) and cable release
Ultra-violet, polarizing, color balancing and color correction filters
Film

View cameras
Field or technical camera
Wide-angle lens, 75mm or 90mm for 4 x5-inch format
Standard lens, 150mm for 4 x5-inch format (optional)
Long focus lens, 360mm upwards for 4 x5-inch format (optional)
Adjustable lens shade
Tripod and cable release
Viewing cloth or hood
Changing bag
Filters, as above
Film and holders (either double dark slides or a Graflex holder)
Polaroid back and film
Separate light meter (spot meter best)

35mm SLR

Small tripod

Cable release

28mm lens

55mm lens

⌐ UV filters

Long-focus lens

400mm lens

Light meter

Film

Lens hood

Photographing Trees

As components of a landscape, trees can be treated decoratively, but as subjects in their own right they generally need to be photographed clearly and distinctively. This is by no means always simple, as most have complex shapes and normally grow in settings that are, to the eye, confused.

Photographs of trees can be simplified by first finding specimens that are distinct and preferably isolated, and then by shooting at a time of day and in weather that gives the most suitable lighting. Alternatively, you can photograph large stands of trees, emphasizing the patterns and textures of massed tree trunks and foliage, or concentrate on details of roots, branches, leaves, and so on.

Single trees
For a clear, isolated view of a single tree, consider the following points.

☐ Some species, such as elm and acacia, tend to grow more or less singly, scattered over open ground. However, even among species that grow in stands, occasional individuals can be found just beyond the edge of a woodland or forest.
☐ A steep hillside, by arranging the vegetation more vertically, tends to isolate individual trees, and can provide a plain background.
☐ The sky forms a very clear backdrop, although it is usually least interesting with continuous cloud cover, which gives little more than a plain silhouette of a tree. Look for skyline views, on the tops of hills and low rises.
☐ Water, from a high viewpoint, also provides a simple background. Look for trees near the edge of lakes, rivers, or the sea, and photograph them with a long-focus lens from higher up the slope.
☐ Mist and fog can isolate trees very

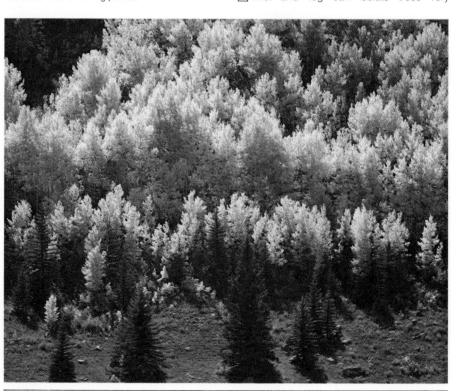

effectively, even in a forest, by muting distant tones and colors, and by separating a scene into distinct planes. Clouds in mountains have the same effect.

☐ Low-angled sunlight will pick out some individual trees, although the exact effect is difficult to predict. Early morning and late afternoon are, therefore, potentially good times of the day, although in mountainous country the middle of the day may be better, depending on the angle of slope.

☐ The best focal lenth of lens depends on the viewpoint selected, so ideally you should have with you a range of lenses. Zoom lenses are useful for refining the composition when there is little choice of camera position. More often than not a long focus lens, with its ability to make the background appear larger in proportion to the tree, helps simplify the image.

Groups of trees
Look for a focus of interest, such as one tree that has turned to its autumn colors before its neighbours, or a single palm tree in a hardwood rainforest. This helps fix the attention in what otherwise would be a disorderly jumble. Also look for repetitive patterns of trunks or leaves. Photograph stands of trees either from a distance, looking towards the edge of the forest, or with a wide-angle lens from inside.

Equipment
So much depends on the location of a good specimen that no useful priorities can be given for lenses or other equipment. As in landscape photography, any format is suitable; the more choice of lens focal length that you have, the better. Follow the checklist for landscape photography on pages 106-7.

Three simple techniques combine to make a clear, attractive portrait of aspen in Colorado's Uncomphagre National Forest. A viewpoint was chosen that looks across to a hillside, against which the trees are arranged on a plain background; a telephoto lens crops out unnecessary surroundings; and a time of day was chosen when the sun just grazed the slope, picking out the bright foliage.

The gnarled and wind-contorted attitude of a Monterey Cypress on the California coast is picked out by bright late-afternoon sunlight. Lighting is one of the most crucial elements in separating a tree from its surrounding.

Working In Close

Although large animals such as bears, or deer or big cats are obviously attractive wildlife subjects, most creatures are extremely small – so small, in fact, that they cannot be photographed adequately with a normal lens. To fill the frame of even a 35mm transparency with an insect or small flower, the lens has to be able to focus down to a few inches only, and must also be able to give sharp images at such a short distance. Regular lenses generally focus no closer than about one foot (30cm) and are designed to perform best at distances greater than this. As a result, close-up photography needs additional equipment, and some special techniques to go with it.

Close-up photography has a reputation for being technically difficult, but now that most cameras are SLRs and have TTL meters, and flash units are small, reliable and automated, there are no longer the problems that there once were. Mechanically, close-up photography has become very simple, and in the field of wildlife and nature photography should be part of the basic repertoire of skills.

Changing the scale of photography

The reproduction ratio and magnification of a close-up photograph depend on how much smaller or larger than the subject the image is. If the photograph is later enlarged to make a print, the reproduction ratio and magnification are also increased.

Close-up equipment

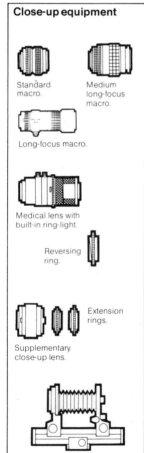

Standard macro.

Medium long-focus macro.

Long-focus macro.

Medical lens with built-in ring-light.

Reversing ring.

Extension rings.

Supplementary close-up lens.

Bellows extension.

Some of the expressions used may at first sound abstract, but many close-up photographs can be taken without knowing any detailed theory or making any calculations.

Reproduction ratio and magnification

These are the two most common ways of comparing the size of the image with the size of the subject. When the reproduction ratio is written, the figure on the left is the size of the image, and the figure on the right is the size of the subject. The magnification simply shows how many times larger is the image than the subject. So, if an insect that measures 6cm appears as 2cm in a transparency or negative, the reproduction ratio is 1:3 and the magnification ⅓ x (or 0.33x).

Close-up, macro and micro

Practically, close-up photography starts at distances less than a normal lens can focus (about one foot or 30cm). At this point some adjustment generally needs to be made to the exposure. From a reproduction ratio of 1:7 to life-size (1:1) is roughly the province of close-up photography; photomacrography covers from 1:1 to 20:1; beyond 20:1 needs photomicrography (with a microscope).

Lens extension

This is the *extra* distance that separates a lens from the film, created by adding an extension ring or bellows. It can be measured either in millimetres or as a proportion of the focal length of the lens.

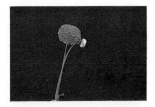
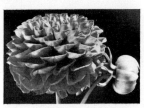

Magnification 1/10 x. For this moderate close-up, any normal lens will focus sufficiently close without any attachments.

Extending the lens

By moving the lens further away from the film, closer subjects can be focused sharply, and these are magnified. The focal length of a lens is the distance from the film to the centre of the lens (strictly speaking, the nodal point, but generally the middle of the assembly of glass elements). Extending the lens by half its focal length magnifies the image to half life-size, extending it by the full amount of its focal length gives a life-size image, and so on. The usual way of extending the lens is with either a ring or bellows. Given the same extension, a short focal length lens will magnify more strongly than a long focal length lens.

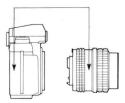

Magnification 1/2 x. This level of magnification – half the size of the real subject – is the limit of focus for most specially designed macro lenses, but regular lenses need extending.

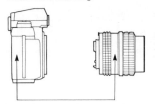

Magnification 1 x. At this magnification, the image is the same size as the object. For this, the lens must be extended from the camera by its focal length.

Lens extension and reproduction ratio

Lens extension (percentage of focal length)	120	140	160	180	200	220	240	260	280	300
Reproduction ratio	1:5	1:2.5	1:1.7	1:1.2	1:1	1.2:1	1.4:1	1.6:1	1.8:1	2:1
Magnification	0.2×	0.4×	0.6×	0.8×	1×	1.2×	1.4×	1.6×	1·8×	2×

Choice of Equipment

Close-ups without flash
Photographic equipment
35mm SLR with macro lens. Long focal lengths give attractive perspective and can be used at a greater distance than a standard 50mm or 55mm lens, but have less depth of field and need longer extensions to increase magnification.
Extension rings to increase magnification from 0.5x up to life-size.
Low-level tripod or tripod with reversible centre column.
Cable release
General purpose color film, about ISO 64
81EF color balancing filter for shaded subjects on sunny days; 81A filter for cloudy weather; and color correction filters for reciprocity failure at exposures of about one second or more (see pages 44-5).
Silvered reflector, either cloth or card
Windshield: umbrella or transparent plastic shield with supports.
Thick copper wire to support stems of plants
Field equipment Notebook and pencil.

35mm SLR

Macro lens

Extension rings

Cable release

G.P. film

Low-level tripod

Filters

Thick copper wire

Notebook and pencil

Close-ups with flash
Photographic equipment
35mm SLR with macro lens. Extension rings. Fine-grained color film, about ISO 25 or 64. Pre-tested flash unit configuration, as illustrated. Spare batteries. Flash meter. Table of exposure settings.
Field equipment Small torch (flashlight) that can be taped to camera for focusing at night. Spare torch (flashlight) batteries. Tape. Notebook and pencil.

Flash meter

Fine-grained colour film

Flashlight

Lens-mounted flash unit

Without flash
Natural light, diffused or in shade, gives a low contrast view – good for showing camouflage, as here, but a little weak in defining shape. Depth of field is usually shallow.

With flash
Flash allows more depth of field, and crisper small detail. Deep shadows can help to define limbs.

Ring flash
Ring flash gives a characteristically flat lighting effect, with virtually no shadows. Reflective surfaces give bright, unavoidable reflections. Ring flash photographs have a definable sameness because of the unchanging position of the light, but are very useful for illuminating crevices and holes.

Exposure and Depth of Field

The usual system for taking close-up photographs is to extend the lens. As this cuts down the amount of light reaching the film, the exposure needs to be increased, and this awkward calculation has been the traditional bugbear of close-up photography. However, if your camera has a TTL meter and you are not using flash, no special calculations are needed: simply follow the read-out in the viewfinder.

If, on the other hand, you cannot measure the light through the viewfinder, there are several ways of working out the extra exposure. The simplest is the scale at the bottom of this page, designed specifically for outdoor situations where you have no time to make any calculations. Alternatively, use the equation below. In either case, *start* with the regular exposure setting, measured with any light meter. For instance, if a hand-held meter reading taken from a clump of wild flowers was 1/125 sec at f8 for a particular film, then either of the two methods given here would show you that a life-size (1:1) image of the stamen of one flower would need an increase in exposure of four times. This, in other words, would mean adding two f-stops, giving a final setting of 1/125 sec at f4 (or an equivalent, such as 1/60 sec at f5.6).

Calculating the increase in exposure

Exposure increase =

$$\left(\frac{\text{lens focal length} + \text{extension}}{\text{lens focal length}} \right)^2$$

As an example, if you add a 20mm extension ring to a 55mm lens, the extra exposure will have to be:

$$\left(\frac{55 + 20}{55} \right)^2 = 1.36^2 = 1.85x$$

This, in other words, means adding another ⅔ f-stop.

Instant exposure scales
These two scales have been worked out for 35mm and rollfilm formats, and are extremely simple to use. First compose the photograph and adjust the focus. Then aim the camera at the scale below, moving it or the book until the figures appear sharp (don't alter the focus). When the large arrow is close up against the left edge of the frame as you look through the viewfinder, the last figure you can see on the right is the extra exposure.

6x6 format (for 6x7, use shorter side)

f-stop increase	4	3	2	1⅔	1⅓
Exposure increase	16.0	8.0	4.0	3.2	2.5

35mm format

f-stop increase	4	3	2	1⅔	1⅓	1	2
Exposure increase	16.0	8.0	4.0	3.2	2.5	2.0	1

Depth of Field

The closer the camera is to a subject, the more shallow the depth of field, and this is very characteristic of close-up photography. With some subjects, such as insects, front-to-back sharpness is usually the ideal, which means making the most of what depth of field is possible. Other subjects, particularly those, such as wild flowers, that have complicated backgrounds, may benefit from having little depth of field as this isolates them graphically from their surroundings.

There are three ways of improving depth of field in a close-up shot:

Use a small aperture Even though some slight image quality is lost at very small apertures, the general effect is a sharper image overall. However, exposures are likely to need to be long to compensate, so that camera shake and movement of the subject (leaves in even a slight breeze) could become new problems. Also, at exposures of more than about one second, many films will change color (see pages 44-5).

Change the position of the camera or subject If a long subject is photographed side-on rather than head-on, it presents less depth to the camera. If the situation allows, and provided that it is not likely to spoil the image, make sure that the distance between the nearest and farthest parts of the subject are as shallow as possible. Do this either by moving the camera or by re-arranging the subject (for instance, by twisting the stem of a flower gently). Obviously, this cannot work with roundish objects.

Use a bellows with a swivelling front Some bellows have a lens mount that can be rotated slightly, and what this does is to tilt the plane of sharp focus. So, if a leaf slopes diagonally towards the camera, the lens mount can be tilted so that the focus coincides with the leaf. This is really a way of managing *without* great depth of field rather than increasing it.

One way of managing without depth of field is to photograph a subject at its shallowest. At 30 inches distance, the depth of field with this 200 mm macro lens at f 11 was only $^{3}/16$", but nevertheless adequate for this damsel fly at rest.

Using Flash

For most photographs of insects and small animals in the field, flash is essential. To achieve sufficient depth of field for most of the image to be sharp, the lens must nearly always be stopped down close to its smallest aperture. With natural light, even on the brightest day, the shutter speed would then have to be extremely slow with fine grain film – too slow to prevent camera shake without a tripod, and too slow to freeze the movements of an active subject. Additionally, flash is indispensible for the many insects that are nocturnally active.

The normally harsh lighting from the small tube of a portable flash unit is improved at close distances with small subjects. The reflector and window of even a small unit is at least as large as most insects, so that at reasonable magnifications the light appears moderately well diffused. Even so, although a single flash head is satisfactory, the close working distances often mean that it has to be positioned to one side of the insect, and consequently casts strong shadows. Because of this, most close-up photographs of this type look better if a reflector (mirror, foil or white card) or a second flash unit is positioned on the other side of the subject.

Using flash in close-up adds yet another problem of exposure measurement. Most automatic flash units, which use a thyristor circuit to give the same intensity of light whatever the distance to the subject (see pages 36-7), are designed for use at normal distances, and do not produce sufficient light for the really small apertures (around f22 and f32) that are needed in close-up work.

For variety, an off-camera flash position can simulate, at least partly, natural lighting, particularly if the flash is softened. For this effect use either a proprietary diffuser (a small sheet of plastic) or a handkerchief.

Although it is possible to 'fool' the sensor into giving a higher light output, by covering it with a neutral density filter (see pages 48-9), there are other problems: the sensors on most automatic units, while perfectly adequate when used over more than a few feet, cannot be focused precisely on a subject that is only a few inches away, and so are not reliable.

Some cameras will give TTL flash readings when used with a dedicated flash unit, and these remove most problems. However, if your camera cannot do this, a small manual flash unit is probably the best choice. A unit with a guide number of about 40 with ISO 64 film is ideal for a working distance of a few inches.

Ringflash
A ringflash comprises a circular tube that fits around the front of the lens, like a collar. Because the light comes from all sides, the effect, particularly in close-up, is shadowless illumination. This is particularly useful at great magnifications, where a conventional flash head might have to be used at such an angle to the subject that much of the image would be in deep shadow. The quality of lighting is, therefore, monotonous but useful. As the light remains fixed to the front of the lens, exposure calculation is straightforward, and only the f-stop needs to be changed.

Two flash units in sync
WARNING. Unless you use a flash unit designed to be used with an extra head, you are likely to face two problems:

1. If the triggering voltage is not the same for each unit, as may well be the case if they are of different makes, the sync may not work. It is better to use two units of identical make.

2. More than one unit coupled together puts a greater load on the camera's sync contact. A small photocell slave trigger is safer.

Shadow fill 1
One method of avoiding dense shadows on one side of the subject is to fit a second, opposite flash. Sync. with a slave cell is safer than a sync. junction.

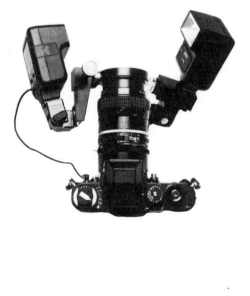

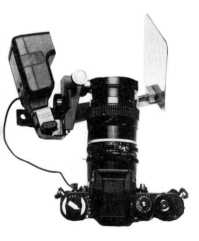

Shadow fill 2
A simpler alternative is to clip a mirror or reflective metal plate opposite the flash.

Calculating Flash Exposures

Exposure can be adjusted by altering either the aperture setting or the distance from the flash to the subject, and there are advantages to both methods. Changing the aperture is straightforward and quick, but you may need your smallest aperture to maintain depth of field. Changing the position of the flash allows you to keep the same depth of field, but can be slow and may interfere with the subject. Measuring distances accurately, to within an inch, with a handheld camera can be very difficult, and for this reason many photographers who specialize in field close-up photography use a fixed configuration of camera, lens and flash. The flash is fastened in one position relative to either the camera body or the lens (this depends on how it is attached), and prior testing establishes the f-stop needed at various magnifications. To some extent, the increase in lens extension at greater magnifications compensates for the more intense light at closer distances, so the spread of aperture settings is not particularly great.

With this system everything, including focus, is pre-set, so that all that is needed is to move in towards the subject until the image appears sharp. By restricting yourself to a few magnifications – say 0.25x, 0.5x, 0.75x and 1x, you can use settings that you have tested and are completely certain of.

Measuring exposure

At close distances, two adjustments need to be made in calculating exposure with a flash unit.

1. The guide number is different when a flash unit is used at distances of less than about 3 feet (1 metre). This is chiefly because at close range even a small flash head is no longer a point source of light, and so its intensity does not increase proportionately as it is moved closer. Without a flash meter this is difficult to predict, but tests on some typical small units show that the guide number at 20 inches (50cm) may be about 85% of normal, at 10ins (25cm) about 70%, and at 5ins (12cm) about 60%. In addition, check the guide number of any new flash unit, as shown on pages 36-7.

2. The lens extension needs to be included in the calculations. Follow the instructions below to calculate the magnification from this. The formulae are:

Flash-to-subject distance =

$$\frac{\text{guide number}}{\text{f-stop} \times (\text{magnification} + 1)}$$

OR

$$\text{f-stop} = \frac{\text{guide number}}{\text{distance} \times (\text{magnification} + 1)}$$

By far the best method of calculating close-up exposure with flash is to run a series of tests with the help of a flash meter. The meter measures the actual intensity of light at any distance, and is unaffected by any change in guide number. The only adjustment that you then need to make is for the lens extension, for which you can use the scales or tables on the previous pages. Although fairly expensive, a flash meter is essential equipment for critical work. Testing the exposures at different magnifications makes it possible to pre-set your equipment when you go out into the field.

Calculating the magnification
Measure the extension between the lens mount and the front of the camera, as shown. Divide it by the focal length of the lens; the answer is the magnification. In the example at right, the lens is a standard 50mm and the extension is 100mm, so the magnification will be 2x.

Measuring distance

One useful technique for measuring the flash-to-subject distance, provided that the insect is sluggish and will not jump or fly away, is to attach a small tape measure to the side of the flash head.

Using a flash meter

A small portable flash meter such as this is invaluable for serious work, and overrides guide number and distance calculations. Fit the diffusing dome supplied, hold the meter in the position of the subject (to check, look through viewfinder to see if in focus) and point it towards the camera. Then simply allow the exposure increase shown on page 114.

Hides or Blinds

Hides (blinds) are camouflaged camera positions sited close to places that animals are likely to visit regularly, such as nests or water holes. Erecting and using them calls for a different kind of effort from that of stalking, involving more preparation and forethought, and more patience. Hide photography is relatively cautious, and relies little on the serendipitous encounter that plays such a large part in stalking. To some extent, the two kinds of wildlife photography reflect differences in the personalities of photographers, but for long-term observation of many species, close to the most sensitive places in their existence, hides offer the only way.

Design and construction depends on the location and the type of camera position you need, and also on how much of an effort you are prepared to make. As with personal concealment (described on pages 88-9 and 92-3) the principle is to fool the senses of the animal you plan to photgraph rather than to construct camouflage that is aesthetically satisfying to you. In practice, this usually means paying much more attention to movement and noise – for instance, a loose cover flapping in the wind is virtually a warning beacon to most birds and mammals.

The majority of hides are individually designed according to the needs of the particular project, but one common type is shown here – a portable design using a lightweight interlocking frame and a fabric covering. The dimensions are a guide only, but beware of making a hide that is only just large enough to sit in; discomfort will prevent you making full use of it.

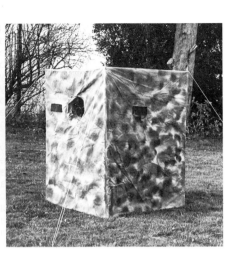

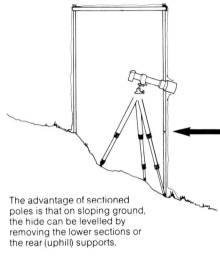

The advantage of sectioned poles is that on sloping ground, the hide can be levelled by removing the lower sections or the rear (uphill) supports.

Portable hide

This box-frame construction is fairly standard, and can be bought ready-made or made from basic materials. Photo courtesy of Jamie Wood Products Ltd. It is built in much the same way as a tent, and a camping supplier should be able to provide most of the materials. It is important that, when erected, neither the fabric nor the frame moves noticeably in a moderate wind.

Allow extra length for ground flaps (see page 125 for finished effect).

Variations in Design

For certain kinds of work it may be better to construct a hide that is specifically tailored to the surroundings than to install a portable design. Makeshift hides, using natural materials such as branches and leaves, straw bales can be effective even though simple, while for serious long term observation a permanent shelter can be built

Permanent hide (blind)
Because this kind of hide is intended to be a regular fixture in the landscape, there is more time for the animals to become accustomed to it, and it may not be necessary to camouflage it thoroughly. Nevertheless, this is an extra precaution, and easy to provide. Vegetation can even be planted and encouraged in front.

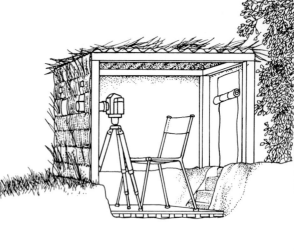

Pit hide (blind)
This design is suitable for sloping ground that lacks natural cover, as even in open grassland it can be made virtually invisible. The pit should be at least deep enough to sit in, if not to stand in, and this can involve more digging than you might expect. Fit a raised flooring of wooden slats to keep your feet dry, as rainwater is likely to accumulate in anything but the most well-drained ground. Cover with fabric, pegged down on all sides, and scatter grass or leaves to blend it with the surroundings. A small bowed frame at the front will lift the covering sufficiently for the camera.

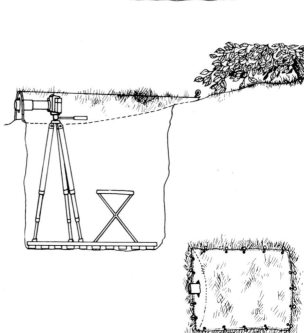

Natural hide (blind)
Essentially a screen of foliage, this is particularly suitable wherever there is a reasonable amount of undergrowth. Either adapt bushes by bending together the branches at the front and clearing a space for you and the camera behind, or construct a screen from scratch, using dead branches. More vegetation can be woven into the screen to make it denser. When finished, inspect the hide from the front.

Tree hide (blind)
The two advantages of a tree hide are that it can put the camera on a level with nests, and that it isolates your scent from the ground. Although used mainly for birds, it can be a good location for photographing large mammals, particularly shy nocturnal ones like badgers and foxes, or ones that are potentially dangerous. The basic prerequisite is a stable platform. This can be made by securing planks between two thick branches, but be careful to do as little damage as possible (in most national parks or nature reserves, conservation regulations will in any case prevent this kind of construction). Then, drape fabric such as camouflage netting over a simple framework (branches or cane poles, for example). For protection against rain, fit a waterproof fabric panel on top.

Floating hide (blind)
In wetlands, it may be easier to build a hide on water than to try and find dry land, and there is usually more choice in positioning a floating shelter. Use a raft or a small boat as a basic structure. To prevent it from drifting or turning, anchor it at more than one point; in the arrangement shown, allowance can be made for tidal movement, which is important in coastal and estuarine water.

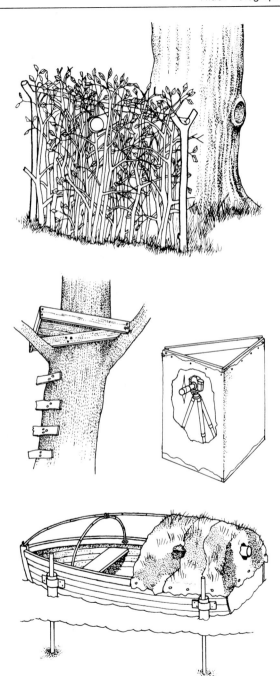

Using a Hide or Blind

A hide (blind) is only as good as the way it is used, and carelessness in siting it or in working from it can undo all the effort of construction. As the point of using a hide is to enter an animal's safety zone and still be able to take photographs, there is every opportunity for alarming your subjects. Decide on the best site in advance, move the hide into it carefully, and continue to take precautions to conceal yourself when entering and leaving.

Selecting a site
Choose the site by visiting the area at a time when no animals are present: it you cannot do this, observe carefully with binoculars from a distance. Much depends on the actual habitat, and on what you are trying to photograph – feeding place, water hole, nest, or whatever – but look for the following:

☐ A clear view of where the animals will be, from camera level (this may be lower than head-height, so check with the camera, lens and tripod set-up that you will use).

☐ Good lighting on the subjects at the time of day you expect to be photographing them. Avoid backlit positions, for not only will it be difficult to see the animals, but the hide itself may be sunlit, and therefore more obvious.

☐ Some cover for the hide. Avoid an exposed area such as a field – the edge of woodland or undergrowth is better. Also avoid being silhouetted against the sky from your subject's viewpoint.

☐ A photographically satisfactory background to the subjects.

☐ A position that is likely to be downwind from the animals in typical weather conditions.

Introducing the hide (blind)
When photographing migrants, the hide can be placed straight into position, provided that you do it before they arrive in the area. As they are not likely to be thoroughly familiar with the territory, they will probably not notice the fresh addition of the hide. However, if you are entering an animal's regular territory, take these precautions:

☐ Establish the animal's pattern of activity around the site from a distance with binoculars, noting its arrival and departures, and the times when you can reliably expect it to be absent.

☐ With a prefabricated hide, erect it at a distance, and each day move it a little nearer the site you have chosen. This helps to make it seem familiar.

☐ Only move at times when the animals are not present – for instance, when a bird leaves its nest for food.

☐ Judge the rate of approach by observing the animal after each move. If its behaviour seems unaltered, continue; if, however, it appears disturbed, slow down the advance, or even pull back for a day or two.

☐ If, on the other hand, you are building a hide on the spot, do a little each day, so that it takes shape gradually. This, like moving a hide forward slowly, will ease it into the animal's awareness.

☐ Clear any natural obstructions to the view, but with care. Removing branches close to the hide causes no problems, but be cautious about removing cover from near a nest, for it will make it easier for predators to find.

Using the hide (blind)
In use, the most critical times are when you enter or leave the hide. Even inside, however, move quietly and carefully.

Whenever possible, enter and leave the hide when the animal is absent. Otherwise, enter with a companion, who then leaves. This should fool most animals into thinking that humans have entered and left, and that the site is therefore empty once more.

Inside, avoid touching fabric walls. The movement may be very obvious to an animal.

Be careful when you push the lens through an opening in the wall, and when you withdraw it. When you are not using the hide, it may help if you leave a tube or bottle of roughly the same dimensions in place of the lens; the animal will then become familiar with it.

Although the hide will, to some extent, muffle sound, keep as quiet as possible.

Make sure that you are sufficiently comfortable to stay for a few hours. A folding canvas chair, food and drink are all important. On a hot day, the hide may become very stuffy; if so, ventilate by opening the entrance flap at the bottom or in the rear wall.

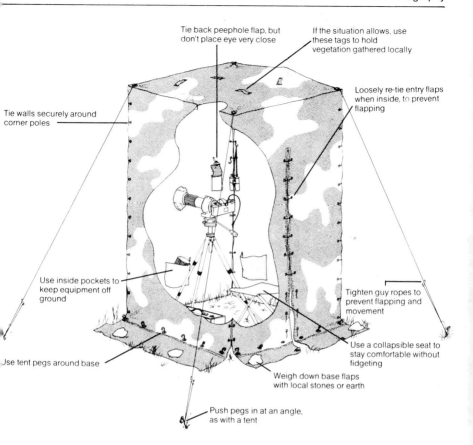

Tie back peephole flap, but don't place eye very close

If the situation allows, use these tags to hold vegetation gathered locally

Tie walls securely around corner poles

Loosely re-tie entry flaps when inside, to prevent flapping

Use inside pockets to keep equipment off ground

Tighten guy ropes to prevent flapping and movement

Use tent pegs around base

Use a collapsible seat to stay comfortable without fidgeting

Weigh down base flaps with local stones or earth

Push pegs in at an angle, as with a tent

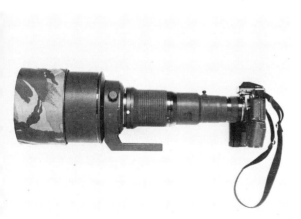

Lens camouflage

Disguise the lens as much as possible, as it is likely to be the most noticeable feature of the hide. A strip of camouflage material, cut to fit the lens hood, is effective. Sew it to slide over the end, or secure the loose ends with Velcro.

Baiting and Luring Techniques

One way of improving the chances that an animal will visit the site opposite a hide (blind) is to use a bait or lure. The list of things that are likely to attract an animal are, on the whole, obvious. The necessities of life, when they are in short supply in the wild, exert a powerful pull; dietary treats are as tempting for animals as they are for humans; and imitations of the sights, sounds and smells of certain other animals can trigger strong behavioural responses.

The danger in using baits and lures is that they can disrupt an animal's normal life. Regular feeding may create a dependence that renders an animal less fit to look after itself. Playing recorded calls to elicit an excited response (such as defence of territory) may cause stress. If you use any of these baits or lures, do so with discretion.

To be effective, baits should be:
– Easy to find. Consider the senses that the animal will use and choose a location accordingly – upwind if scent is important, visible if sight is the major sense.
– In a safe place. A prey species may avoid bait left in an exposed location; close to cover is usually better.
– Appropriate to the animal's diet.
– Normal-looking and free of human odour.
– There when the animal is hungry. For many species, this usually means winter rather than spring and summer.

Food
Seed-eating birds: Cereal grains, sunflower seeds
Fruit-eating birds: Fresh fruit, raisins
Small mammals (fieldmice, squirrels, etc.): Mixture of equal parts suet, peanut butter, raisins, oatmeal.

Electronic lures
Tape recording and playback equipment can be used to simulate the kind of calls likely to attract an animal. Make recording with a highly directional microphone and monitor the level with headphones. To elicit a call just for recording may need a proprietory calling device, available for game species at least. When playing back, conceal the equipment, and operate at a distance with a long lead.

Shotgun mike

Recorder

Headphones

Deer call

Rabbits: Fresh vegetables and fruit: carrots, lettuce, onions, apples. Also bread.
Squirrells: Cereal grains, peanuts, sunflower seeds
Snakes: Mice, whole eggs
Cats: Fish, meats, catnip, canned cat food, fish paste.
Weasels: Fish, fresh offal.

Butterlies and moths 'sugar' mixture: approximately equal proportions of beer, treacle and rum.

Water
For small animals, an artificial supply of water is practical, and is even more effective if it can be made to flow or drip. Heavy-gauge plastic sheeting sunk into a hollow is one of the simplest ways of making a pool, but do be careful to camouflage it for natural-looking photographs. Birds in particular are attracted to dripping water – a plastic container with a tap can be secured above the pool (as some birds may be nervous of an object suspended above them, a length of tubing leading out from the container is an improvement).

Light
Moths and many other nocturnal insects are strongly attracted to light, although this lure is more useful for collecting rather than photographing on the spot. Placing a torch (flashlight) or lamp behind a white sheet creates a large area of light, and insects can be picked off easily.

Decoys
The main use of artificial decoys, especially with ducks and other birds that congregate in flocks, is to attract others of the same species by showing that a particular site is safe for landing. Be careful that the decoy does not appear in the shot.

Scent
Certain mammals can be attracted by scent, especially one that resembles sexual pheromones, but there has been little practical research so far. Deer scents are commercially available, and anise oil attracts bears and some deer. The herb catnip also attracts certain members of the cat family.

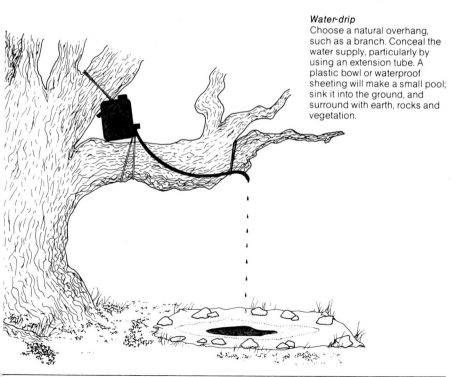

Water-drip
Choose a natural overhang, such as a branch. Conceal the water supply, particularly by using an extension tube. A plastic bowl or waterproof sheeting will make a small pool; sink it into the ground, and surround with earth, rocks and vegetation.

Remote Control Photography

An alternative to concealing yourself in order to approach animals closely is to leave the cameras fixed in position and operate them from a distance. Despite the noise of its operation, a camera alone is less noticeable than a photographer and much less threatening to wildlife. As an extra precaution, make the equipment less obvious by draping with camouflage netting or cloth (it may also need to be waterproof if there is a likelihood of rain or morning dew) and by muffling its sound with a blimp. If the situation calls for a large number of photographs, a replacement camera back that can accept bulk film (up to 250 exposures) will be useful.

There are two classes of remote control device: those that the photographer operates, and those that react automatically to the arrival of an animal. Although it is possible to build equipment that will press a camera's shutter release mechanically, using a solenoid motor, the choice of winders and motor drives – many quite inexpensive – makes electrical electrical triggering the most practical method.Setting the motor-drive to single-frame rather than continuous operation gives more control over the film used. When using the camera's automatic metering, cover the eye-piece to prevent light entering. Virtually all remote control systems offer variations on one function – they close a circuit. As this is the simplest of all electrical operations – in practice, bringing two contacts together – any number of devices can be used depending on your ingenuity and the circumstances. The following are the obvious methods:

Ad hoc triggers
A self-triggering system can even be constructed on the spot, using an adaptation of any number of traditional traps. This saves the weight and expense of a custom-built device and, by using local materials, the elements may be less conspicuous. One of the simplest but most effective devices is the spring-pole, still used in some parts of the world for trapping small animals and ground-dwelling birds. Adapted to non-lethal use, the tension in the pole, when released by an animal touching the trip, can be used to bring together two electrical contacts.

Operator Triggers

Cable extension
Winders and motor drives have sockets for an electrical cable release. If this cable ends in adaptable contacts, such as alligator clips or jack plugs, any two-wire cable can be attached to extend it. To avoid short-circuiting by rain or damp ground, seal all connections thoroughly. Over 50 metres range there may be noticeable loss of current, which would require an amplifier to restore.

Infra-red trigger
The receiver of this two-part device fits into the camera's hot-shoe, while the transmitter is held by hand. There are no wires, and both parts are powered by their own batteries. The transmitter puts out an infra-red pulse, which over line of sight will trigger the receiver up to about 60 metres. To some extent, the signal will bounce off rocks, but this reduces its strength.

Radio control
Radio has great range – between about 300m and 700m depending on the conditions – and can be operated out of sight but in some countries needs a licence. In Britain, which has strict broadcasting controls, this is not normally granted. Some camera manufacturers make radio control transmitters and receivers for this specific purpose, but systems designed for radio-controlled models are easy to adapt and may be cheaper.

Muffling the noise of a remotely controlled camera

Although remote control makes it possible to place a camera closer to an animal than a hide (blind) containing a photographer, the problem of camera noise remains, and is often made worse by the need for a motor-drive to advance the film automatically. Enclosing the camera in a sound-proof bag – known as a blimp – can go a long way towards concealing it. There are very few commercial blimps, but it is easy to build a fairly effective one using thick cloth and a lining of closed-cell foam.

Trace the outline of the camera onto paper
(1) and then add about an inch all round to allow for the thickness of the lining and for the stitching
(2) Use the paper as a template when cutting the cloth, which can be camouflage material for even more effective concealment
(3) Cut a mirror image of this for the back of the camera, and cut holes for the lens and viewfinder
(4) Cut extra strips for the width, as shown, and a flap for the viewfinder (the bottom of this can be sealed with 'Velcro' tabs). Also buy a heavy-duty zip fastener.

Cut identical pieces of cloth for the inner lining and of quarter-inch foam for the insulation. Stitch together. Pass external connections, such as remote leads or radio receivers, through the double zip. For extra muffling make a padded tube for the lens.

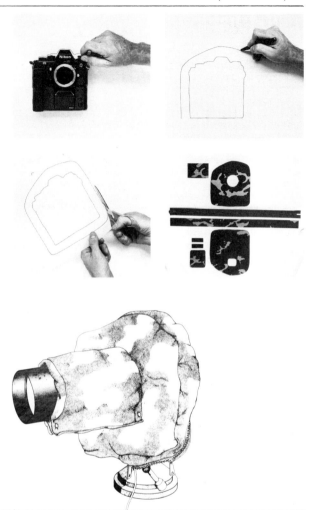

Automatic Triggers

Pressure contact

A pressure plate or trip-wire placed along a regularly-used trail is a relatively straightforward way of arranging for an animal to take its own photograph. A simple micro-switch, available from electrical goods suppliers, is a convenient basis for most systems. Such self-triggering devices can operate at very short distances.

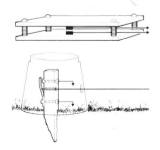

Light switch

Using the same principle as security systems and many automatic doors, light switches can be adapted to trigger the camera when an animal breaks a fixed beam. A constant beam of light is aimed across a trail or flight path to a photoresistor: if the beam is interrupted, the resistance in the circuit is altered and can be made to activate a relay. To make the light beam less obvious, attach a red filter. An infra-red beam can be used in the same way.

Night Photography

With the exception of insects, and other small animals, which need the close-up flash techniques described on pages 114-15, large scale lighting nearly always has to be used for nocturnal wildlife. In a carefully positioned remote control set-up, as shown on pp. 128-9, lights can often be placed within a few metres of the subject, but otherwise you will have to use them at some distance and with a long-focus lens. With most films the distances at which you are likely to be able to work will probably be close to, or even beyond, the limits of normal portable flash units.

Spotting animals in the dark
Nocturnal animals have more efficient night vision than humans, so you are at a distinct disadvantage if you rely on your own senses. Nevertheless, to use your eyes as efficiently as possible wait at least 20 minutes for them to become fully dark-adapted, and use your peripheral vision to look for movement rather than shapes. Your retina uses two types of light-sensitive cell – rods and cones – and the rods, which are more sensitive in poor light, are more concentrated away from the centre of vision.

Avoid looking at bright lights, and remember to close your eyes briefly when you trigger a flash unit. By closing one eye when shining a torch (flashlight), you can preserve some night vision. A torch used for spotting has two special advantages: in many animals it produces very strong eyeshine (reflection from the retina) that is visible long before the animal itself can be seen; and it also often has a mesmerizing effect on the animal.

An alternative spotting system is an image intensifier. This device amplifies existing light so that even a modest amount of starlight is sufficient to give a fairly clear view. The image is monochromatic and usually greenish in color but unfortunately still of such poor quality that it is not really satisfactory to adapt to still photography. For viewing, however, it is useful, if expensive. Another, more cumbersome, system uses an infra-red beam and sensor.

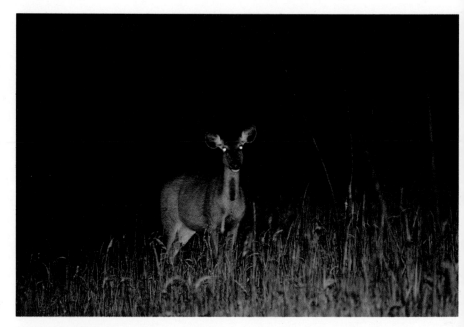

A spotlight held this deer partially mesmerized and concealed the photographer's approach.

Focusing in the dark

SLR viewing screens dim the image, which is normally no disadvantage in daylight, but in the dark may prevent you from focusing a sharp image of an animal that you can see directly. A torch (flashlight) is one answer, although it might scare off some animals; the eyeshine is usually the easiest thing on which to focus. To leave your hands free, tape the torch to the lens or flash bracket.

From a hide (blind), either focus the lens in daylight on a particular place where you expect an animal to appear, or else note the distances of different locations during the day and then use a small torch to adjust the focus by the scale marked on the lens.

The shutter speed, once it has been set to flash synchronization, needs no change, but the aperture ring on the lens can be, altered in the dark by counting the click stops.

Lighting

Although car headlights or a spotlight powered by the vehicle's battery can be used with fast film, they are not very effective at a distance. The best lighting is the most powerful portable flash unit that you can find.

Published guide numbers for flash units are not always reliable, and in open spaces at night are likely to be optimistic. Test your equipment beforehand, using the procedure on page 37. When stalking, you may find that you have no time to keep checking the distance and aperture. In an emergency, shoot anyway, and then note the distance on the lens scale. Later, test the flash on another roll of film, using a person as a substitute for the original subject, at exactly the same distance and with the same flash and aperture settings. When this test shot has been developed, you can decide whether the original roll needs altered processing (see pages 44-5).

Nevertheless, there are likely to be a number of situations where a regular flash unit used on the camera is still not powerful enough. At a hide (blind), one answer is to move the flash unit closer to where the animals are likely to appear, and trigger it with an extension lead or photo-cell, as shown on pages (128-9). Otherwise, a high-speed film may be necessary, despite the loss of image quality – with ISO 400 film a 2000 BCPS flash unit has a guide number of 200 (ft), and can be used up to 50 feet with a lens that opens up f4.

Tele–Flash

Some attachments are available for concentrating the light from a flash unit to an angle of view similar to that of a moderate long focus lens. By making more efficient use of the light tele-flash devices make it possible to work at greater distances than a normal flash unit would allow. One system, for example, uses a parabolic mirror and gives an effective improvement to a flash unit used with it of about three f-stops. Because the light is concentrated into a narow angle the flash and the camera lens need to be aligned very carefully. For an accurate check, look through

the viewfinder at the same time as triggering the flash manually – when everything is correctly adjusted, you should see the light centred in the focusing screen.

Infra-red

A radical alternative, but one that only allows black-and-white photography, is to use High Speed Infra-red film with an infra-red flash. The technique is straightforward: simply tape a visually opaque filter, such as a Kodak Wratten 87 over the flash unit. This hides the light output of the flash from even the most acute and wary animal, but does not block the infra-red radiation that exposes the film. In darkness, there is no need to use a filter over the lens.

Photographing Birds in Flight

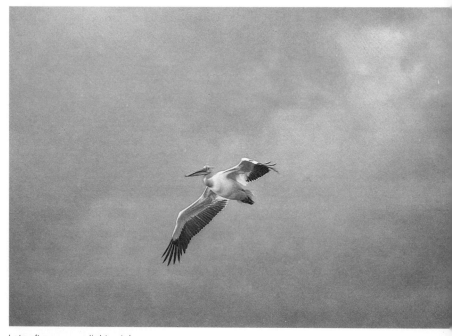

Late afternoon sunlight catches
a white pelican flying against
approaching storm clouds.

When flying, birds make good active subjects for the camera, but they are not easy to photograph. There are, certainly, few creative problems, but it takes practice to produce even a technically efficient shot. The two principal ways of losing a picture are very basic: soft focus and incorrect exposure.

It is only worth attempting to photograph a bird in flight if you can produce a reasonably large image of it, *and* freeze the wing beats. Large birds such as herons and storks are easiest, not only because of their size but also because they move relatively slowly. As a rule of thumb, try and make sure that the image of the bird, wing-tip to wing-tip, fills at least half the picture frame. With negative film, which can later be enlarged when printing, it may be possible to accept a smaller image but the greater the enlargement the more grainy and less sharp the picture will appear. Small birds have to be photographed so close, and at such

high speed, that very specialized triggering and lighting equipment is needed (see Close-up Photography, pages 118-9 and Remote Control, pages 132-3).

Unless you want to produce a streaked image for creative effect, use the fastest shutter speed possible, at least 1/250 sec. Although panning takes care of the bird's flight even at a slower speed, the wings easily appear blurred. In bright sunshine, a fine-grained film can still be used.

Viewpoint
The usual camera position is below the bird (although many sea-birds can be photographed from cliff-tops, looking down) but generally, the higher you can get, the better. Nesting sites usually offer the most reliable opportunities because the flight paths are regular, and can be checked. A nesting colony is even better.

Follow focus
Turn the focus ring slowly and steadily towards its closest setting, to match the approach of the bird.

Continuous re-focusing
Move the focus forward from infinity until the bird's image is sharp. Shoot, de-focus, and start again.

Mixed focus
Hold the focus still, closer than the bird, and wait. Allow the bird to fly into sharp focus.

Focusing

There are three focusing techniques, each with some advantages:

Follow-focus This method, in which you try to keep the bird in focus the whole time by turning the focusing ring at an exact rate, is the most ambitious – and the most difficult. In practice, the focus nearly always drifts, even when using the Novoflex pistol-grip system. Results that are slightly out of focus are common unless you practice frequently.

Continuous re-focusing With this method, the bird is focused several times as it approaches, but after each shot the lens is moved out of focus to start afresh. This makes each focusing attempt much more positive than trying to maintain a sharp image the whole time.

Fixed focus This is a one-shot technique with a high chance of success. The lens is focused ahead of the bird, which is then followed in the viewfinder. Without moving the focusing ring again it is fairly easy to anticipate the precise moment at which the image becomes sharp. As there are no reference points in the sky, focus first on the bird and then quickly re-focus nearer.

Exposure

Because the sky dominates pictures of birds in flight, it also influences meter readings and the TTL meter display in the viewfinder may be misleading. One solution is to take a reading from an average subject on the ground – or even from other similar birds if you are near a nesting colony. Another is to decide, quickly, how much lighter or darker than average you want the sky to appear – if you follow the meter reading, the result will be a mid-tone. As a guide, for an acceptable exposure, make the following adjustments to the reading, depending on the kind of sky background:

Photography from Vehicles

Although most vehicles are restricted to roads or tracks, and so offer a limited choice of viewpoints, they have the great advantage of being, in effect, mobile hides (blinds). For most animals, a vehicle, despite its noise, is much less of a threat than a human being on foot, and in places with regular traffic most of the local wildlife becomes accustomed to them. This is particularly noticeable in those wildlife sanctuaries where the only method of touring is by vehicle along established trails; many species will tolerate a remarkably close approach.

Ideally, a vehicle should be rugged, with high clearance as most wildlife locations have unpaved roads; high, so that it offers clear views over surrounding grass and undergrowth; roomy, so that equipment can be laid out ready for use, and equipped with all-round viewing through windows that can be opened fully (or better still, have a roof hatch).

Land Rovers, Jeeps and similar models are the best, provided that they are not crowded with passengers. In African game parks, the roof can usually be opened, and this gives not only a higher camera position but also a 3600° view which makes it possible to pan a moving animal and change direction quickly. Where the tracks are relatively good, two-wheel drive vehicles, such as VW Combis, also fitted with roof hatches, can be adequate.

In a number of game reserves that offer organised safaris, however, less satisfactory vehicles, such as small buses, are used. Although these make it possible for tour operators to carry a large number of visitors, they offer only second-rate conditions for photographers. If you have no alternative but to ride in one of these, try to use the front seat next to the driver: as well as being able to use the

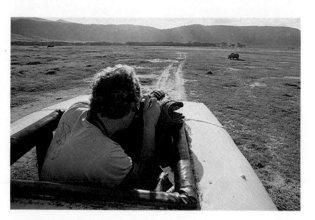

With large plains animals such as this black rhinoceros in Ngorongoro Crater, a vehicle is the only safe and practical means of photography. As close approach is likely either to be dangerous or to upset the animal (with the notable exception of lions), a telephoto lens is essential. Here, the photograph was taken through a roof hatch, and a jacket used as camera padding.

Typical safari vehicles have provision for shooting through a roof hatch. The extra elevation and all-round view that this gives makes it much better than a regular side window.

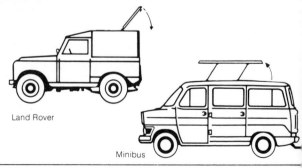

Land Rover

Minibus

near-side window you can, if necessary, lean over and shoot through the driver's window.

A vehicle appears least threatening to wildlife when it is either stationary or moving slowly, but starting, stopping, or obvious changes of engine tone can put animals to flight. So, when approaching an animal, it is better to roll to a stop with the engine switched off. Also anticipate the best viewpoint as you approach. Starting up again and reversing to avoid an intervening branch may scare the animal. In very well visited game reserves, however, the animals may be sufficiently familiar with vehicles for these precautions to be unnecessary. You may find it useful to brief your driver in advance about the techniques, thus avoiding frustration at critical moments!

Never leave the vehicle, for outside it you will immediately be identified as a threat. The window ledge of a Jeep is, in any case, an extremely good support for even the heaviest long lens, but use a thick cloth, towel or bean bag to avoid scratching the lens barrel. Purpose-built lens supports that attach to the

window or door are more convenient, but not greatly so. When shooting, switch off the engine and move about inside as little as possible, to avoid camera shake. If you can, darken the interior so that you are not, from the animal's point of view, silhouetted against the window behind you. The roll-down canvas sides in a Land Rover or Jeep are ideal.

If you have a driver, sit in the back of a Land Rover or Jeep so that you have access to both sides. In a tour bus the best position is the front seat, from where you can ask the driver to switch off the engine when you want to shoot. If you are driving yourself, you will only be able to use a long lens conveniently through the passenger window, unless you mount a special bracket on your door. The focal length of lens depends on the local conditions and types of species you are looking for, but ideally you should have two to hand – a very long focus lens for most situations, and a moderate, wide-aperture long focus lens (about 180mm on a 35mm camera) for a quick, close opportunities.

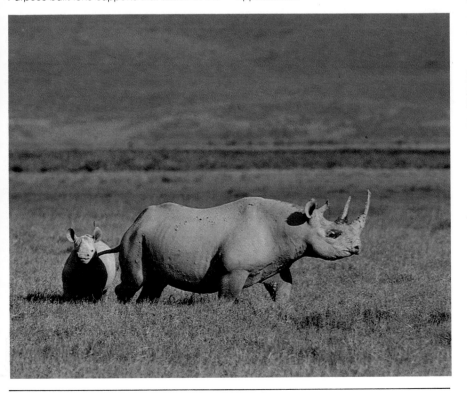

Photography from Boats

For photographing wildlife along water edges such as river banks, lake shores and sea cliffs, a boat often gives the clearest and closest views. Along deeply indented coastlines, estuaries and marshy areas, it may be the only practical means of transport. However, in many ways, a boat is far from ideal as a camera platform. Cameras have to be held by hand to avoid engine vibration, and even when the engine, if any, is switched off, waves make the boat unsteady. Also, it is highly visible and often noisy, and unless anchored or under power, it tends to drift with the current or wind. Manoeuvreing precisely is not easy, and so it is much better to have someone else steer rather than try and manage everything on your own.

Procedure

As with photography from other kinds of transportation, always check and prepare as much as possible before setting out.

Choose a place in the boat that gives the least restricted view forward, preferably with a surface on which to rest the camera. In most cases, this means the bow. Shelter equipment from possible spray, or wrap it in a waterproof bag.

A long lens is generally the most useful, as most animals will spot you easily at a distance and will eventually flee or dive as you approach. Either hold the camera by hand, or rest it on a soft, padded support. Whenever possible, switch off the engine before shooting, to avoid vibration.

On rivers, it is easier to approach by drifting silently downstream than by sailing under power upstream. Be prepared to take animals by surprise as you round a bend in the river.

Equipment

35mm SLR
Very long focus lens, 400mm or
 more
Moderate long focus lens, 135mm
 to 200mm
Wide-angle lens, 20mm to 28mm,
 for occasional scenic views
Ultra-violet filters
Soft padded support, such as a
 spare life-jacket
Plastic bags and rubber bands to
 protect equipment from spray
Waterproof camera bag
Slow or medium color film
Fast color film
Clean dry cloth to wipe equipment
Waterproof hooded jacket
Life-jacket
Camouflage netting

35mm SLR

U.V. filters

400mm lens

Wide-angle lens

Moderate telephoto

Slow or medium film

Fast film

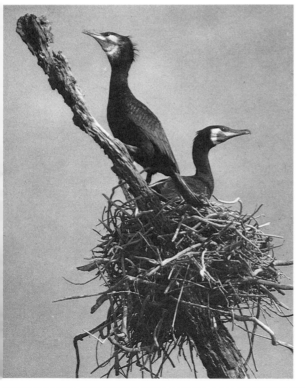

From small boats, all landscape
shots are essentially waterline
views. Because of this, there is
usually no choice but to place
the water horizon at the bottom
of the frame, particularly with a
telephoto lens (out-of-focus
water in the foreground adds
nothing to a picture). Look for
hills, trees, or interesting skies
as backgrounds. The lake in Sri
Lanka (far left) was a flooded
forest.

Boats are highly visible to
animals; when approaching,
start shooting early, as birds
may take flight at any moment.
Some species, such as these
great cormorants (left), are less
disturbed than others.

Photography from Aircraft

An hour's flight over an area of natural scenery, even though the hire may not be particularly cheap, is often a good investment in yielding strong images. It can provide a unique overall view of a habitat that you have already been photographing from ground level, and may offer unusual scenic details such as flowering trees and estuarine patterns, and occasionally shots of wildlife. Be careful, however, when photographing animals, not to fly so low that they are upset: in many conservation areas, overflying is restricted for just this reason. Generally, only large groups of animals make subjects large enough to fill the frame, even with a 200mm lens, which is about the longest focal length that can be used successfully from a light aircraft.

Problems

There are no unusual difficulties in aerial photography. Simply take the following precautions:

☐ Avoid vibration by *not* resting your arm or the camera on the aircraft body; by using a higher shutter speed (preferably 1/50 sec or faster); and by trottling back on the engine when shooting.

☐ Do not lean out of the aircraft – the airflow may tear the camera from your hands, quite apart from the other, more obvious, dangers.

Shooting angles in flight

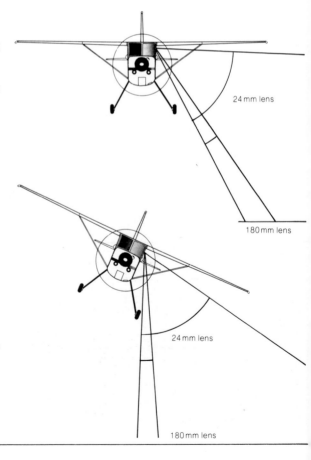

Level flight

Normal flying allows only diagonal shooting at a shallow angle, which is satisfactory for distant scenic views but not for close or graphic photographs. The shorter the focal length of the lens, the more restricted is the angle, as the wing tips and wheels mark the limits of view.

24mm lens

180mm lens

Banking

A steep shooting angle, even vertical in some instances, is the most generally useful – it gives good possibilities for composition and allows close approach. For this, the aircraft must be banked, and as this puts it into a turn, shooting may be limited to only a few seconds. One technique is to slip the aircraft sideways towards the subject, reducing the throttle to dampen vibration. The alternative is the circular flight pattern. For shots that include the horizon and sky, the aircraft must usually be banked *away*.

24mm lens

180mm lens

Banking the aircraft makes possible near-vertical shots such as this of a cinder cone in California's Lassen National Park.

Reduce the effects of haze by using an ultra-violet or polarizing filter, and by flying low with a wide-angle lens rather than high with a standard or long-focus lens.

Although the focus can be set at infinity with a wide-angle or standard lens, take more care with a long focus. lens, particularly as aircraft vibration can make focusing difficult

Preparation

Flying time is very expensive, so time spent planning the flight, briefing the pilot and preparing the aircraft and cameras always saves money. Basically, do as much as you can *before* take-off.

Mark the flight plan on a map, anticipating exact locations as much as possible.

Prepare a list of subjects that you are interest in, and show it to the pilot. Consider wide-angle views of the whole area, closer shots of special features such as waterfalls or lakes, and likely large wildlife.

Check with the pilot and airfield personnel what the weather conditions are likely to be. Generally, the best conditions for photography are a fairly low sun, clear air and minimum cloud. Either early morning or late afternoon may be better, depending on local weather.

Brief the pilot on the type of shots you want, and how you would like him to position the aircraft for them (see box).

Open windows, hatched or doors as necessary for an unrestricted view. Never shoot through glass or plastic. Adjust your seat and shooting position while still on the ground.

Lay out camera equipment so that it is secure but accessible.

Circling a subject

For a sequence of near-vertical shots of a single subject, such as a herd of animals, a tightly-banked circular pattern is best. In practice, however, it is not always easy to centre the circle over the subject, and the tendency is to place the *aircraft* over the subject. Discuss this with the pilot before take-off.

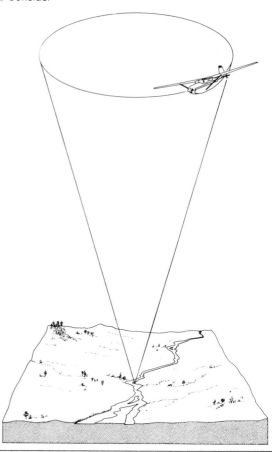

Types of aircraft

For general aerial photography, a high-winged single-engined aircraft like this is probably the best choice. Flying time is relatively inexpensive, the aircraft is manoeuvrable, and the view unrestricted. Retractable wheels are an additional advantage as they offer a wider view.

Larger, low-winged aircraft are generally more popular among pilots, and have the advantage of speed (useful if the airfield is distant from where you are going to shoot), but offer very limited visibility. The rear luggage hatch may be the only unrestricted camera position, and this is cramped. Hire costs are relatively high.

Although the most expensive to hire of all aircraft, large fast helicopters such as the Bell Jet Ranger offer the advantages of high speed to reach the subject without delay, great manoeuvrability, and a clear view. Cost is the only problem.

Light, twin-seater helicopters usually have very good visibility, and a complete door can generally be removed. Their slow speed may, however, limit time over the subject. All helicopters vibrate strongly when hovering, and slow forward flight gives less risk of camera shake. Avoid including the rotor blades in frame; although they appear blurred to the eye, a high shutter speed will record them on film quite clearly.

Photographic Equipment

Two 35mm SLRs
Strong camera straps
Motor drives (a distinct advantage)
Wide-angle lens, 20mm to 28mm, for scenic shots
Standard lens, preferably with a wide maximum aperture
Moderate long focus lens, between 135mm and 200mm, for details of scenery and wildlife.
Ultra-violet and polarizing filters
General purpose color film about ISO 64; 10-20 rolls for a flight of one or two hours (film use is always high in aerial photography)
Fast color film about ISO 400; two or three rolls, in case light fails
Map and marker
When flying in cold weather, warn jack and gloves (if severe, include down jacket, mittens and silk undergloves).

35 mm SLR

35 mm SLR — second body

Motor drive

UV and Polarizing filters

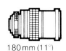
Gloves

20 mm 50 mm f2 180 mm (11°)

GP color film
Fast color film

Section 3: Habitats

The basic techniques of finding and photographing animals that have been dealt with so far are essentially a standard repertoire. Each location, however, still exerts its own distinctive influence on a field trip, and in the following pages a more intimate description of all the principal natural habitats will be found, with a special emphasis on the type of wildlife you can expect to see and how you can find it.

These short surveys also include a practical guide to the conditions that can affect photography – the type and intensity of lighting, for instance, and the special problems and opportunities of composing effective images. Within each habitat description is a recommended selection of equipment, based on practical experience, and a concise guide to taking good care of cameras, film and yourself in all likely conditions, from benign temperate woodland to extremes of cold and heat.

Grasslands

So much of the world's natural grassland has been converted to agriculture and grazing for domestic animals that very little remains in its original state. In addition, even the surviving grasslands have been so efficiently hunted that now it is virtually only the game reserves that have anything like their original complement of wildlife. Nevertheless, these limited areas, particularly in East Africa, offer some of the best opportunities anywhere for wildlife photography.

Although the term grassland sounds definitive, it covers a great variety of habitats, usually with no obvious lines of demarcation. Only a few natural grasslands are bare of trees and shrubs, and close to the conditions that allow true forests to grow it is difficult to distinguish between wooded grassland and open woodland containing grass cover. Most of the savannah grassland of the tropics is intermingled with trees, either scattered or clumped together in thickets, while temperate grassland of the middle latitudes is more likely to be treeless. In both savannahs and temperate grasslands, however, streams and waterways are often lined with riverine forest. Also the grasses themselves, although appearing similar at a casual glance, vary enormously. There are long and short grasses, species that clump together in tufts, and others that are favoured by certain animals and so affect the distribution of wildlife. All in all, grasslands are more complex environments than might at first be imagined.

Basically, grasses grow where trees cannot. Where the soil and climate are favourable to trees, forest usually predominates, and while grasses can usually grow in the same conditions, the trees tend to stifle competition, cutting off the light and taking up nutrition from the soil. However, trees generally need good drainage, a moist sub-soil and freedom from strong winds, and so where the land tends to be flat or only slightly undulating, and the rainfall is light and seasonal, grasses have a better chance of thriving. When rainfall becomes too light even for grasses, desert takes over.

Because there are many types of grassland, from long-grass prairies to acacia-dotted savannah or semi-desert scrub, useful generalizations are limited. However, most grassland country is flat or rolling, without strong relief, so that there are probably fewer opportunities for landscape photography than in other habitats. Against this, however, because visibility is good, and grazing animals often gather in herds, along with their predators, some protected grasslands are prime sites for wildlife photography.

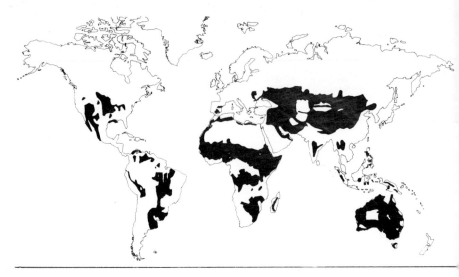

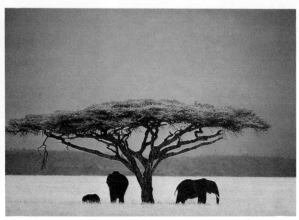

Although grassland differs so much that there is no single type example, these two views of the Serengeti in Tanzania are characteristic of much savannah grassland. The granite kopje (above) is important photographically, for the high viewpoint from such isolated rocks attracts predators such as lions.

In flatter grassland (below) isolated trees, such as this Acacia, provide shelter.

Grassland Wildlife

Grass is an accessible and fast-growing food, and covering the ground in a nearly continuous carpet can sustain bulky animals, such as bison, zebra and wildebeeste. From the point of view of photography, this means that many grazing animals are large enough to see, and photograph, at a considerable distance. Not only this, but grazers often gather in herds, which provide some good photographic opportunities, particularly for massed shots. In a habitat that has little protective cover, and where predators can spot potential prey easily, many species find safety in numbers. At any one time, a large herd has many pairs of eyes, ears and nostrils alert in all directions, and while most of its members have their heads down to the grass, there are always some checking the safety of the surroundings.

There is safety also in speed, and most large grass-eaters run to avoid danger. This often provides the chance for action photography, but it also puts the photographer on the same footing as a predator – needing stealth or speed in order to approach grazing animals. Predators, in different ways, have adopted chasing tactics to make kills: ambush techniques, which can work well in the closed environment of a forest, are rarely sufficient. The cheetah, which is a very well-adapted plains animal, hunts mainly by day, following a stealthy initial approach to within about 50 yards, with a running pursuit at speeds of up to 70mph (112kph). It cannot, however, maintain such a speed for more than about 400 yards. Lions, lacking the cheetah's great speed, often hunt in groups to restrict their prey's direction of

Grazing herds make good accessible subjects, but usually appear best from higher. Look for hills and outcrops, and use a telephoto lens. Where there is an annual migration, this is usually an impressive sight – these wildebeeste were moving west in early March in search of new grazing.

Where grassland supports herds, they in turn support large, fast predators. Kills are not so frequent that a visitor can expect to see or photograph one in a visit of only a week or two, but feeding lasts longer, and a full-grown wildebeest like this should last an average pride of lions at least one day.

light, sometimes using a pincer formation to attack a selected victim. As a result of these chase tactics, and because of the good visibility, there is usually a better, though still slim, chance of seeing a kill in grassland than elsewhere. Most animals tend to flee towards cover, where it exists, so that if there are thickets or riverine forest nearby, you may be able to anticipate which way the animals will run.

A concentrated herd of animals crops an area of grass quite severely, so grazers are constantly on the move. Because grassland climates tend to be seasonally dry, herds must also follow the new pasture that springs up immediately after rain and sometimes, as in the Serengeti in Tanzania, there is a definite annual migration from drier to wetter areas. In other places seasonal drought reduces the choice of watering places and animals that stay in the area during this season are forced to concentrate at certain times of the day in predictable locations. And, of course, where

grazers gather, so do their predators, so the dry season *may* be the best time to guarantee wildlife sightings. As always, however, local conditions are very variable and it is essential to check them in advance rather than make general assumptions. A further precaution should be borne in mind: it is not unusual in highly seasonal climates for the date of key events, such as the start of the rains, to vary greatly from year to year. Check this *before* departing on a special trip.

Another defence on open plains is to burrow out of trouble and many grassland animals shelter underground, either digging burrows themselves, as do prairie dogs and viscachas, or taking over exisiting holes, as do many of the mongooses. Animals that use burrows are often difficult to photograph by surprise as they usually stay close to holes and are likely to bolt underground at any sign of danger. However, shots of heads poking up just above ground level are usually not difficult.

Finally, some animals have few, if any, predators, and therefore have little reason either to seek the protection of a herd or to flee. Rhinoceros, for example, tend to be solitary and their reaction to threat is as likely to be attack as flight. Lions are particularly tolerant of close approach by a vehicle, and this is probably related to the confidence that comes from having no serious enemies.

Locating different species

Finding animals in open grassland is usually easier than in any other habitat, simply because there is less cover, and herds of large grazers are the most visible of all. However long grass and substantial tree cover can conceal quite large animals. For this reason, it is better to be able to look out over the plains from some height, and for this a vehicle, or even a horse, is an advantage. Also, as large, fast predators are not uncommon, walking in some grasslands is dangerous.

Mixed grassland often carries both grazer and browsers, and in each group, particular among the former, some animals are more specialized than others. Wildebeeste and zebra, for example, feed only on certain species of short grass, while giraffe favour the leaves of thorny acacias. In contrast, other animals are generalists, and species such a elephant, rhinoceros and buffalo can feed in wider range of habitats. Local advice or comprehensive field guide will give you some indication of where to look for particular species. Knowing the preferred prey for each predator also helps in finding them.

Streams, which provide both water and cover (in the form of trees and shrubs) are usually good sites for photography, and are particularly likely to be visited by animals late in the afternoon. Some predators that hunt less by chasing than by surprise, such as leopards keep close to such places.

Although generalization is risky, mos

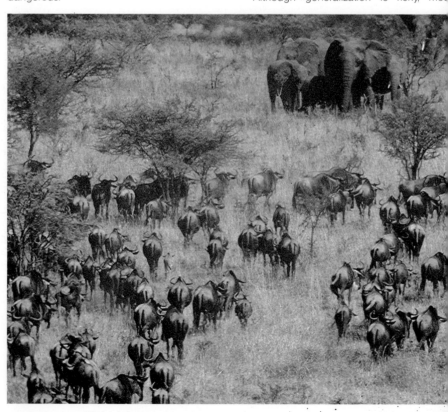

grassland predators, relying on keen sight, favour vantage points from which they can survey the landscape. Likely locations are trees and bushes (which also provide shade from the midday sun) on slightly higher ground, and elevated rocks such as the 'kopjes' in East Africa.

The most active times of day for many species are early morning and late afternoon, with the middle of the day reserved for resting or quiet browsing and grazing. In general, herefore, early and late are usually the most rewarding times for grassland photography, as hey are in most habitats. However, one special feature of grassland is that, because there is relatively little cover, finding animals is not much more difficult in the middle of the day han at other times. Finally, the grasslands – like other habitats – have their nocturnal residents. These *are* difficult subjects, and the only solution is to use the special techniques for night photography described on pages 130-1.

Approaching grassland animals

If finding animals in open grassland is relatively easy, getting close to them is often not. Most grassland species have senses that are efficient over a considerable distance and a vehicle, which can travel as fast as most running animals, is useful. However, the distance for photography depends to a large extent on the size of the animal, and with large grazers and browsers such as elephant, giraffe and rhinoceros, their safety zone (see pages 92-3) does not need to be breached if a powerful long-focus lens is used. Ease of approach depends on how familiar the animals are with human beings. In a well-visited game reserve, many animals will tolerate the close approach of a vehicle (though hardly ever of a person on foot). This tolerance varies among species; warthogs, for example, are usually noticeably shy, whereas lions will nearly always allow a vehicle to approach to within a few yards.

At the top of the grassland food ladder, large predators have little to fear. Lions in particular are usually easy to approach and give good opportunities for photographing details of family life. Here a Ngorongoro lioness suckles her cubs in the early morning.

Permanent water holes and rivers are likely sites for seeing wildlife. Hippo pools are always well-known locally. In photographically easy locations like this, look and wait for moments of interest rather than shoot when nothing is happening.

Photographic Conditions

Good visibility, and the lack of the large shaded areas that would be caused by strong relief and dense vegetation, are characteristic of most grasslands and remove many technical problems from photography. To offset this, it is usually difficult to maintain visual interest and variety in a landscape that is more featureless than most.

Plains light
Because of the typically low relief, most subjects in grassland are exposed to the full available light from the sky. While this does not make direct sunlight any more intense, it does increase the level of fill-in reflection from other parts of the sky, and so lowers contrast. On a cloudy day, the lighting is virtually shadowless. In general, plains light is more consistent than

in most other habitats and, because the horizon is low, lasts longer.

Through lack of familiarity it may be difficult to judge the light level without a meter particularly in tropical savannah where a high midday sun may seem brighter than it actually is. Close to the equator the sunlight is at its brightest by about 9.00 in the morning and stays at that level until about 3.00 in the afternoon. Consequently, as there is usually little shade, the exposure setting normally needs little adjustment except for very early and late in the day. In panning a running animal, for example, you are less likely to need to alter the shutter speed or aperture than you would if shooting in woodland.

However, the consistency of plains light can also make it monotonous, particularly when the

Any high point is valuable in grassland – use it to keep the horizon at the top, or to exclude it entirely. Here, a setting sun sharpened the details of a herd of antelopes walking in line. ►

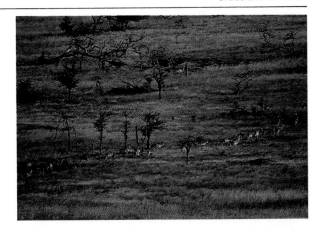

In a featureless setting, with neither an attractive sky nor foreground, backlighting adds visual interest to this flock of ostriches, outlining the feathers of each bird. ►

One answer to the problem of making an attractive composition with a flat horizon is to frame the image below it. Here, the backlit grass just before sunset is thrown out of focus by a powerful telephoto lens (600mm) and becomes simply a wash of colour. ◄

sun is high and the direction of the light is the same whichever way the camera is pointing. Photographically, early morning and late afternoon are particularly important times and these coincide, fortunately, with the times of greatest wildlife activity.

Overcast conditions create very flat lighting, and distant views can appear particularly dull. Generally, animals are much easier to see, and appear more prominently in photographs, in sunlight rather than under a cloudy sky. On a cloudy day, the sky is *much* brighter than the land (by a difference of up to 5 f-stops), and a landscape shot may benefit from using a neutral graduated filter to darken the sky area of the picture.

Local storms, such as those common in afternoons around the rainy seasons in the

tropics, can bring a welcome variety of lighting, particularly when the subject appears in sunlight against dark stormclouds.

Composition in a flat landscape

Interesting composition is difficult on flat grasslands. To capture the sense of spaciousness, a wide angle lens is helpful; and placing the horizon line low in the frame can convey the characteristic sensation that the sky dominates the scenery.

From ground level it is not easy to see much more than the foreground and middle distance, and any slight elevation helps. Even using the roof of a vehicle is a noticeable improvement. A slightly higher viewpoint also makes it possible to photograph animals without always having to include the horizon.

151

Choice of Equipment

In its effect on equipment, grassland is a moderate environment, and, particularly if you are using a vehicle, there are few special precautions you need to take. The great visibility gives many opportunities for shooting at a distance, and a very long focal length lens is the prime piece of equipment.

Photographic Equipment

Basic
35mm SLR
Spare meter batteries
Long-focus lens, 300mm to 500mm
Medium or slow color film (light levels are relatively high in open grassland), with some high-speed color film for dawn, dusk or stormy weather.
Ultra-violet filters to protect lenses from dust and reduce haze effects.

Optional
Two or three extra SLR bodies, loaded with the same film to avoid delays, or with high-speed or black-and-white film.
Motor drive with fresh batteries
Very long-focus lens, 600mm or greater
Medium long-focus lens, 135mm to 200mm, for close-range shots (such as of lions from a vehicle) and for middle-distance shots of very large animals (such as elephants).
Wide-angle lens, 28mm to 35mm, for scenic or establishing shots.
Spare light meter
Polarizing filters to reduce haze effects, although the need for high shutter speeds may prevent its use in action photography.
Felt-tip marker to identify films

35 mm SLR

UV Filters

Extra SLR bodies

Motor drive

Batteries

Medium or slow film

Extreme long-focus lens

Long focus lens

Medium Long-Focus lens

28 mm lens

35 mm lens

Light meter

Polarizing filter

Felt-tip marker

Camera care

Dust in the dry season is the most common problem, and is made even worse by vehicles. When moving to and from a location, keep all equipment in a sealed camera case. When you are ready to photograph, however, you will have to reconcile protection from dust with access to the cameras. One solution is to keep cameras individually in thin nylon or plastic bags. Fit *all* lenses with clear ultra-violet filters.

In a vehicle, follow the precautions outlined on pages 134-5. Never let the equipment rest against anything hard or sharp, and use padding liberally.

Gasket-sealed case

Field Equipment

Clothing

Unimportant in a vehicle, but otherwise wear soft boots or jogging shoes, comfortable walking clothes, and take a light anorak (except in the dry season). In savannah, avoid shorts because of ticks, thorns, etc, and take a hat as protection against tropical sun unless you are thoroughly acclimatized. Camouflage is less effective in open grassland than in woodland but avoid bright colors and contrasting tones; browns and greens are least noticeable.

Medical

Take sunburn cream, especially in savannah. Tropical grasslands often coincide with malarial areas: if so, take a full course of malaria prophylactic, starting a week before the visit. Check in advance whether there are other local infections and diseases, such as trypanosomiasis, and take necessary precautions.

Miscellaneous

Water bottle
General purpose knife
Map and compass
Notebook and pen

Water bottle

General purpose knife

Compass

Notebook and pen

The Temperate Woodlands

In temperate parts of the world the natural vegetation on well-drained land is woodland. Unlike the tropics, these regions, which include western Europe and the eastern United States, have marked seasons and so most of the trees are deciduous, dropping their leaves each winter and growing mainly in spring and summer.

Forests grow where they can, and are held back not by other plants but by low temperature, lack of water, and poor drainage. Cold winters and insufficiently warm summers mark the boundary in high latitudes, and also on mountains, while low rainfall, particularly in the summer when the trees need it for growth, holds them back from the centre of continents like North America, Asia and Australia. There is, however, a more potent limit than all of these – the one created by man's need for agricultural land. The climate of these temperate woodlands is one of the most congenial for us, just because it has no extremes of rainfall or temperature. The patchy distribution of deciduous forest today belies its original extent, and most woodland now survives as 'islands' in belts of farmland. Most of the large animals, too, have disappeared through hunting, giving a rather tame and park-like flavour to all but a few of these forests.

Nevertheless, the conversion of original woodland into fields has not driven away all the wild plants and animals, and in the older rural areas of Europe the traditional pattern of hedgerows, meadows and copses supports a full and rich population of ground plants, birds, insects and small mammals. Deciduous woodland is inherently full of variety, and the trees can be closely packed, allowing little sunlight to reach the forest floor, or more scattered and intermingled with grassland. The general appearance of woodland also depends on which tree species are dominant, in contrast to the coniferous forests of colder climates and the rainforests of the tropics where all trees seem very similar to each other at first glance. Deciduous trees can have very different and characteristic shapes. There is no mistaking oak, or birch or elm, and the different tree associations from woodland to woodland give each a tangible character.

There is a variety also in seasonal change. In these middle latitudes there is a great difference in the height of the sun and the length of day between summer and winter, and so woodland grows seasonally. The lengthening day and rising temperatures of spring trigger activity, and deciduous trees sprout new leaves to catch the sunlight. In autumn, these thin delicate leaves die and fall and through the winter the trees are dormant. Most other woodland life follows suit and the forests change dramatically in appearance, green, dense and full of life in summer, dull brown, open and quiet in winter.

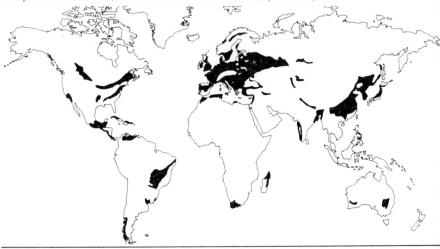

In woodland that is fairly open – such as in dells and copses – low sunlight in the early morning and later afternoon streams through the trees (above). Coherent views are often easier in such locations than in the denser heart of large forests.

From a distance, woodland makes simple, manageable compositions in misty conditions – not uncommon in fine weather at dawn. Look for hillsides that give a clear, high view.

155

Woodland Wildlife

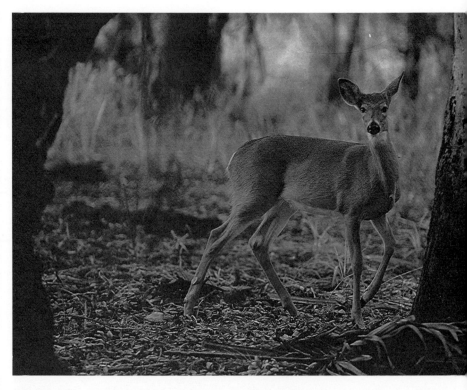

Despite being beleagured natural habitats, and having lost most of their large mammals, temperate woodlands are still rich environments for nature photography, containing a large variety of plant and animal life. The fundamental reason for this is that trees create a number of different habitats, at different heights above the ground yet all in one place. At the top, where most of the leaves grow to trap sunlight, is a flimsy lattice of thin branches. Lower down, the plain, bark-covered trunks provide another food source. Closer to the ground, where less light filters down, bushes and shrubs grow, while on the woodland floor, undergrowth mingles with all the litter that falls down from the higher levels. Because of these different layers, each with its own characteristics, there is less direct competition for food among the animals than there is in a simpler habitat such as grassland.

Instead there are many niches, and most woodland life has evolved so that it specializes.

As a general rule, the woodland edges and glades have a greater variety of animal life because more sunlight reaches the ground during the growing season, allowing more ground plants to thrive.

Finding mammals

Where protected, deer are common and not particularly difficult to find and photograph. In North America the main species is the white-tailed deer, a browser that is most active in mornings and evenings. In Europe, the most visible species is the roe deer. When not disturbed, deer may be active by day as well as by night (red deer and fallow deer are basically nocturnal). Stalking is likely to be more successful than using a hide (blind), as deer move around a fair amount.

Larger mammals, such as elk, are found

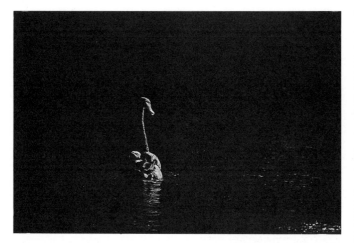

Although light levels are low at these times, early morning and evening are good times for stalking woodland mammals. By moving quietly and using tree trunks for cover, it is by no means difficult to approach to within a few yards of animals like this white-tail. In a situation like this, when the animal has been alerted, there is likely to be time for only one shot.

The forested edges of pools, lakes and rivers are usually worth patrolling for wildlife, for mammals and for water-birds. Brighter lighting makes it possible to photograph here earlier and later than in the middle of the woodland.

more in coniferous forests to the north, with one or two local exceptions (such as european bison in the Bialowieza forest in Poland). Most medium-size mammals, such as badger, wild boar, fox and marten, are both extremely wary and mainly nocturnal; the most reliable method of photographing them is by finding their shelters and using a hide (blind) or remote control arrangement at night, but this is always difficult. Early morning stalking is occasionally successful, but needs luck.

Most small mammals are also shy and nocturnal, though hares and rabbits may be seen during the day. Squirrels are active throughout the day but tend to live in the thicker parts of the forest and move fast, so that high-speed film is usually needed.

Finding birds
Woodland birds are more visible and abundant than mammals but because most are relatively small they are difficult to approach close enough for a large image in the viewfinder. On the whole, hide (blind) photography is more successful than stalking.

The woodland bird population is divided into groups living at different levels. In the highest – the canopy – small insect-eaters such as the tits are common, and this layer is also patrolled above by raptors such as sparrowhawks. Below this level, the tree trunks are the province of bark-feeding insect-eaters such as woodpeckers, nuthatches and tree-creepers. In the shrub layer, even lower, the profusion of berries attracts birds such as finches and thrushes, while the undergrowth and ground levels are inhabited by foragers such as wrens and nightingales, and by blackbirds and others that eat earthworms.

157

Woodland Invertebrate Life

If the larger woodland animals are difficult and frustrating to photograph, small-scale wildlife is abundant and presents less problems. Insects, spiders and other invertebrates are common and varied because there is such a variety of suitable habitats within the forest. In particular, the heavy forest litter on the ground – leaves, branches, fallen fruit and dead trees – is a major source of food and shelter and is, on the whole, the most rewarding place to search. Ants, beetles and wingless insects make up most of this population. For bees, butterflies and other insects that help in pollination, the heads of nectar-bearing flowers like snapdragon and honeysuckle are good sites to investigate.

The greatest abundance of insects is in high summer, and most are active during the heat of the day. Keeping sufficient depth of field for a sharp image of the entire insect is probably the main technical problem, and the usual answer is to use a portable flash unit, as described on pages 114-17. Occasionally, however, there are situations where you can work by daylight alone – opportunities not to be missed as they provide a chance for a variety of naturally lit shots that can make a welcome change from the conventional and predictable character of flash lighting. One such opportunity is very early in the morning, when insects are sluggish and can be photographed with a slow shutter speed. If the air is still, it is even possible to fit the camera to a tripod and make exposures of around one second. Of course, the very inactivity may be a little dull.

Another opportunity is by silhouetting the subject against the sun or its reflections. This can be particularly successful with a spider on its web, or with any insect that is clearly outlined on a leaf or stem. In either case – slow shutter speed or backlighting – the larger the insect, the less magnification is needed and the less of a problem depth of field is. With most insects,

Backlit dew defines the structure of a spider's web against a shadowed background.

you can make the most of what depth of field you have by shooting side-on to its body.

For most insects a thorough search among forest litter, in cool damp places under rocks and wood, on bark, and on the undersides of leaves is as successful a technique as any. Butterflies, however, are not very approachable and baiting may be better, using a 'sugar' mixture painted on, say, a tree trunk (see pages 126-7). This is likely to yield better results in clearings and at the edges of woodland than in dense forest.

An alternative to photographing insects in woodland is to collect them and later photograph them in controlled conditions, such as in a studio or at home. Use a net to catch flying insects and for sweeping vegetation, or a cloth tray held underneath leaves and branches that are then beaten with a stick. Take appropriate vegetation home with you if you intend to reconstruct the habitat realistically.

A slow-moving spider at 1/30 sec in natural light

Photographing into the early morning sun silhouettes a caddis fly.

Flowers and Fungi

With so much vertical growth and with a seasonal leaf fall, the soil receives ample nutrients from decomposed litter. In clearings and around the forest edges where sunlight can reach, ground plants are common, and open woodland often has a profusion of flowers in the spring and summer. Even more characteristic of the forest floor are fungi, which feed on decaying organic matter, breaking it down into simpler chemicals that plants can use. Some of the largest and most spectacular fungi are woodland species specializing in breaking down lignin from rotting wood. The best time to find fungi is autumn when there is most dead organic matter on the ground.

Photographically, flowers, mushrooms and toadstools are similar subjects – their size and location calls for a similar approach. Individual portraits fall within the range of close-up photography, and need the techniques described on pages 110-19, but being relatively static subjects they are, on the whole, easier than insects. Rather than photograph the first specimen you find, look for others that may be in better condition or in more attractive settings.

Lighting

Except when wind reaches the forest floor (and the trees usually provide sufficient shelter), flowers and fungi stay still enough to be photographed by natural light, even using quite long exposures. Nevertheless, dense forests are often quite dark, and flash photography is an alternative.

Both shade and shafts of direct sunlight can be attractive natural lighting effects. One of the special advantages of shade is that the low contrast simplifies the image and gives good color saturation. If necessary, use a card to shade the flower, but beware of the clear blue sky at the edge of the forest – it will give a pronounced color cast (see pages 34-5). Also, a white card or piece of silver foil can be used in sunshine to fill in shadows.

Flash lighting is often most successful when it imitates direct sunlight. To do this, hold the flash *over* the subject rather than mount it

With larger fungi, it may be possible to show something of the surroundings in the same shot. A 20mm wide-angle lens was used for the photograph at left of bracket fungus, to include some of the riverbank background.

Rotting wood on the forest floor is the prime site for most woodland fungi (above). The lighting is usually very dim, calling for a tripod and long exposures (one second or more) under natural lighting.

Low plants with long runners, like the wild strawberry above, may make more effective compositions when photographed from directly above. If so, full depth of field throughout the picture is important.

on the camera. For extra realism, calculate the exposure so that some of the background, in daylight, is also recorded (to be safe, bracket exposures). A sheet of tracing paper, white cloth or a diffusing umbrella (the kind used in studio photography) can be used to diffuse the light from the flash unit for a gentler, less intense, effect.

Depth of Field

For a clear documentary portrait a relatively small aperture is essential, and this, in natural light, will mean a slow shutter speed. A low tripod position or an alternative ground-level support is then virtually mandatory. If the background and foreground also appear sharp, the picture may appear confused; an unobstructed foreground and distant background help to isolate the image.

The shape of most flower heads is deep, and at very close range complete sharpness may not be possible. In this case, move back and re-compose. At slow shutter speeds even a slight breeze will cause blurring – so use a

piece of card, a jacket or your body as a windbreak.

An alternative, impressionistic, approach is to use a wide aperture for shallow depth of field and an image which relies on a blurred mixing of out-of-focus colors.

Composition

Generally, flowers and fungi can be photographed at three different scales: as standard portraits, nearly filling the frame; in extreme close-up, concentrating on details, or as components in a small landscape, shot from a distance.

The viewpoint chosen depends on the species, but a low camera position is often useful. Intervening blades of grass and debris can be cleared or bent back out of view. Backgrounds are usually best when simplest, and the further they are behind the subject, the less sharp and distracting they will appear. A long-focus lens enhances this effect. Small alterations to the camera position can change the background radically.

Photographic Conditions

The variety that is the keynote of life in deciduous woodland is mirrored in its appearance, particularly if the copses and hedgerows of traditional farmland are included. The lack of large exciting mammals is in many ways compensated by the possibility of so many different views within even a small area of woodland; landscapes on an intimate scale under lighting that changes greatly with the weather and the season.

Summer shade and pools of light

That there are so many different small habitats in temperate woodland makes it difficult to predict general lighting conditions, but when the trees are in leaf, the shade deep inside most forests poses something of a problem for stalking active animals. A tall, well-established beech wood, for example, lets so little light reach the ground that even on a sunny day exposures of around 1/60 sec at f 2.8 are likely with I S0 64 film, and high-speed film may be necessary with a typical moderate telephoto lens that has a maximum aperture of about f2.8 or f4.

When the canopy is thin and sunlight does break through, contrast is likely to be very high in summer. Although shafts of sunlight can be welcome when they pick out just the right subject – a small clump of bluebells, for instance, or a deer emerging from a thicket – when it simply dapples the scene in front of the camera indiscriminately it may just spoil the image, especially with transparency film which has little latitude. Visually, woodlands are in any case quite complex, with branches and leaves making intricate shapes, and harsh lighting adds to the confusion. The range of brightness in these conditions can be as high as 6-f stops.

Small-scale subjects such as flowers can be shaded to make the lighting more even, but with overall views it may be better to wait until late afternoon or early next morning when the low angle of the sun picks out the sides of tree trunks and can be attractive rather than confusing. With telephoto shots of animals, be prepared for rapid changes in the exposure setting (see pages 94-5). Cloudy-bright weather and hazy sunlight are the easiest conditions, and give simpler images.

The seasons affect woodland light greatly. Although the winter sun is low, the trees are

Shade on the forest floor is darker in the summer, because of the leaf canopy. This portrait of a small geranium needed ¼ sec at f11 on ISO 64 film.

bare of leaves, so that the light levels in a typical deciduous forest may be only about 2 or 3 f stops less than under an open sky. Also the general coloring changes, from predominantly green in late spring and summer, to yellows, reds and rich browns in autumn (the most intense colors occur with extremes of temperature – cold nights and hot days), – and then to dull browns and greys in winter. However, unlike rainforest, none of these colors permeates so thoroughly as to call for filter correction.

Within any season the light is likely to be changeable because temperate woodlands are generally in climates that have

For overall views of a complex
woodland interior, the weaker
light from a hazy or low sun is
likely to be better than that from
a bright midday sun.

unpredictable weather. This is especially true
of western Europe.

Enclosed spaces and complex settings

For all but close-up views, where the
surroundings are less obvious, composing
woodland photographs generally involves
finding clear viewpoints and simplifying the
image. The mass of branches, trunks and
leaves can make confusing patterns *and* get in
the way of middle-distance shots. When
stalking, tree trunks and undergrowth offer
good protection from the view of an animal you
are approaching, but they can also intrude on
the picture and careful side-stepping may be

necessary.

The depth of most woodland views is great
– too much, in fact, for the depth of field of most
long-focus lenses even when used at a small
aperture. In a shot of an animal, great depth of
field is seldom important, but in a scenic view it
usually is. Wide-angle lenses remove the
problem, but to use a long-focus lens for a
scenic photograph some clear foreground is
usually needed, so look for glades, ponds and
firebreaks.

Clearings also help to simplify the view, as
do any conditions that separate the scene into
zones, such as mist and fog. Hilly areas usually
offer the most choice of viewpoint.

Choice of Equipment

Unless you have a special interest in one species or type of subject, woodlands are essentially places for general photography. There are likely to be few large animals, and a typical photographic nature walk will probably yield more plants, flowers, insects and small-scale landscapes than anything else. Close-up equipment and a small tripod add to the weight of a shoulder bag, but are valuable accessories.

Photographic Equipment
Basic
35mm SLR
Spare meter batteries
Moderate long-focus lens of about 135mm to 200mm with a wide maximum aperture (for deer and other medium-sized animals).
Macro lens for insects, flowers and fungi. A longer focal length makes it unnecessary to approach insects very closely. 100mm to 200mm is a useful length.
Wide-angle lens for scenic views inside woodland.
Medium-speed color film (ISO 64 to ISO 100) for most work, with high-speed (ISO 200 to ISO 400) for stalking in dense interiors of woods.
Ultra-violet filters to protect lenses
Small tripod
Extension rings for extreme close-ups.
Electronic flash unit and close-up bracket
Cable release

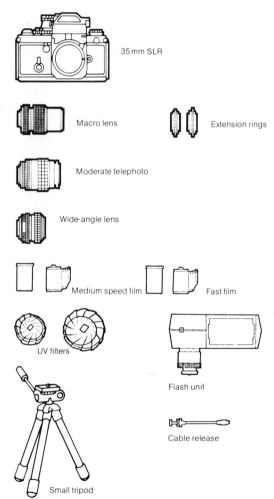

35mm SLR

Macro lens

Extension rings

Moderate telephoto

Wide-angle lens

Medium speed film

Fast film

UV filters

Flash unit

Cable release

Small tripod

Optional
Extra 35mm SLR body loaded with
ISO 400 film (main body has
ISO 64 to ISO 100 film)
Long focus lens, 300 to 500mm
Spare light meter
Felt-tip marker to identify films

Extra camera body

Long-focus lens

Light meter

Marker

Camera care
These are some of the mildest
conditions likely to be found in
nature photography but
nevertheless take the basic
precautions of protecting
equipment from knocks and
scrapes, and from showers. A
padded, waterproof shoulder bag
is sufficient.

Shoulder bag

Field Equipment
Clothing
No special requirements beyond
comfortable walking clothes and
soft boots or jogging shoes. Take a
light waterproof anorak in case of
rain.
Medical
No special precautions unless
you are setting off on a long hike, in
which case take the minimum first
aid kit described on pages 90-1.
Miscellaneous
Water bottle for long trips. General
purpose knife. Map and compass
(for use in thick, extensive forest).
Notebook and pen.

Water bottle

General purpose knife

Notebook and pen

Compass

The Northern Forests

Where the climate is colder and the sunlight less intense, the character of forests changes sharply. In order to capture as much of the sun's energy as possible, the successful trees of the northern forests do not shed their leaves seasonally but instead are evergreen. Also, by being narrow and pointed in shape, rather than broad-topped as in deciduous woodland, these evergreen trees see more of the sun when it is low in the sky, as it is for much of the year in high latitudes. The large numbers of needle-like leaves are so efficient at catching sunlight that the floor of a coniferous forest is noticeably dark.

Green plants have little chance under these conditions, and a typical pine forest is virtually free of undergrowth. There is usually only a thick carpet of pine needles that decompose only very slowly in the low temperature. The lack of variety in the plant life has its effect on the animal population, which is sparse compared with the diversity of wildlife in deciduous woods. There are far fewer species, and smaller numbers of those that are present.

Nevertheless, evergreen coniferous forests, or 'taiga' as they are sometimes called, are an important wildlife habitat because they cover such vast areas, mainly of Canada and the northern United States, Scandinavia, and the north of the Soviet Union. They also dominate many mountain ranges in lower latitudes up to the tree-line. These evergreen forests have survived on such a scale because the climate with its harsh winters, has not attracted man to any great extent. Paradoxically, there are more large woodland animals such as elk, moose and bear in these sparsely-populated forests than anywhere else.

Photographic conditions

Much of the general advice given for temperate woodland applies equally to photography in northern forests. There is however, less variety in the landscape and this involves more work in searching for interesting subjects. The edges of these forests become even more important for the photographer, as it is here, where sunlight does reach, that plant insect and bird life is more abundant.

Photography deep inside pine forests is in any case difficult as light levels are extremely low. The density of tree trunks makes clear views hard to find, although the regular ranks can make interesting patterned images with a long focus lens.

Although the trees themselves do not change their appearance with the seasons most northern forests lie under snow in winter which helps to vary the conditions for photography.

Equipment

See pages 164-5. In winter, special clothing is essential; see pages 208-9.

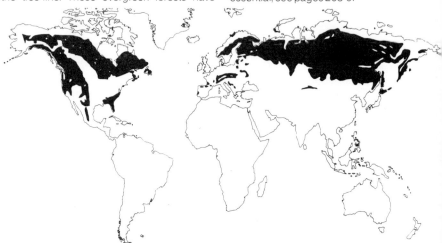

Generally, the most valuable areas for photography are where the forest is mixed with meadows. Here, as in this valley (above) in Glacier National Park in Montana, there is a greater variety of scenery and the light is sufficient for reasonable shutter speeds.

Large mammals, like this bull moose, are one of the special attractions of Northern forests. Most are *not* safe to approach closely.

The Tropical Rainforests

Just as weak sunlight and low temperatures limit the variety and abundance of life in the northern forests, the hothouse conditions of most equatorial lowlands produce forests at the other extreme, with a profusion of plant and animal life unmatched anywhere else in the world. Sunlight and moisture are the two essential ingredients for photosynthesis, and where these are abundant, the result is rainforest – a dense mass of tall hardwood trees that play host to even greater numbers of parasitic and epiphytic plants.

The largest of the world's rainforests is that of the Amazon basin, covering an area similar in size to the continental United States. Other major rainforests are in the Congo and in South -east Asia (including Malaysia, Indonesia, the Philippines and New Guinea). Similar

conditions on a smaller scale can also be found on many Caribbean islands.

At a casual glance, and from a distance, rainforests appear fairly uniform. All the major trees are broadleaved, with dense crowns and straight, plain trunks, while the tangle of creepers and lower vegetation hides any but the most obvious differences. But, in fact, one of the special characteristics of rainforest is the enormous variety of species; there may be as many as 40 different types of tree in one acre – nearly always intermingled. There are virtually no stands of a single species as there are in temperate woodland. This profusion of tree species provides the foundation for the variety in every other area of rainforest life.

The general shape of rainforest is made distinctive by its great height. Deciduous

A Three-dimensional world

This cut-away view of a typical primary rainforest shows what can hardly ever be seen from inside – it is arranged in vertical layers. These vary from forest to forest, but generally include two main bands of tree-tops, one of them often continuous; a lower tier of young trees and, where enough light can reach the ground, some shrubs and undergrowth. Apart from the banks of rivers and streams, however, and the occasional clearing where a large tree has fallen, the ground is so shaded by the upper canopy that very little grows, and the forest floor is usually uncluttered. Wildlife follows the plants, and many animals and birds live in distinct layers, most of them in the trees.

Trees in fruit attract monkeys and birds such as toucans, hornbills and parrots

Epiphytes including orchids

Buttress

woodland has a few identifiable layers from ground level to canopy, but rainforest is multi-storied; life and conditions at different levels are quite different. The upper canopy layer is typically 100 feet above the ground, with occasional forest giants towering above this, and between here and the forest floor are distinct habitats, arranged vertically.

Rainforest trees are very efficient at gathering sunlight, forming a canopy of leaves that is often continuous and which, unlike deciduous woodland, remains unbroken throughout the year. As there are virtually no seasons the vegetation is evergreen, as a result very little light ever reaches the ground which is relatively open and free of undergrowth. This seems contrary to the popular view, but only because most visitors see no more than the edges of rainforest, which are thickly entangled. Instead of using the soil, many plants feed off the sap of trees or trail aerial roots to collect airborne moisture.

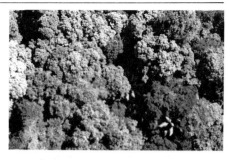

The unbroken canopy
From the air, only the upper canopy layers are usually visible; the ground remains hidden, and even some streams are concealed. Although at first glance the types of tree appear similar, there are generally far more species in a given area than in temperate forests.

The canopy layer and forest giants usually contain more animals and birds than temperate forests, animals include monkeys, bats, sloths, anteaters, cats and mustelids.

Ground-dwelling animals include cats (though these can usually climb), hoofed animals such as deer, wild pig, tapir, and many rodents. A few birds, such as jungle fowl, also live here.

Large birds of prey, such as eagles, soar over the canopy layer looking for tree-dwelling prey.

Woodpeckers are often visible because many tree trunks are smooth.

Ground plants and undergrowth around streams and forest clearings.

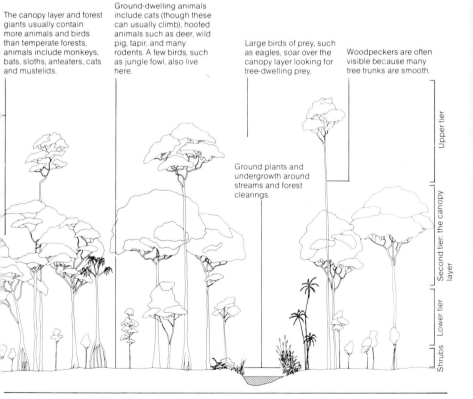

Upper tier

Second tier: the canopy layer

Lower tier

Shrubs

Rainforest Wildlife

The profusion of wildlife in tropical rainforest is unparalleled, and is due mainly to a combination of the sheer variety of living space and the exuberant plant growth. The physical framework, with its distinct layers, provides many different living conditions and the large numbers of plant species offer a great choice of diets. As a result, the animal population, at all levels, has evolved to fill these niches.

Most rainforest animals are specialists, avoiding direct competition for food. For example, five New World monkeys that are often found in the same area of forest are the howler, spider, capuchin, tamarin and night monkeys. All eat fruit, but by specializing they divide the food resource of the forest rather than fight for it. The howler eats more foliage than the spider monkey, and the capuchin extends its diet to include insects and small vertebrates, while the tamarin concentrates even more on insects and the night monkey, with essentially the same diet as the capuchin, feeds at night.

In habits and appearance, all groups of animals show enormous diversity, which for photography is one of the rainforest's great attractions. Most, however, have arboreal skills and are adapted for climbing, hopping or

As in temperate woodland, water margins are often good places to see wildlife. Rainfall is always high, so that where drainage is poor in low-lying forest, swamps and brackish pools are likely, often inhabited by cayman (left) alligators or crocodiles, together with turtles, water snakes, otters, among others.

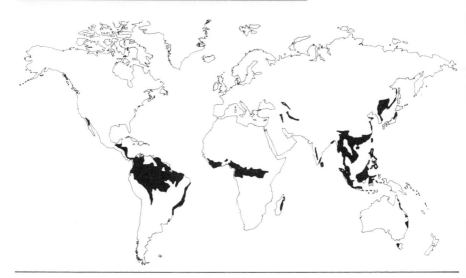

jumping between branches. Most forest birds have short stubby wings that give them great manoeuvrability in the restricted spaces of the canopy.

Finding rainforest animals

For a number of reasons it is difficult to catch even a glimpse of most rainforest animals above the scale of insects, despite the richness and complexity of the wildlife. Few animals live on the forest floor, for the basic reason that food there is relatively scarce and not particularly nutritious. Ground-plants and shrubs are uncommon; grasses almost non-existent, and fallen fruit decomposes quickly in the high temperature and humidity. As a result, ground-dwellers tend to be small, few in number, and mainly solitary. There are three groups: medium-sized browsers such as the tapir and bongo; terrestrial rodents like the agouti and elephant shrew; andsuch as the leopard and margay. None, however, are numerous.

Life is more abundant higher up, but is correspondingly more difficult to reach. The densest of all the micro-environments in the forest is the upper canopy – an interlocking mass of branches and leaves – and most of the birds and small animals are concentrated here. Some descend to lower layers in search of food, but the majority spend their entire lives without touching the ground.

The underlying behaviour of most rainforest animals adds to the difficulty of seeing them, for in this closed environment the best means of protection, either from attack or from discovery when stalking prey, are stealth and camouflage. Most animals, and particularly the mammals, move quickly and secretively, and many have markings that help them to blend in with their surroundings. Cryptic coloring is especially common, and animals like the okapi, jaguar and Malayan tapir have strong, high-contrast patterns that break up their shape against the uneven background of trunks, branches and vegetation.

The exceptions to this secretive way of life are generally found at higher levels and include some of the primates, such as squirrel monkeys and gibbons that move in noisy troops, and many brightly-colored birds, especially fruit-eaters such as parrots, toucans and hornbills. Stalking these more obvious animals is often possible by following the noise they make and by searching for fruit-bearing trees.

The best general sites to find many rainforest animals are the forest edges and close to river banks, where they are more visible. Where rainforest is interspersed with grassland, water holes and salt licks may be good sites for hides (blinds), and the advice of local guides is essential. Large carnivores can be attracted to hides (blinds), and for serious photography of animals living in the upper canopy, a tree hide or pylon hide is the only answer, even though constructing one is no easy matter.

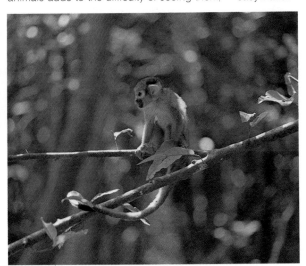

Most wildlife is arboreal, which sets obvious problems for photography. Occasionally, squirrel monkeys (left) and other species will descend to lower levels in search of food, but catching them at the right moment takes patience and some luck. A tree-hide is a painstaking alternative, suitable only if time is no problem.

Photographic Conditions

As most aspects of rainforest, from the size of tree to the variety of species, are on a larger scale than those of temperate woodland, many of the basic conditions of forest photography are exaggerated in the tropics. This is especially true of lighting.

Midday darkness in deep forest
In dense primary rainforest, the upper canopy of leaves effectively cuts off the ground from all direct light, and while this results in a fairly open forest floor that is quite easy for walking, it also creates light levels that are generally too low for hand-held photography with normal color films and most lenses. Even though midday tropical sunlight is extremely bright, as little as one four-thousandth of it may reach the ground – a difference of 12 stops. Forest floor photography with ISO 64 film may need exposures as long as one second at f2.8 even in the middle of the day, and although this is extreme, *typical* exposures are not likely to be shorter than 1/8 sec at f2.8. For tripod photography of trees, plants and other static subjects this is no problem, although you may have to allow for reciprocity failure (see pages 44-5). Wildlife subjects, however, need either flash on fast film, or both. Extreme cases, such as medium-sized animals stalked with a long focus lens, may even need a flash intensifier of the type described for night photography on pages 130-1. Occasionally, natural-light stalking is practical with ASA 400 film (possibly up-rated) and a fast long-focus lens (opening to about f2.8), if the animal is photographed as it pauses, but is uncertain situation you cannot rely on such marginal conditons.

One benefit of this deep forest gloom is that all the light is diffused and so contrast is low, which helps to resolve the tangle and complexity of tree trunks and leaves. However, because the light *is* diffused by vegetation it often has a green cast – not very pronounced as rainforest leaves are dark green in contrast to the bright hues of those in temperate forests – but noticeable even so. A warming filter, such as an 81 B or 10 Red, helps.

Sun flecks and shadows at forest edges
Not all rainforest is completely covered by the upper canopy. In lighter forest and at the edges and along river banks, some sunlight penetrates. These are often the most useful areas for wildlife photography but the contrast of light in the middle of the day is high. Sunflecks break the shade to give a dappled and sometimes dazzling view, and the contrast between light and shade is nearly always too high for film – typically eight stops. As a general rule expose for the bright areas, and look for images where the main subject of interest, such as a flower or animal, is completely sunlit so that you can ignore the shadows. For some scenic views it may be better to wait until later in the day when the sun is low and the sunflecks have disappeared.

Even with fast film, light conditions in dense primary forest are often marginal for photography. Stalking is particularly difficult, needing a long but light lens. This picture of a monkey was taken with a 400mm lens at 1/60 sec and f5.6 on ISO 400 film, and is more typical of conditions than the photograph on page 171.

One method of sorting out the visual tangle of most rainforest landscapes is to choose one distinctive tree as a focus of attention, and then to shoot directly upwards with a wide-angle lens.

Insects and Flowers

If mammals and birds are a genuine problem for photography in tropical rainforest, small-scale life is an easy and spectacular source of subjects. Insects and other invertebrates exist in such profusion that even on a casual walk there is no difficulty in finding many species. As in temperate woodland, the prime places to look are around rotting wood and among other debris on the forest floor, and on the leaves of shrubs.

The high temperatures and abundance of food make ideal conditions for insects, and this, together with the large number of separate niches, has led to the evolution of some very specialized and distinctive forms. Camouflage and mimicry are two of the most extreme kinds of adaptation, and are more highly developed and spectacular here than in any other kind of habitat. Look for mantids, katydids and stick insects that imitate vegetation, and also for insects that use strident colors and patterns (orange and red are common) as a warning that they are poisonous or unpalatable. Many non-poisonous species gain protection through having evolved to resemble some of these harmful species –often so well that you may not realize it yourself.

Sugar baits can be used (see pages 126-7),

Epiphytic orchids are a special feature of many rainforest areas, and although those growing in the upper canopy are generally inaccessible, many grow at lower levels. Full-length portraits are not the only treatment; the lavish decoration of many flowers lends itself to shallow-focus close-ups such as this (left).

or any of the collecting methods mentioned on pages 158-9, if you find it easier to photograph insects *after* a field trip, under more controlled conditions. For moths and other nocturnal insects, a white sheet draped around a lamp or powerful torch (flashlight) is a strong lure; the insects can be pulled off the sheet by hand.

As direct sunlight rarely penetrates to ground level, portable flash is usually essential. Use the techniques described on pages 114-17.

Flowers are less common than in temperate woodland but are often larger and gaudier. The dim light on the forest floor inhibits the growth of ground plants; most flowers are at higher levels, and are epiphytic – clinging to stems and branches. The most spectacular of these are the orchids whose flowering times depend on the species rather than the month as there are no distinct seasons in true rainforest. Use a long-focus lens and tripod for high-level epiphytic plants.

Fungi are very common around rotting wood and the roots and buttresses of living trees. Some large and bizarre forms thrive in the heat and moisture but may last only a few hours. For natural-light photography, use a tripod and time exposure.

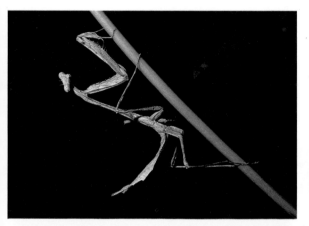

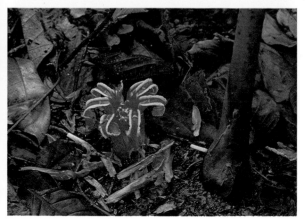

While flowers and fungi can be photographed in natural light with long exposures, insects usually need flash (the mantis, above left). Occasionally, however, shallow focus and daylight can be used effectively. as in the head-on view of a dragonfly (above right), photographed with a handheld macro lens at a magnification of 0.5x. A long-focal length lens, such as 200mm, has a greater working distance and so is less likely to scare insects.

Choice of Equipment

Insufficient light inside the forest demands fast film and fast lenses, while the additional light from an electronic flash is often also necessary. Typical conditions are rather severe on equipment, particularly over a period of several days. Heat and humidity together are the worst conditions for storing film. Without taking precautions, sensitivity, contrast and color balance may deteriorate noticeably in as little as two or three weeks. Also, the emulsion softens and and is more liable to scratching and marking, and fungus may form blemishes. Moisture can 'short' electrical circuitry in the camera body and corrode bright metal parts. Over a few weeks, fungus may even attack lens surfaces and if this happens they may have to be re-ground.

Camera and film care

As much as possible, keep everything sealed. Use dry cloths or towels to wipe down and wrap around equipment. A gasket-sealed metal camera case is ideal for equipment storage, as is an insulated picnic box for film. When out taking photographs use a waterproof shoulder bag, and use plastic bags sealed with rubber bands for individual items.

Use a dessicant such as silica gel crystals, kept in small metal containers with perforated lids, or in porous plastic or muslin bags. Paper indicators are available that are blue when dry and pink when saturated with moisture: store these with the equipment and film. Use one or two ounces or fresh silica gel for each 200 rolls of 35mm film out of their cans, wrapping them tightly in a plastic bag to exclude air. About six ounces will be effective in an average-sized, gasket-sealed camera case; the less air space, the less humidity. Regenerate silica gel when it is moisture-laden by heating it to 200 C (390 F) for two or three hours. Uncooked rice is an alternative to silica gel and is usually readily available in the tropics, but ten times the quantity is needed for the same drying effect. Never seal anything in humid air without silica gel. Do not put fungicides in storage containers – they can harm color film.

Keep equipment and film as cool as possible by avoiding direct sunlight (or wrapping in light-colored cloths) and by raising containers above ground level so that air can circulate around them. An insulated picnic box is useful, and can be buried about two feet underground for extra coolness. Bright reflective surfaces (white or metallic) are best for cases. If bags have become wet, dry them out in the sun at midday, when humidity is lowest and allow them to cool in the shade before re-packing. Only open factory-sealed cans of film just before use; and try to have exposed film processed with as little delay as possible.

Field Equipment

Clothing
There are two different approaches to dress in humid tropical conditions: protective and lightweight. Protective clothing can keep you relatively dry, limit insect bites and scratches from branches and thorns, but is also hot and cumbersome. Lightweight clothing is more airy and comfortable, but leaves you more vulnerable to bites, stings and scrapes. In heavy continuous rain, and in mud and stream beds, not even waterproof clothing will keep you dry so it may be better to wear as little as possible and keep some dry clothing wrapped in a plastic bag. The best protective clothing – hooded waterproof jacket, canvas and rubber boots etc. – is military. Shorts, T-shirt and light jogging shoes make good basic lightweight dress. Cottons absorb sweat and are more comfortable than synthetics. Where there is mud and steep slopes, use footwear with deeply moulded soles. A peaked rainproof cap is useful, and a head sweatband will prevent sweat from dripping onto the camera.

Medical
Use insect repellant cream or spray liberally. Never go barefoot: several burrowing parasites favour the soles of feet as point of entry. Take a tube of broad-spectrum anti-fungal cream or ointment and check your feet regularly for anything that looks like athlete's foot, and your body for rashes. Use anti-bacterial ointment on any wound and treat *all* bites, cuts and scratches promptly.

Leeches are active when it is wet. Deter them with insect repellant but if they have already started to climb your legs, *don't* try to pull them straight off: they may take some of your skin with them. Instead, apply more insect repellant, or hold a lit cigarette near them until they drop off. Camphorated ointment removes leeches quickly and applying salt or soap to them is also effective. Leech wounds bleed freely for some time.

Drink regularly, and take one salt tablet or teaspoon of salt for each pint of water.

Photographic Equipment

Basic

35mm SLR

Spare meter batteries

Moderate long-focus lens,
180mm to 300mm, with wide
maximum aperture for
photographing larger animals.

Macro lens for insects, small
reptiles, fungi and plants

Electronic flash unit(s) and close-
up bracket

Spare batteries for flash

Extension rings for extreme close-
ups

ISO 400 color film for deep forest
interiors, and medium speed
color film for flash photography
and for the higher light levels
around clearings and river
banks. 'Amateur' film may be
better than 'professional' film
over more than a few days (see
pages 40-1).

Ultra-violet filters to protect lenses,
and skylight filters to warm up
forest shadows.

Silica gel sachets

Neck and shoulder straps in
leather or cloth, to absorb sweat

Small tripod

35mm SLR

Macro lens Extension rings

Flash unit

Camera strap

Moderate long-focus lens

Fast & medium film

Silica gel

Dessicant

Small tripod

Optional

Extra SLR body loaded with
medium speed color film (main
body has ISO 400 film)

Motor drive with fresh batteries

Long-focus lens of between
400mm and 600mm if
conditions allow well-lit shots at
forest edges

Wide-angle lens, 20mm to 24mm,
for scene-setting shots of forest
interior.

Hand-held light meter

Felt-tip marker to identify films

Nikonos or other waterproof
camera

Miscellaneous

Water bottle

General purpose knife

Compass

Notebook and pen

Cloth or towel

Extra camera body

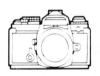

400mm lens

Nikonos

Motor drive

Wide-angle lens

Light meter

Marker

General purpose knife

Water bottle

Riverside, Estuary and Marsh

Where topography hinders drainage, chiefly in the lower reaches of slow rivers, and fringing flat coasts, the shallow lagoons, marshes and swamps that form are an important and rich habitat for wildlife. Less a product of climate than terrain, wetlands have in common sluggish drainage and a physical make-up that is neither completely water nor truly land, but a complex pattern of the two.

Most wetlands are in a state of slow transition, either gradually silting up and bein colonized by plants that bind the soil, becoming increasingly watery. The vegetatic varies greatly in character, from reed-bec fringing open lakes to a dense mat of gras and sedge or small stands of trees like cypres and alder that thrive in water-logged soil. some wetlands, such as the Florid Everglades, raised islands are dotted amon the marshes, supporting denser vegetatic

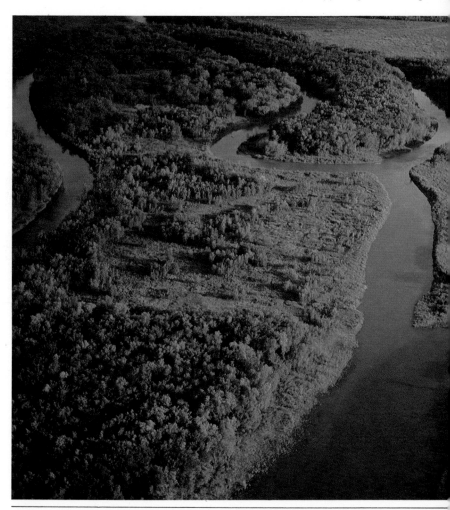

and an often richer concentration of wildlife.

Flat and low-lying, most wetlands are near the sea and at the ends of river systems so they are usually well-supplied, one way or another, with minerals and food materials. Large estuaries and deltas have zones that are fed from both directions – freshwater deposits from the river, and the twice-daily saltwater tide. Wetlands that are exclusively saltwater support a distinctive vegetation – plants that can survive where most cannot. The most spectacular of these is the mangrove, a tree that stands stilt-like on raised roots above the mud. Growing in communities along sheltered tropical coasts, mangroves trap detritus among their roots and support a fairly dense population of animals, many of them highly specialized. Their tangled root system makes mangrove swamps very difficult to penetrate.

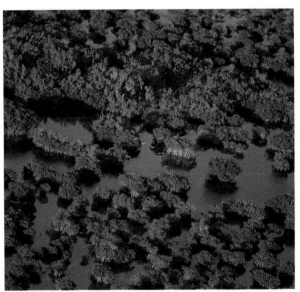

Freshwater wetland surrounding a sluggish meandering river (left) is an excellent habitat for ducks, geese and waders. Lying on the central flyway of North America, this stretch of the Souris River in North Dakota is a well-known refuge for waterfowl.

Unique in character among wetlands, mangrove swamps are usually only accessible by boat. These clumps of red mangrove (above) mark the southern limit of the Florida Everglades; they support a rich variety of animals from flamingos and herons to manatees and alligators.

Wetlands Wildlife

Wetlands offer food, water and security. Being relatively rich in nutrients they support a varied population of plants and small animals, and this in itself is sufficient to attract larger animals that have the means to move around in shallow water. Birds, above all, are suited to this environment, and for wildlife photography they are the great attraction of wetlands; the world's largest bird sanctuaries are in marshes and estuaries. Because land-based animals – and this includes most mammals – are at a physical disadvantage, there are few large predators and so wetlands offer birds relatively secure accommodation.

Wetland birds

In the shallow waters, fish and crustaceans represent an accessible food supply that does not call for deep diving skills, and many bird species live by fishing or dredging. Long-legged waders such as herons and storks may spear their prey with dagger-like beaks. Others, like spoonbills and flamingoes, sieve their food with highly specialized bills. Smaller waders, such as stilts and avocets, are restricted to the shallower edges while large divers, like the anhinga and the cormorants, hunt fish in deeper water.

This reliance on fish and crustaceans has indirectly, one great advantage for photography. In order to catch this relatively large food, many wetland birds are themselves large. Technically, large waders are easy to photograph, because they do not need to be approached so closely in order to secure an image that fills the frame – and because they move relatively slowly.

The water level in many wetlands rises and falls seasonally, and this affects the distribution of wildlife. Many are also visited seasonally by vast numbers of migrants, so that for any particular location you should check in advance which are the best months for the species that interest you most.

Approaching water birds

The water, boggy soil and tangled vegetation that deter predators also make quiet approach difficult for photographers. Stalking on foot is worth trying from dykes and raised ground, but

Temperate marshland

Some trees, such as the Alder, can tolerate marshy conditions provided that there are areas of slightly firmer soil. Where branches overhang the water, kingfishers may perch

Water lilies often cove surface of ponds and sheltered margins of la

At the edge of the marsh, sedges are common, and this slightly drier ground may be used by small marshland mammals, such as water voles and muskrats. Otters travel more extensively.

Reed-nesting birds include the reed-warbler, bearded tit and reed bunting. Coots and grebes also nest among reeds, but at water level. Pike hunt small fish among the denser vegetation

Shy birds such as rails and crakes use the denser vegetation at the margins of ponds and lakes.

this only gives access to the edges of lakes and marshes, and as there is usually little cover concealment may be difficult. Stalking by wading is noisy and not very efficient, and is usually best reserved for approaching large nesting colonies where birds live in such large numbers that they do not feel threatened by an intruder. In coastal marshes be very careful not to be cut off from the shore by an incoming tide, which may move fast along channels that you have not noticed.

For many species, such as ducks and geese, a hide (blind) is the only reliable viewpoint. Because most of the wetlands that have spectacular bird populations are well known sanctuaries, permanent hides administered by conservation organisations are not uncommon. There may, however, be some competition for access to them among bird-watchers, and it is wise to check in advance whether they are available. With your own hide, follow the instructions on pages 124-5. Visibility, at least for birds, is good in a wetland habitat and you may have to be very careful in entering and leaving – arriving before dawn, or being shown in by a companion, who then leaves.

Boat hides, as described earlier, are very useful and even uncamouflaged boats can be used for watching large colonies. In marshes, a flat-bottomed punt is often the best transport as the water is usually shallow enough to use a pole, which is quieter than oars.

Other animals

In general, large animals are not common, but locally there may be browsers that wade or swim such as hippopotamus, swamp deer, moose or capybara. In tropical wetlands crocodiles or alligators are often numerous; other reptiles and amphibians include turtles, terrapins, frogs and water snakes.

Underwater photography is usually difficult because of silt and vegetation but occasionally clear pools make snorkelling worthwhile. An alternative in shallow water is partially to submerge a glass tank, weighted to keep it on the bottom, and place the camera inside. 'Half-and-half' views, in which the waterline cuts across the image, can be taken like this.

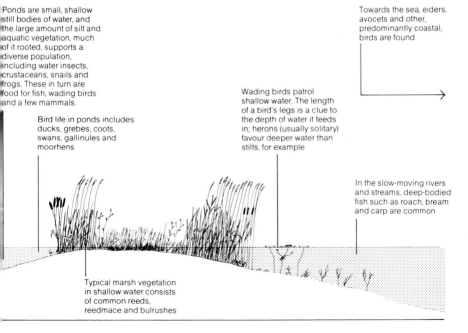

Ponds are small, shallow still bodies of water, and the large amount of silt and aquatic vegetation, much of it rooted, supports a diverse population, including water insects, crustaceans, snails and frogs. These in turn are food for fish, wading birds and a few mammals.

Bird life in ponds includes ducks, grebes, coots, swans, gallinules and moorhens

Towards the sea, eiders, avocets and other, predominantly coastal, birds are found

Wading birds patrol shallow water. The length of a bird's legs is a clue to the depth of water it feeds in; herons (usually solitary) favour deeper water than stilts, for example

In the slow-moving rivers and streams, deep-bodied fish such as roach, bream and carp are common

Typical marsh vegetation in shallow water consists of common reeds, reedmace and bulrushes

Photographic Conditions

Being largely flat and open, wetlands share some of the characteristics of grassland. Light levels are high, and there is little in the way of relief or tall forest to hide the attractive light from an early morning or late afternoon sun; but the repetitiveness of reed-beds and marsh grass, particularly when seen from water-level, can make for dull landscapes. One important visual advantage of wetlands is the water itself, which can add a variety of interesting reflections.

Choosing the light
Wetlands are relatively bright habitats, not only because the landscape is flat but also because the surface of the water reflects light Consequently, both early and late in the day,

The wooded margins of wetlands are, in many ways, easier photographically than open lakes and reed-beds. Even a little cover, as offered by these acacia trees in an Indian bird sanctuary makes stalking possible, and composing the picture is easier than with a flat horizon.

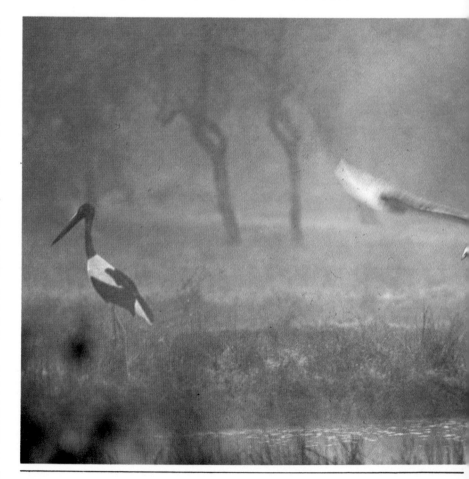

Early morning light in wetlands is frequently pale, misty and atmospheric.

Riverbanks offer another opportunity for tight, horizonless compositions – at least, when a telephoto lens is used. If the foliage is interesting, as above, it may be better *not* to close right in on the animal.

Wetlands are excellent locations for plant photography. A close-focusing macro lens is important for detailed shots, such as of this northern marsh orchid. For good depth of field, also use a tripod.

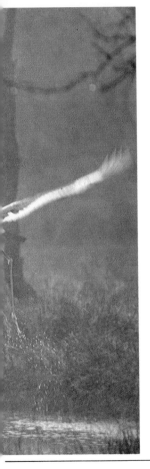

Choice of Equipment

when there is plenty of animal activity, there is still usually sufficient light to use a long-focus lens at respectable shutter speeds. But pay particular attention to the meter readings as conditions may be brighter than you expect.

Low direct sunlight is particularly attractive in wetlands as it gives a texture to the reeds, grasses and water ripples. Side-lighting is also generally good for close photographs of birds. Reflections in water are more intense under a direct sun, and can give well-defined graphic silhouettes. By comparison, the light on an overcast day or under a high sun is more difficult. The lighting conditions in clumps of trees such as the 'hammocks' of the Everglades and in mangrove swamps are essentially those of broadleaved forests.

Viewpoints to relieve monotony

Because horizons are flat, and the reeds and grasses tend to appear as horizontal bands, the common problem in composing marsh landscapes is to avoid empty foregrounds and skies. If the sky is interesting, with strong cloud formations, then one effective technique is to place the horizon line low in the frame. Otherwise, look for ways of deepening the image, so that the picture frame is filed vertically as well as horizontally. One method is to find a raised viewpoint such as a tree or nearby hill and use a long-focus lens to compress the pattern of water and vegetation. Another is to make use of the water, and with a wide-angle lens held close to the surface and pointed slightly downwards, fill the foreground with reflections.

If birds are the main focus of attention, then the one essential piece of equipment in this habitat is a very long focal length lens. The generally bright conditions make even the small apertures of 500mm and 1000mm mirror lenses practical for most of the day. Other ancillary equipment will depend on what approach you use: stalking on foot or boat, or shooting from a hide (blind).

Photographic Equipment

Basic
35mm SLR
Spare batteries
Long-focus lens of at least 400mm
Medium speed or slow color film
Ultra-violet filter

Optional
Second camera body
Motor drive
Long-focus macro lens (100mm to 200mm) for dragonflies, frogs and other small subjects.
Moderate telephoto lens, about 200mm, for overall views of heronries, and for unexpected close encounters.
Wide-angle lens for scenic views
Polarizing filter to reduce haze or deepen blue skies
Tripod for natural-light plant photography.

35 mm SLR

UV filters

Tripod

Motor-drive

Long-focus lens

Medium or slow film

Extra camera body

Mod. telephoto lens

Macro lens

Wide-angle lens

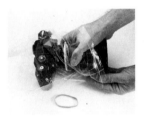
For temporary waterproofing insert the camera, body first, into a strong plastic bag.

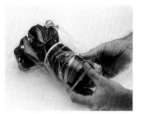
Secure the opening around the lens with a strong rubber band.

To improve viewing, put a smaller rubber band around the eyepiece.

Cut a small opening inside the area secured by the band.

Field Equipment

Clothing

The only special clothing that you are likely to need is wading boots, if you are attempting stalking in shallows. However, in warm weather a pair of light canvas shoes may be more comfortable.

Medical

No special precautions except in tropical wetlands which may harbour malaria-carrying mosquitoes (take a course of tablets, starting at least one week before you arrive) and leeches (remove as described on pages 176-7). In some tropical wetlands, bilharzia, a parasitic disease carried by flukes living in freshwater snails, makes bathing and wading very risky.

Do not enter the water in areas where there are crocodiles or alligators, or where there are carnivorous or parasitic fish (a special problem in Amazonian white-water rivers). In many mangrove swamps, sting-rays often bury themselves just beneath the surface of the mud, and can deliver an extremely painful sting if stepped on.

185

Varieties of Seacoast

Every strip of coastline owes its appearance to the combined action of several factors. These include the composition of the rock (soft shale, for example, could not produce towering cliffs); the silt brought down by rivers and streams; the erosion or deposition from waves and currents, and recent changes in sea level. (Most shores rose after the last Ice Age, which explains the indentations that form great estuaries like Chesapeake Bay and the fjords of Norway – they are drowned valleys.)

The net result is a great variety of seacoasts around the world. In terms of appearance, and the basic pattern of plant and animal life, the main types of shore are rocky, shingle, sandy, muddy, and coral. The division between these types is rarely neat, and on many coasts you can see combinations, such as rocky headlands enclosing sandy bays.

Rocky shores

These vary greatly, depending on the hardness or softness of the rock, its composition, and how it is bedded. At their extreme, they form vertical or even overhanging cliffs, stacks, jagged outcrops and arches. When a shoreline is rocky, it is because it is exposed and because the waves regularly pound with sufficient strength to erode rather than deposit.

Shingle beaches

These loose unconsolidated beaches are made up of smoothly rounded pebbles washed ashore by powerful currents and waves. They sometimes form spits running out across the mouths of bays, and near an estuary may give shelter behind which salt marshes may form.

Sandy beaches

Like shingle, these are beaches that are deposited rather than eroded, but because the particles of quartz are so small, they are built up by less powerful wave action. The slope is usually very gentle.

Muddy shores

Composed of extremely fine particles, coastal mud is virtually flat and a sign of very slow action by waves and currents. Mud flats are relatively easily colonized by plants and often evolve into salt marshes.

Coral reefs

This type of shore is confined to tropical seas, where warm clear water favours the growth of the polyps whose shelters make up the reef. Most corals grow very close to the surface, and major reef-building is due to a gradual rise of sea level (or subsidence of land) that has forced the coral polyps to keep pace. Coral reefs are off-shore features, often complex in structure.

Tides

Tides are the vertical movements of the sea caused by large-scale oscillations under the gravitational pull of the sun and moon although on many coasts their horizontal

Backlighting from an evening sun shines through the crest of a wave breaking against a Monterey shore, California.

movement is the most noticeable feature. How far the tide moves 'in' and 'out' depends largely on the slope of the lower shore, and while it may be negligible on a coastline of rocky cliffs, on broad estuarine sands it may move a mile or more.

There are two tides a day, and as an approximate guide high water and low water are about 50 minutes later each day. Roughly speaking, the tide flows in for about six hours, then out for about six hours. This is complicated, however, by the changing *height* of tides within a 28-day period. When the moon is full or new, high water is at its highest and low water at its lowest. These are the 'spring' tides (nothing to do with the season) and for these

few days the tides are only about 20 minutes later each day. When the moon is at the midpoint of its cycle, the difference between high and low water is least and the tides are called 'neap'. At this time, each is about 80 minutes later each day. The best guide to the tides are published tide tables. The actual height of the tides varies throughout the year, with the 'spring' tides being highest at the spring and autumn equinoxes and lowest at the summer and winter solstices.

Some seas, such as the Mediterranean, have so little oscillation of their water that they are virtually tideless. Many parts of the British coast have an average tidal range of three to five metres.

Intertidal Life

Shorelife is diverse because the coast itself is such an unstable meeting point of two very different environments. Tides pass over the shore twice a day but they reach different heights according to the day and the season, while changes in the weather can locally affect the character of the sea. Shore conditions can change radically within a few yards, creating a high degree of specialization among the animals that live there. One of the principal attractions for the larger animals, such as seabirds, is that food is very accessible in these shallow waters, and nesting sites are often secure against land-based predators.

Rocky shores

Exposed rocks are generally bare of seaweed but often covered in barnacles, limpets and other creatures that can hold on under the pounding of waves. Where the shore is sheltered, in coves and behind headlands, seaweeds are common, zoned by species according to the tidal zone (see box), the degree of exposure, and whether there is a fresh water outlet. Seaweeds shelter a variety of animals, including molluscs and crustaceans.

Rock cliffs are highly favoured by seabirds for their security as nesting sites and for their commanding views. Offshore outcrops have a similar appeal, and in appropriate locations are often shared with seals.

Rock pools, which never dry out, are a temporary refuge for shore life that normally retreats with the falling tide, and for photography are a very convenient microcosm. Anemones, urchins, crabs,

Section of a Rocky Coast

Ledges offer security for cliff-nesting birds such as gulls, guillemots, cormorants, puffins, auks. Occasional salt-resistant flowers, such as sea-pink, take hold.

Splash zone: lichens dominate, and there is little vegetation. Rock lice, springtails and winkles are common.

Upper shore: more sparsely populated than the middle shore, with smaller numbers of barnacles and winkles.

Rock pools: seaweeds, sea anemones, crabs, sea urchins, starfish, small shrimps, springtails.

Middle shore: Barnacles and mussels often compete here, with barnacles tending to be more common at a higher level. Lower on the middle shore large wracks are found, and these prevent barnacle larvae from gaining a hold. Other inhabitants are crabs, winkles, topshells and various other small animals. Birds such as oyster catchers and sandpipers patrol close to the water's edge.

Mean sea level: most crabs live below this, unless stranded in rock pools.

Lower shore: large wrack and darweed. Animals include sea-urchins, dogwhelk, crabs, lobster, crayfish, starfish, and various fish (blennies, rock gobies and others).

prawns and fishes may be stranded in these pools until the next high tide.

Shingle beaches
The weight and movement of the pebbles prevents most animals from living on shingle, and they are generally bare of life. Some plants, such as sea-campion, may colonize the higher parts of old shingle beaches, and when they are backed by salt marshes, small waders such as curlew, godwits and oystercatchers may patrol the water line when high tide has covered the feeding grounds.

Sandy beaches
Most of the life on sandy shores burrows beneath the surface. It includes molluscs such as cockles, tellenids and razor shells; crustaceans; worms, burrowing starfish; sand eels and some crabs. Plant life, however, is sparse. The strand-line is the narrow band of detritus thrown up along the high-water line

and attracts scavengers such as sand-hoppers.

Muddy shores
The organic matter in mud makes it a rich environment for burrowers such as lugworms, molluscs such as clams and cockles, and crustaceans, and so is an attractive feeding ground for waders and ducks. Salt marshes evolve from mud flats (see Wetlands, pages 178-85).

Coral reefs
Coral polyps and the alga that associate with them provide the basis for the most complex and varied of marine communities. Bright colors are common among fishes and invertebrates and the water is shallow and clear (a pre-requisite for corals). In other words, reefs and the lagoons they enclose are among the most spectacular locations for wildlife photography.

Tidal zones
Apart from controlling the appearance of the shoreline, and its accessibility, the tides are an essential influence on the type of animals and plants that live there, and create a number of zones. These are most obvious on rocky shores, and each has a distinctive fauna and flora.

The littoral is the band of shoreline that is intermittently covered by the sea, and has three zones. The principal one is the middle shore, between the average high tide level and the average low tide level, so that most of it is covered and uncovered by

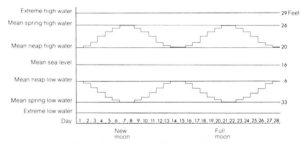

sea twice a day. Below this, the lower shore is only uncovered for about half the days in a 28-day period, around the spring tides, and supports mainly marine life.

Above the middle shore is the upper shore, which is only covered around the spring tides and so has a very sparse population.

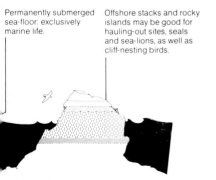

Permanently submerged sea-floor: exclusively marine life.

Offshore stacks and rocky islands may be good for hauling-out sites, seals and sea-lions, as well as cliff-nesting birds.

Photographic Conditions

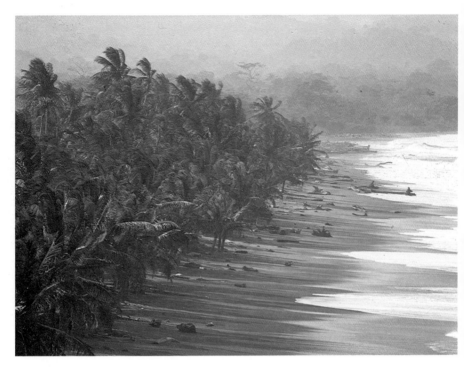

As coastlines vary so much in form there are only a few common denominators for photography. Chiefly, however, light levels are high – enhanced by reflection from surf and sand. Use meter readings with discretion – those taken directly off a backlit sea will suggest exposures too dark for the other parts of the scene.

Fine spray is common on windy days, particularly off a rocky shore when waves are heavy, and it creates long-distance haze. This is accentuated by high ultra-violet scattering, and ultra-violet filters are important (they also protect the front element of a lens from damaging salt deposits)

Water reflections can be useful or awkward, depending on the image you want to capture. Shooting towards the sun can give an attractive high-contrast pattern of bright reflections and dark rocks, while waves are emphasized when backlit. However, when there is clear unruffled water close to shore, it may be useful to suppress reflections so as to show some underwater details. In this case, use a polarizing filter and experiment with the camera angle and position of the filter to find the clearest view.

Sea-bird and seal colonies

Along rocky coasts, colonies are localized but generally well-known so ask people living locally. Most sea-birds and seal colonies are densely packed, which gives good opportunities for massed shots, but as the locations are deliberately chosen for being inaccessible from the land, a very long focus lens is absolutely necessary for strong images. ideal camera positions are high up and directly opposite the cliff or island that supports the colony. However, this inaccessibility has one advantage – the colonies generally feel secure, so that from a convenient viewpoint there is normally no need for concealment.

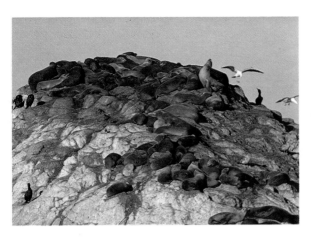

Elevation and a long-focus lens give a comprehensive view of a flat, palm-backed beach on the Caribbean coast of Columbia. Strong surf usually creates pronounced haze.

Sea-lion colonies are often sufficiently concentrated to make good massed shots with a long-focus lens (here 800 mm on a 35 mm camera).

Small-scale views, of tide-pools and the margins of sheltered bays, add visual variety to a set of shore-line photographs. A polarizing filter helps cut surface reflections.

Rock pools
Use basic close-up techniques for photographing the small-scale life in these pools, but take special precautions to avoid reflections from the water. Direct light gives a much clearer image than diffused light so both sunlight and flash are ideal. In either case, position the camera so that the light comes from one side and is not reflected directly into the lens. Even then, the water may reflect blue sky. A polarizing filter cuts reflections, but also reduces the light reaching the film; an alternative is to shade the water above and in front of the camera with something dark, such as a black card or even a piece of clothing.

Mudflats
See Wetlands, pages 178-85.

Tropical beaches
Coastlines in the tropics are not universally fringed with white sand and coconut palms, but many are, and they offer a distinctive type of scenery. White sand, derived mainly from shells, is very bright and reflective under a high sun. When the beach slopes off gently under clear water, rich sea colors from green to blue are usual. For scenic views, under-exposure is often very effective – it darkens the sky, strengthens the color of the water, and can give very graphic images. For this, follow the meter reading without compensating, and even try a darker exposure. Graduated filters and polarizing filters can exaggerate this effect.

Coral reefs
For surface photography, be careful not to over-expose. A polarizing filter is useful for suppressing reflections to deepen the water color and show some marine life. Most reef animals, however, need underwater techniques, using either amphibious cameras or, in areas developed for tourism, glass-bottomed boats.

191

Choice of Equipment

With such a full range of wildlife, from seabirds to molluscs, a general photographic trip to most coastal zones needs a fairly full set of equipment, from long-focus to macro lenses, with flash and close-up accessories included for tidal pools. The exact choice of equipment will be influenced by the type of coastline: estuarine salt marshes are wetlands, and birds are likely to be the main attraction, needing the equipment described on pages 184-5, while a rocky coast will involve some clambering, and even climbing.

The dangers of salt water and sand
By comparison with rainforests and deserts, seacoasts in temperate climates may seem benign locations for photography. However, both salt and sand, which are never in short supply, are very damaging to cameras and lenses. Salt increases the corrosive capacity of water and its ability to short-circuit electrical components. Sand is abrasive, and can damage both mechanical functions and film. If there is wind, salt spray and airborne sand can reach camera equipment unless it is sealed in a bag, and rough seas on a rocky coast increase the danger of it being splashed. In these conditions, take equipment out of your waterproof shoulder bag *only* when taking pictures – *do not* leave them exposed. Alternatively, wrap a camera in a plastic bag as described earlier.

Wipe off salt spray and splashes immediately, and at the end of each day wipe everything down with a clean cloth and fresh water or alcohol. Also blow compressed air into all the crevices to dislodge sand.

If you *drop* equipment into saltwater, you may ruin it completely. Ideally, immerse the equipment in a filled, sealed container of fresh water and deliver it immediatley to the manufacturer, dealer or repair shop. If there is likely to be a delay, dry it after immersion in the fresh water by first using compressed air to evaportate most of the water and then heating it in an oven at no more than 120 F or under a hairdryer. Then have it professionally repaired as soon as possible.

Although the best treatment for immersion in salt water is immediate delivery to a repair shop, this is usually not possible. After a *thorough* soaking in *fresh* water to remove salt, dry thoroughly. A hair-dryer is rapid and efficient.

Photographic Equipment
Basic
35mm SLR
Spare batteries
Long-focus lens, ideally at least
 400mm
Macro lens for shells, crabs, sea-
 anemones and other small
 shorelife
Medium speed or slow color film
Ultra-violet filters
Portable flash
Polarizing filters to control
 reflections from rock pools
Moderate telephoto lens, about
 200mm
Wide-angle lens for scenic shots
Graduated filter for scenic shots

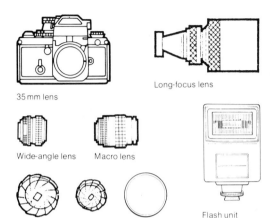

35mm lens

Long-focus lens

Wide-angle lens Macro lens

U.V. and Polarizing Filters

Flash unit

Optional
Amphibious or waterproof camera
Close-up extension ring
Second portable flash unit, with
 photocell slave, as fill-in for
 close-ups
Tripod

Camera care
Carry a waterproof shoulder bag
with additional plastic bags with
rubber bands for wrapping
individual pieces of equipment;
soft cloths for wiping off spray; a
bottle of fresh water or alcohol,
also for cleaning off salt deposits
or mud, and a blower-brush for
removing sand.

Field Equipment
Clothing
A waterproof anorak is useful
against spray. Footwear depends
on the terrain: waders for salt
marshes, ankle-supporting boots
with moulded soles for rocks and
cliffs, or possibly nothing at all on
sandy beaches.

Medical
No special precautions unless
you expect to be climbing rock, in
which case take the first aid kit
described on pages 90-1.

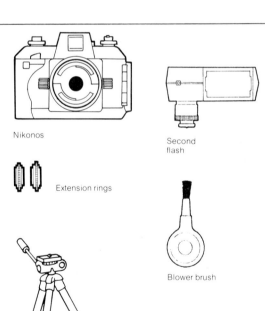

Nikonos

Extension rings

Tripod

Second
flash

Blower brush

193

Underwater Photographic Equipment

Underwater photography is highly specialized, and the diving techniques involved need to be learned from a qualified instructor. This applies to snorkelling as much as to scuba diving. Remember that the most interesting places for underwater photography, such as coral reefs, can have currents, sharp rocks, and a number or creatures that defend themselves, sometimes very actively, by stinging or biting.

Equipment

There is a wide range of amphibious photographic equipment but the basic choice is between submersible housings for regular equipment, and cameras and lenses that are themselves sealed against water at pressure. The advantages of housings are that no extra cameras or lenses need be bought, so saving expense, and that conveniences such as reflex viewing and motor drives can be used. Against this, they are bulky and run a higher risk of leaks through careless assembly. Amphibious cameras (the Nikonos is the only serious contender in mass-production) are more compact and convenient but also, of course, need their own range of lenses.

With a glove-like insert to give a better grip, this simple waterproofing is adequate for shallow diving.

The Nikonos is still the only truly amphibious camera usable at scuba-diving depths.

A variety of models caters for most makes of camera. This is one of the most popular types of housing.

For some cameras such as the Hasselblad, the manufacturers produce custom housing.

The most rugged housing design is in cast aluminium, and can be adapted for several 35mm camera models.

Moulded plastic housings are available for regular meters. Amphibious meters can also be bought.

The most reliable lighting is electronic flash. The most advanced designs adjust exposure automatically.

Standard camera care

Sand, grit and crystallized salt can actually cause leaks by becoming lodged in the O-ring groove, if they are allowed to build up after several dives. Take these standard precautions:

Check a new housing by submerging it *without* a camera. Do this first in a tub or bucket of water and watch for tell-tale bubbles, and then take it to the maximum depth that the manufacturer recommends. Back on the surface, check the interior for drops of water.

Between dives, wipe down the housing, your hands and hair before changing film. If possible, rinse in fresh water before drying. When returning to the boat or shore after a dive, do not leave a housing in direct sunlight; being sealed, it will heat up very quickly and this can cause condensation, and damage to the lens and film.

At the end of a day's diving, first rinse the equipment in fresh water by immersing completely for at least 30 minutes to dissolve all the salt. Then hose down. After washing, dry the outside thoroughly with a clean cloth then open the housing, remove the camera, and pull out the O-ring. (With an amphibious camera, open the body and remove the lens for access to the O-rings.) Clean the O-rings and their grooves with a cloth soaked in fresh water and with cotton buds. Wipe them dry with a clean cloth and re-lubricate, but *lightly*. Too much O-ring grease prevents a tight fit and may cause a leak. It also attracts grit and sand.

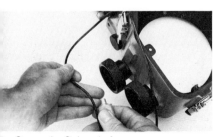

1. Immerse in fresh water for half an hour to dissolve salt.

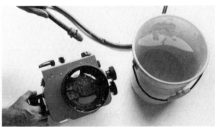

2. Hose down the equipment.

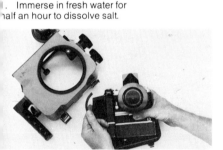

3. Dry and dismantle.

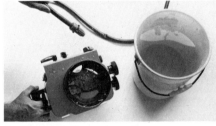

4. Remove the rubber O-rings that seal the housing, and clean with fresh water.

5. Grease the O-rings before replacing.

6. After re-assembling, protect the port with a cap.

Underwater Photographic Technique

Water refracts light, so that both focusing and image size are affected; and it also absorbs light, making artificial lighting virtually essential for close-ups of fish and corals at any depth greater than a few feet.

Lenses underwater

Being denser than air, water acts as a kind of lens so that compared with the view on land the image is different in three ways:
1. Objects appear closer, by a quarter of their distance.
2. They appear larger, by a third of their true size.
3. The angle of view of the lens is smaller, by a quarter.

Choosing lenses

The focal length of a lens remains the same, but it *behaves* as if it were longer. A standard lens for a 35mm camera underwater is 35mm rather than 50mm.

Lens focal length (on a 35mm camera)	Angle of view at the surface	Angle of view underwater
16mm	170°	127.5°
20mm	94°	70.5°
24mm	84°	63°
28mm	74°	55.5°
35mm	62°	46.5°
50mm	46°	34.5°
55mm	43°	32°

One simple correction is to use a port in the housing that is domed rather than flat. This cures the problems of size and distance, although the angle of view remains narrower than in air. However, it has a side-effect: an ordinary lens will no longer focus on infinity. To restore normal focusing, add a supplementary close-up lens or a thin extension ring. Dome ports also correct the problems of distortion and poor resolution close to the edges of the picture, and so are always better than the cheaper flat ports. For the best performance, the curve of the dome should match the focal length of the lens, and it may be necessary to have two ports – one for lenses that are close to standard, and one for very wide-angle lenses.

A number of water-contact lenses are made specially for the Nikonos, and these are already corrected.

Using natural light

Light is absorbed by water. The deeper you go the darker it gets. Also, water absorbs light selectively, starting with the red wavelengths. Because of this, the deeper the water, the bluer it appears. For close views of most marine life natural light is poor as the results are likely to be blurred and blue. For scenic photographs, however, natural light has to be used. Corrective filters, as the table shows, can restore some color balance but lack of contrast remains a difficulty, although this can be solved by using a very wide-angle lens and shooting upwards to include the surface and silhouettes.

Feet	Filter
0	No filter
5	CC10R
10	CC20R
15	CC30R
20	CC40R
25	CC50R
30	All red absorbed
65	All yellow absorbed
75	All green absorbed

Using artificial light

Although continuous tungsten lights are used for motion picture work, flash is more convenient for still photography. Bulbs are powerful and light, and their holders inexpensive, but electronic flash can be used more rapidly and is, in the long run, better value for money.

Except for extreme close-ups, use a pale red filter (about CC10 Red) to cure blueness from absorption. While it is convenient to use a flash unit mounted close to the camera, the lighting tends to be flat and uninteresting and water particles between you and the subject are illuminated to give a speckled effect known as back-scattering. Other lighting positions, particularly ones *over* the subject, are often better.

Within a few feet of the surface, photography without flash is satisfactory provided that the water is clear and the sunshine bright. The safe minimum shutter speed is 1/60 sec although even this is too slow for fast-moving fish.

Flash is virtually essential for close-ups at any reasonable depth. By keeping the shutter speed slow, as here, natural light adds depth to the view.

197

Mountain and Moorland

Ultimately, temperature and rainfall are responsible for most of the differences that separate one habitat from another. By virtue of their height, mountains experience colder weather than the surrounding lowlands (on average, the temperature falls 3°F for every 3,000 feet), and by interrupting the flow of air and forcing it to rise, they generally create wetter conditions, at least on the slopes facing rain-bearing winds (see pages 84-7).

As these changes occur gradually, from the foot of the mountains to the summits, the vegetation also changes – with the result that there are several zones, each occupying a band of mountainside at a particular height. A journey up a mountain sometimes resembles a longer journey polewards, with trees becoming more cold-adapted until they are replaced by tundra-like vegetation which itself finally gives way to bare rock and icefields.

How much of a contrast there is between the lowest and highest zones depends on both the height of the mountains and on the latitude. The extremes are reached in the major tropical ranges, such as the northern Andes, which encompass tropical rainforest and permanent ice, while the northern Rockies cover only the colder, wetter part of the spectrum of habitats. So, while mountains have special features of their own, they also comprise a number of different habitats, and in making a mountain journey you will need to refer to more than one part of this section of the book.

Typically, mountain scenery and conditions begin above the tree-line, which depends on the summer temperatures more than on anything else. In colder climates the tree-line is low – extending, in Britain, to just below 2,000 feet before deforestation by man – while in tropical mountains such as Mount Kenya it is closer to 10,000 feet. When it is high enough to experience a regular cloud mantle, the result is cloud forest, characterized by a profusion of epiphytes.

Moorland, which can vary from heather to bog, is typical of moderate and gentle slopes above the tree-line, and is characterized by acid soils that support low vegetation. Most of the British uplands are moorland, with a covering that varies from gorse and heather to grasses, sedges and mosses, while the extensive paramo of the Andes, and the afro-

Moorland at 2000 feet in the British Lake District.

Peaks and icefields in the Northern Andes.

alpine zone of Africa's equatorial highlands have, in addition to this typical vegetation cover, bizarre arborescent plants such as the espeletia and giant lobelia.

Higher than this only mosses and lichens survive, and eventually, only rock and ice remain. The snow-line in the north of the Andes, where it borders the Caribbean, is at 16,000 feet, while in the extreme south, in Tierra del Fuego, is as low as 2,300 feet.

Most animals are as restricted to particular zones as the plant communities. The forest levels have the kinds of species already described on pages 154-75, and these are generally the most heavily populated slopes of a mountain. Above the tree-line there is less food and less shelter, and consequently fewer animals.

Mountain wildlife has adapted to altitude in a number of ways including greater lung capacity, larger hearts, and a higher concentration of red corpuscles in the blood. All are methods of using more of the lower pressure of oxygen. Other common adaptations are good eyesight and climbing ability, shown by such mountain herbivores as ibex, dall sheep and chamois. Large birds of prey have evolved great wing spans to make use of the thermal updraughts common in mountains.

Photographic Conditions

Wildlife above the tree-line is not abundant and is, as a rule, very wary. But as visibility is usually good among rocky and snow-covered high country, clear views are often possible with a very long focus lens. Landscape possibilities are nearly always good, and owe much to the variety of relief and weather.

Mountain scenery

The vertical component in mountain landscapes gives a freedom in composition that is a welcome contrast to the difficulties of making strong scenic images on plains and in wetlands. The best impression of height is either from a distance or from adjacent peaks so that, in general, you can expect to find the most spectacular views as you approach a mountain range from several miles' distance and then when you have climbed to the upper levels. The journey in between is often disappointing for scenic photographs.

Long-focus lenses compress the images of foothills and ridges in a way that emphasizes the scale of peaks and ranges in the distance and, unusually for landscape photography, this often works just as well in a vertical format as in a horizontal one. Foreground rocks and slopes

can be brought into the picture with a wide-angle lens for a more integrated, expansive view – a treatment that often works best from a height looking slightly downwards.

The thinner and largely uncontaminated air gives great clarity over a distance, but because the atmosphere is less efficient at screening ultra-violet rays, film records quite a strong blue haze at high altitudes. This is stronger during the middle of the day and generally more apparent in backlit scenes. An ultra-violet filter is a basic precaution, but one that is yellow-tinted is even more useful – particularly for long-focus lenses.

Mountain wildlife

The large animals are the browsers and grazers, such as ibex, yak, vicuña, bighorn sheep and Rocky Mountain goat. All are extremely agile and have sufficiently good eyesight to make them very difficult to stalk without being spotted. Generally, you can expect to be seen from an early stage so you must usually rely on the extent to which the animals will tolerate your approach. This depends on the terrain, on whether the animals are in a large herd or are feeding individually, on the season, and on other, local factors.

Panoramic viewpoints are one of the classic features of mountain landscapes, and many lend themselves to a wide format. In this photograph from the upper slopes of an Andean volcano, a wide-angle lens helps to establish depth in the view.

By contrast, a telephoto lens gives a strong perspective, giving tightly-cropped views of isolated details, such as this cloud-bound ridge, also in the Andes. Early morning and late afternoon are often the clearest conditions.

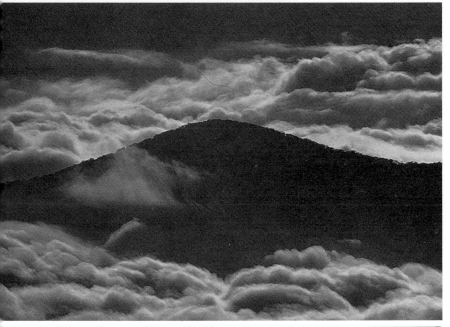

Choice of Equipment

Travel in mountains is usually strenuous and all equipment needs to be chosen with an eye on weight. Lightweight cameras and lenses are ideal, for it is far more sensible to limit the photographic equipment you carry than to leave behind essential field equipment that may be needed for safety. Accidents are no uncommon, and almost all mountains experience very changeable weather, so tha adequate clothing and precautionary equipment such as a first aid kit and rope, are essential.

Photographic Equipment
Basic
35mm SLR, preferably lightweight
Spare batteries
Long-focus lens, 300mm to
 500mm, lightweight if possible
 (mirror lenses save weight).
General purpose color film, about
 1S0 64, and a few rolls of fast
 color film.
Wide-angle lens, 20mm to 28mm,
 for overall scenic views.
Ultra-violet filters

35 mm SLR

400 mm lens

Wide-angle lens

UV filters

General purpose film

Optional
Second camera body
Macro lens for mountain flowers.
Pocket tripod for flowers, and
 cable release.

Extra camera body

Macro lens

Small tripod

Cable release

Camera care
Cameras and lenses need, above all, good protection against physical damage. Knocks and scrapes are likely, and everything you carry should be well padded. A regular shoulder bag is useful only for hill-walking on moderate slopes; for any climbing, equipment should be packed securely in a proper back-pack; a camera bag specially adapted to be carried securely on the back, or in one of the newer lightweight pouched belts. If you carry a camera 'at the ready' on a neck-strap, add a restraining chest-strap to stop it bouncing about as you climb.

Field Equipment

Clothing
Mountain clothing should be light but strong; should give adequate protection against wind, cold and rain, and must also be adjustable as weather conditions can change sharply in a single day. Clothing that traps air gives the best insulation. A good basic combination is a windproof, waterproof anorak with hood and zip-front; a long-sleeved shirt (woollen or cotton); light-weight sweater, and breeches (trousers cut down to just below the knee) with long thick stockings. A second lightweight windproof anorak is useful if prolonged rain is likely, and a down jacket is ideal for winter or at high altitudes. For severe conditions, add long underwear, snow gaiters, spare socks, down mitts with silk inner gloves and woollen headgear.

Choose boots to suit the terrain – either hill-walking or climbing boots. They should have Vibram soles and be watertight, and climbing boots should be rigid, with thick soles.

Medical
Take a first aid kit as shown on pages 90-1.

Miscellaneous
Always carry a map and compass, torch (flashlight), water bottle, glucose or dextrose tablets, an emergency nylon rope, about 50 feet long, and an emergency space blanket. In addition, for rock, snow or ice, suitable climbing gear is essential. Never attempt climbing if you lack the experience or equipment.

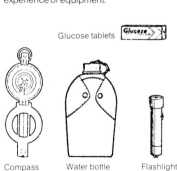

Glucose tablets

Compass Water bottle Flashlight

Arctic and Montane Wildlife

One of the most important natural limits is the tree-line, a limit set principally by cold. Beyond it – either upwards or polewards – the vegetation changes to an incomplete covering of grasses, sedges, mosses and lichens. The influence of temperature is underlined by the fact that in the Arctic the tree-line coincides with the 10°C summer isotherm. Where the July temperature reaches no higher than 10°C, trees cannot grow – and the sparse vegetation that does survive has to cope with largely acid soils that thaw near the surface for only a short time each summer and remain solidly frozen for most of the year. Closer to the poles, ice covers the land for even longer, and most of Greenland, and all of Antarctica except for the Antarctic Peninsula, have a permanent mantle of snow and ice.

These meagre conditions for life do, in fact, support very little. In the tundra the brief thaw, when the permafrost turns from a rock-hard surface to mud and slush, forces plants to rush through their vegetative cycle in two months or less. Animals cope with the long winter by migrating, hibernating, or living poorly. These conditions of extreme and prolonged cold are, geologically speaking, recent; and polar wildlife has not yet, in the main, fully adapted. Most birds migrate to warmer latitudes, as do the caribou, the major game animal of the Arctic. The length and severity of the winter prevents full-term hibernation from being completely successful. Bears, for instance, sleep during the coldest months but emerge occasionally to feed.

Most mammals – hares, foxes, wolves, weasels and musk oxen – remain active from necessity, but their condition deteriorates with the lack of food. Musk oxen live largely off their fatty tissues, becoming thinner until spring. Many animals build their winter shelters in snow, where temperatures are higher than above ground.

Large marine animals are relatively numerous in sub-polar waters because of the high concentration of plankton which supports a very large pyramid of life, from fishes to seals, birds and other predators.

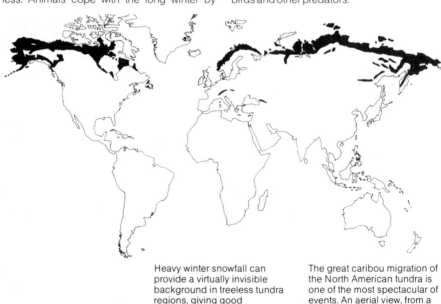

Heavy winter snowfall can provide a virtually invisible background in treeless tundra regions, giving good opportunities for graphic images such as the photograph (top right) of musk-oxen.

The great caribou migration of the North American tundra is one of the most spectacular of events. An aerial view, from a light aircraft (right) is probably the most reliable.

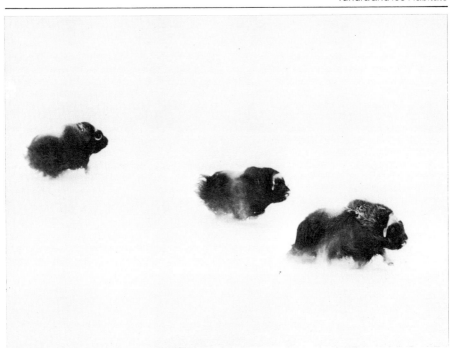

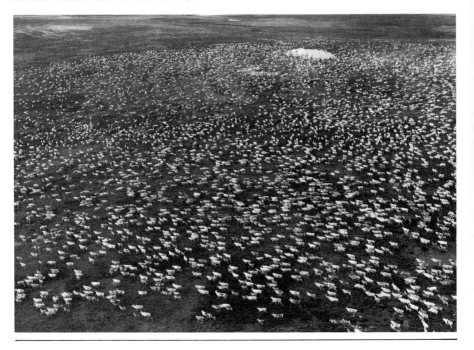

For most of the year, weather conditions in the polar regions are extremely harsh and the physical protection of film and equipment is a major issue. Difficulties of access and movement, and the scarcity of animals, make the winter an unproductive season for wildlife photography although it can provide dramatic images, particularly of stark landscapes. As most plant and animal growth and activity is concentrated in the short spring and summer, there are more popular times for a visit.

Most polar locations are difficult and expensive to reach. The most accessible are northern Scandinavia and Alaska; Siberia is to all intents unvisitable, while the only ways to reach Antarctica are to join a summer cruise or stay with a scientific team.

Tundra spring and summer
For two or three months each year the tundra plants bloom, insects emerge in great numbers, migrants return, and all animal life is at its most active. One of the attractions for photography is the number of large animals. Bears, caribou, moose, musk-oxen, seal and walrus can all be seen relatively easily. Many other mammals, including marmots, foxes, squirrels and snowshoe hares can be approached surprisingly closely, although wolves are always difficult to find.

Herding is characteristic of several species, including walruses, seals, penguins, caribou and musk-oxen, often giving spectacular opportunities. The herds often gather at known assembly sites so always ask local advice.

At this time of year there are no special precautions to take to protect equipment. The sun is never high (38° maximum on midsummer's day on the Arctic and Antarctic circles) and this gives attractive lighting when the sky is clear. The days are long, and night-time is actually twilight, which gives unhurried

Seals commonly surface at breathing holes and in gaps between floes. Generally inquisitive, even the presence of a photographer can draw them into view.

At the end of the summer breeding season, walrus bulls gather at a few specific locations in large numbers – several thousand in one place. Round Island in Alaska, where this bull was photographed, is one well-known site.

opportunities for interesting landscape photographs.

Mosquitoes and midges are, unfortunately, very common in the summer. Take large quanitites of insect repellant.

Lighting conditions in snow

Although the physical conditions can be difficult to deal with, snow offers a welcome change in landscape photography from the normal tonal arrangement of land and sky. It reduces overall contrast in a scene by reflecting light back up into the shadows, but in detail views can provide a white background or high-contrast silhouettes of trees, rocks and dark-coated animals. By coating the land it also tends to simplify images.

Some precautions are necessary when setting aperture and shutter speed. A direct meter reading off snow will indicate a setting that is too dark, because it converts the whiteness into a mid-tone. To preserve the delicate texture of snow, either take an incident light reading, or else take a direct reading and give one or two f-stops' more exposure. For example, if a TTL reading from sunlit snow is 1/250 sec at f22, set the camera instead for 1/250 sec at f16, or even f14 or f11. Because snow needs to be exposed precisely to preserve its luminous quality, bracketing exposures is a sensible precaution.

Being an efficient reflector, snow also picks up the color of its surroundings, and especially the blue of a clear sky. Shadows in snow on a bright sunny day are inevitably blue, but this is only likely to be a problem if the main focus of interest is in the shadow area (see Color Temperature, pages 34-5, for corrections).

Stalking in snow calls for white camouflage. Dress in white and use white tape over black camera parts; a white screen on a light wooden frame can also be effective.

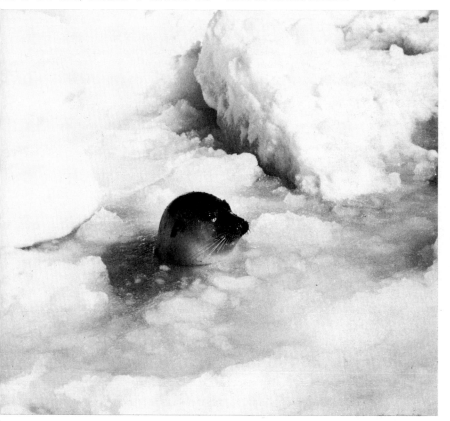

Choice of Equipment

There are different levels of severity of coldness. From freezing point at 0°C (32°F) down to -18°C (0°F), the precautions are principally the commonsense ones of keeping equipment dry and as warm as possible. Below -18°C (0°F), however, some of the materials alter their characteristics: film becomes brittle and less sensitive, metal can stick painfully to skin, and some lubricants thicken, causing moving parts to slow down or jam. Severity also depends on the time that you spend out in these condtions. In any low-temperature environment, condensation is potentially serious when cold equipment is brought indoors. It can also be a problem when wind-driven snowflakes melt and then freeze on cameras that have just been take outdoors, and when warm breath condense and then re-freezes on cold metal and glass.

Camera and film care

Expose equipment to the cold only whe shooting. For the rest of the time keep insulate in a padded waterproof bag or under as man layers of clothing as possible. A large coverin flap on the bag helps to keep out snow, an matching Velcro tabs on the inside of the stra and on the shoulder of your jacket prevent slipping. An oversize front-zippered parka i good protection for a camera on your chest.

When moving into a warm interior, eithe leave the equipmet in a moderately cold roor

Photographic Equipment

Basic

35mm SLR, taped

Several spare meter batteries (all batteries are less efficient when cold, so change frequently)

Selenium hand-held meter (unaffected by battery power loss)

Long-focus lens of between 300mm and 500mm

Wide-angle lens, 20mm to 28mm, for panoramic views.

Medium-speed or slow color film (snow is reflective and raises overall light levels) with some 1S0 400 color film for dull weather, dawn and dusk.

Yellowish ultra-violet filters to reduce blueness (particularly in mountains) and to protect lenses from wind-blown ice crystals.

35mm SLR

Wide-angle lens

Long-focus lens

Medium or slow film

Fast film

UV filters

Lens brush

Camel-hair brush, or brush-and-blower, for removing snowflakes.
Camera tape
Heavy duty plastic bag and silica gel

Dessicant

Optional

Extra SLR bodies

Motor drive for ease of shooting with gloves. However, it may strain cold and brittle film to breaking point, so only use when absolutely necessary, and keep the camera inside the clothing as much as possible.

Spare batteries for motor drive or separate battery pack connected to camera by lead and kept warm inside clothing.

Very long focal length lens, 600mm or greater.

Extreme long-focus lens

Light meter

Polarizing filter to control reflections from ice, and to darken blue sky.
Electric thermal clothing adapted to wrap around equipment. An oversize sock, with a hole cut in

the end for the lens will cover a camera. The battery pack should be kept separate unde clothing.
Felt-tip marker to identify films.

or seal it in a heavy duty plastic bag containing silica gel and with as much air squeezed out as possible, so that condensation forms *on* the bag and not on the cameras. Remove film from cameras before bringing indoors.

When moving out into the cold, protect the equipment from snow until it is close to the outdoor temperature. Otherwise, the snow will melt and then refreeze in joints. This may be very difficult to remove and can even damage equipment by expanding. Camera tape can be used to seal joints.

If camera lubricants are likely to thicken, consider having the camera bodies 'winterized'. This involves replacing normal lubricants with others based on silicone, molybdenum or Teflon, but is costly. Many modern cameras already contain this kind of lubricant, and do not need winterizing. Find out if this applies to your cameras by loading them with film and placing them in a freezer set to the temperatures you expect to be working in.

Never breathe on equipment if you can possibly avoid it. If you can use batteries in a separate pack, do so, and keep it warm under your clothing. Otherwise, cold batteries will deliver only a fraction of their power, and will need to be replaced frequently. Another way of keeping equipment warm is to pack it in felt cases with one or more hand-warmers.

Because film becomes brittle at low temperatures and may acquire small flash marks from static discharge, load and wind on gently, preferably by hand rather than with a motor drive. As films lose speed at very low temperatures, bracket your exposures. Color films may show a color shift so test first in a freezer and select a compensating filter if necessary.

Field Equipment

Clothing
Buy standard cold-weather gear from a ski shop or Army-surplus store. The main items needed are a front zippered, hooded, down-filled parka, large enough to close over a camera carried round the neck; heavy mittens, attached by cord to the cuff of the park (slits in the palm or cuff make it easier to expose fingers for shooting); silk under-gloves; heavy socks; down-filled overtrousers, heavy lined boots and snow gaiters. If the parka has no hood, take a thick woolly hat or a cap with ear-muffs.

Medical
Avoid touching metal parts of the equipment with your bare hands; it may stick. Wrap camera tape around parts that will be close to your face; if white, it also helps camouflage the equipment in snow.

Frostbite occurs when the cold stops blood circulation, and in particular affects extremities such as toes, fingers, nose and commonly the cheeks. *Do not rub* and do not immerse in warm water. Instead, warm gradually (use your armpit for fingers, someones else's (for toes).

Hypothermia, or exposure, occurs when the body core temperature drops very low. Warm slowly. Do not take alcohol. See a

doctor. Carry a space blanket or large polythene sack as emergency cover in case you are stranded in snow; these are best if brightly colored, to attract attention.

Space blanket

Glucose tablets

Lifeboat matches

Flashlight

Miscellaneous
Dark glasses
Glucose or dextrose tablets
Torch (flashlight)

The Desert World

While most habitats have evolved under a number of influences, deserts exist for a single reason – lack of water. Any region that receives less than 10 inches (25cm) of rain in a year is classified as a desert, but even at this low level there are differences in aridity. Ten inches of rain falling regularly and slowly can support a respectable cover of vegetation, but if it falls only in a few violent storms, and is inconsistent from one year to the next, few plants can survive the long droughts in between.

Desert landscapes

The more arid a desert, the less vegetation there is and so the more stark the scenery. In extreme desert areas, such as Death Valley, the Namib, and parts of the Sahara, the bare topography is fine material for graphic, simplified images. Not only are these very arid deserts sufficiently unusual to be interesting for their contrast with other habitats, but they also provide the rare opportunity to construct sparse, geometric photographs. With little or no grass, shrubs or trees, the shapes and textures of rock and sand are the most important ingredients.

There are three main types of pure desert topography, all influenced to some extent by the wind, which is an important agent only in the absence of vegetation. Desert pavement – the 'reg' of the Sahara – is a surface of rocks and gravel scoured of fine particles by wind.

Dunes form where the wind is forced to slow down and so drop some of its load of sand; this happens in the lee of rocks and low hills, but dunes, once begun, are self-perpetuating. Rocky uplands usually stand out abruptly from the generally level desert terrain, and are sharply weathered by occasional violent run-offs from storms, the blast of wind-blown sand, and the flaking due to temperature changes.

Desert scrub, composed chiefly of bushes, bunch grass or cacti, modifies the lunar quality of desert landscapes and is more common than bare sand and rock. Although most of this vegetation makes for less striking images, cacti such as the saguaro have such strong shapes that they can be used very graphically.

With so little rainfall, desert light is more predictable than most. As with many landscapes, a low sun gives the most positive modelling for shapes and textures such as the ripples in the sand dune or the texture of an eroded rock-face. The midday sun, however, also has some value for creating stark views, and for photographs taken completely in shade in rocky uplands. (The high reflectivity of sand and rock faces can give a very attractive light for details of sandstone formations.) In the heat of the day, haze may lower contrast in distant views, and heat shimmer just above the surface of the ground can give a partly blurred image, especially noticeable with long-focus lenses. Ultra-violet and polarizing filters help.

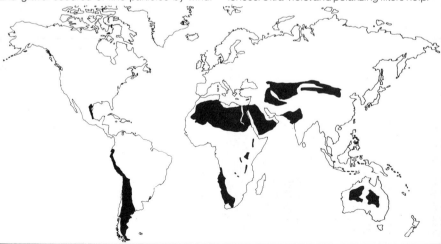

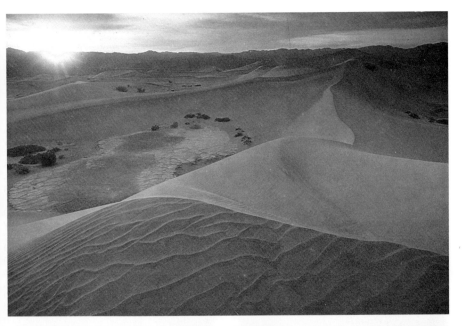

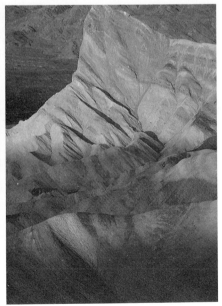

Three different landscapes from one location – Death Valley in California – show the local variety in desert topography. Dune areas (top) are relatively limited. Badland scenery (left) is evidence of areas that have periodic but irregular run off. Semi-permanent creeks are often salty through evaporation, but can support some vegetarian and aquatic life (above).

Desert Wildlife

In the face of the scarcity of water, desert life is limited and so not as rich a source of photographic material as other habitats. It is, though, highly specialized, and many of the adaptations that plants and animals have evolved in order to live with little water are themselves fascinating subjects.

Desert plants and animals

The common characteristic of all successful desert life is an ability to make the maximum use of available water, by being able to locate it in small, hidden quantities and by conserving it once inside their bodies. For vegetation, the mechanisms include fleshy structures (for plants such as cacti), long tap roots, and leaf shapes that reduce evaporation. Some plants germinate only after rare rainfall, developing very rapidly and for a short time only. Animals use mechanisms such as kidneys that concentrate urine to reduce water-loss, not sweating, and a metabolism that allows them to

Cacti (above) are characteristic plants, particularly in the deserts of the American Southwest.

The level, dry terrain in most desert areas makes photography from 4wd vehicles possible, used here to advantage for a close view of a kangaroo's bounding action (right).

survive on the water content of their food alone. The kangaroo rat, for instance, and the Saharan addax, an antelope, survive without drinking water.

Most animals, and the mammals in particular, also conserve water by not exerting themselves during the middle of the day. Many are nocturnal, and so difficult to photograph.

The most reliable places to find desert animals, though luck and great patience are still necessary, are in isolated refuges of shelter, food and water such as springs in rocky uplands and large plants such as the yucca and saguaro. Early morning and evening are the best times of day.

With medium-sized and large animals the lack of cover makes close approach difficult, and a long focal length lens is valuable. Small-scale life – insects and reptiles – requires a macro lens, but the high light levels may allow you to work in natural light, without close-up flash equipment.

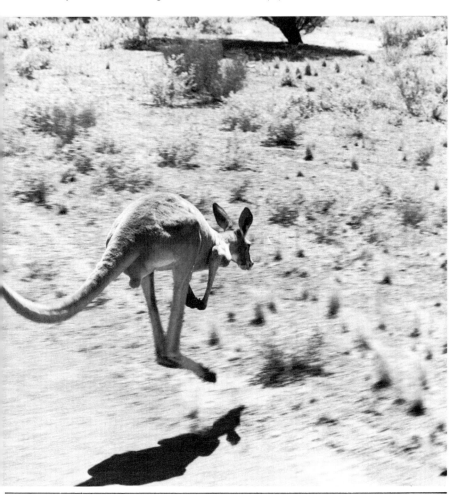

Choice of Equipment

The great dangers for cameras and film are heat and dust. As in rainforest, high temperatures will cause film to deteriorate rapidly and although this is offset slightly by the dryness of the air, bright constant sunlight can quickly heat up black-surfaced equipment to temperatures that may make batteries leak, and make lubricants too thin. If a camera body has become so hot that it is uncomfortable to handle, it has reached about 50°C (122°F) and at this temperature color film inside will be harmed noticeably in only a few days. Above 60°C (140°F) electrical components may malfunction.

Wind-blown dust and sand are capable of grinding lenses into uselessness, and will penetrate joints to cause serious internal damage to moving parts.

Photographic Equipment

Basic
35mm SLR
Spare meter batteries
Long-focus lens of between
 300mm and 500mm
Macro lens for small reptiles and
 insects; a long focal length (say,
 200mm) is best for wary lizards
 that will not tolerate close
 approach.
Wide-angle lens, 20mm to 28mm,
 for panoramic views.
Medium-speed or slow color film.
 'Amateur' may be better than
 'professional' (see pages 40-1)
Ultra-violet filters to protect lenses
 from dust and sand, and to
 reduce haze effects.
Neck and shoulder straps in
 leather or cloth to absorb sweat

Optional
Extra SLR body
Motor drive with fresh batteries
Very long-focus lens: 600mm or
 greater
Moderate long-focus lens:
 between 135mm and 200mm
Spare light meter
Polarizing filter
Felt-tip marker to identify films

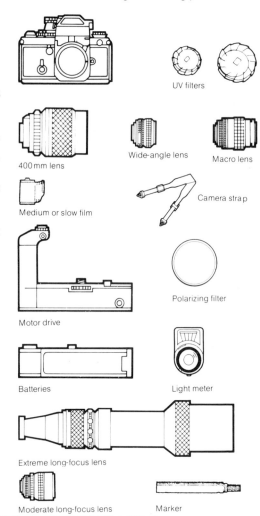

UV filters

400mm lens

Wide-angle lens Macro lens

Medium or slow film

Camera strap

Polarizing filter

Motor drive

Batteries Light meter

Extreme long-focus lens

Moderate long-focus lens Marker

Camera and film care

As far as possible keep everything in shade, and avoid enclosed unventilated spaces such as car interiors. If equipment must remain in the sun, cover everything with a white cloth or other reflective material. Keep cameras packed and sealed when not actually shooting (reflective cases – metallic or light-colored – absorb least heat) and whenever possible raise cases off the ground for ventilation.

If wind-blown dust and sand is mild but constant, tape over all joints in equipment, but if wind-blown dust and sand is severe, seal the camera in a plastic bag. In a dust-storm, an underwater camera may be best. Always keep a filter over each lens, to protect it from abrasion, and remove sand and dust particles frequently with a blower-brush.

Do *not* use silica gel; it will make film brittle in desert conditions. Advance film gently in case of dust or sand in the film compartment and always be alert for gritty, scraping sounds when operating moving parts.

Camera case

Field Equipment

The basic requirements for desert survival are *water, salt* and *shelter.* Always take water with you, even if the weather is not hot. As a rough guide, one gallon is the *minimum* for an all-day hike, but this requirement varies according to the individual and the conditions. Thirst is *not* a reliable indicator that your body needs water so drink regularly rather than wait until you are thirsty. Take salt tablets and, if possible, rest in shade during the middle of the day.

Clothing

Light-colored clothing reflects sunlight and is more comfortable than dark, but pale brown is less conspicuous than white. Cotton absorbs perspiration better than does synthetic material (which should be avoided). Unless you are fully acclimatized wear a long-

Water bottle

sleeved shirt, long trousers and a wide-brimmed hat as protection from sunburn. A head sweatband protects cameras from sweat, and wristbands are also useful. If you are camping overnight, remember that deserts quickly become cold after sunset. Wear soft desert or trekking boots, high enough to keep out sand when walking on dunes.

Medical

Avoid sunburn by exposing skin to the sun gradually (first day; 30 minutes' maximum) and by using suntan lotion. Treat any burned areas by covering and applying cold water compress. Do not apply ointments.

Fluid loss is the main danger, and the cause of heat exhaustion. Its symptoms are fatigue, dizziness, fainting, sweating and cramp. Avoid it by carrying plenty of water; by taking salt (one teaspoon or one tablet for each pint), and by keeping as much of your skin covered as possible. Treat by taking fluid in *moderate* quantities.

Heat stroke is a more serious condition, characterized by collapse, high temperature, and hot, *dry* skin. Treat as heat exhaustion, but get to a hospital as soon as possible.

Town and City Wildlife

Although most of the large natural habitats of the world are far from centres of population and may even take something of a small expedition to reach, urban surroundings themselves offer the essentials for life to a variety of animals. Easily overlooked in the search for wildlife that is still unaffected by man's activities, the animals that live *with* us in towns and cities are not only accessible subjects for photography, but show some fascinating adaptations to the unnatural world of streets and buildings.

Those creatures that succeed in urban areas are mainly opportunists, flexible enough in their behaviour and dietary needs to adapt and make use of new circumstances. Towns and cities offer some distinct advantages:

there is a surplus of waste food in the form of garbage; medium-sized and large predators are discouraged from entering; there is no hunting by humans, and among the dense complex of buildings there is a wide choice of shelter.

Where to look for wildlife

There is some distinction between parks and gardens, which provide close-to-natural islands in a basically artificial environment, and sites that are uniquely urban sources of food and shelter, such as wasteland, docks and harbours. The former are essentially refuges for animals that need a reasonable imitation of their more usual natural environments (forests,

Some parks and ornamental gardens are stocked with exotic species, such as this peacock in London's Holland Park.

Opportunist feeders, such as this grey squirrel, are generally the most visible of urban wildlife.

Normally shy and elusive animals are often a little less so in built-up areas, where they are to some extent accustomed to human traffic.

wetlands and grasslands), while the truly urban habitats offer new opportunities.

Parks and gardens These are prime sites for many species that are found in the countryside – in European and North American cities, squirrels, rabbits, pigeons, blackbirds, woodpeckers, ducks and many other woodland and waterbirds are common. In larger parks there may be deer and a fuller range of animals, while some parks also have exotic imports, such as peafowl in ornamental gardens.

Waterways Canals and rivers, though not usually as well stocked with food as waterways in natural surroundings, attract a limited variety of waterbirds.

Docks and harbours Coastal towns, and in particular fishing ports, provide a rich source of food for gulls, pelicans and other seabirds. In the tropics, vultures are ubiquitous scavengers.

Other sites Ledges, crevices, eaves and other parts of buildings that are essentially unused and unvisited by humans are likely shelters. House-martins, swallows, barn owls, and bats can be found sharing buildings with man – while the cliff-like faces of downtown high rise blocks offer the security of remoteness, sometimes enough to attract kestrels to nest on them.

Zoos and Wildlife Parks

A zoo is not a substitute for a natural habitat, but it does have some exceptional advantages for certain kinds of photograph. For many people it may offer the only opportunity to see rare species, and animals that are secretive or nocturnal. The condition of the animals, at least in a well-run zoo, is also likely to be better than in the wild where the general wear-and-tear of a competitive existence takes its toil in injury and disease. That the animals are in captivity does not invalidate photography (provided that the results are not passed off as pictures from the wild), but it does mean that you need to pay attention to details of the surroundings and the way that the animal is behaving. Many zoo backgrounds are unattractive or inappropriate, and this should be easy to see immediately, but less obvious are patterns of behaviour which may be unnatural and not uncommonly induced by stress.

There are three basic types of zoo photograph: naturalistic, portraits, and zoo settings. The present trend in zoo management, towards cageless compounds and simulated habitats, caters very well for naturalistic views. Choose your zoo carefully, and look for one that has enclosures which are either stocked with vegetation from the animal's natural surroundings, or present a neutral background (in shade and out of focus, even a concrete wall can be unobtrusive). A moderate long-focus lens, between about 100mm and 200mm, is the most generally useful for isolating the animal from its surroundings, making the backdrop appear larger, and for blurring unwanted foregrounds and backgrounds. Early and late are usually the most active time of the day. To see active behaviour may mean waiting for long periods, but the results are

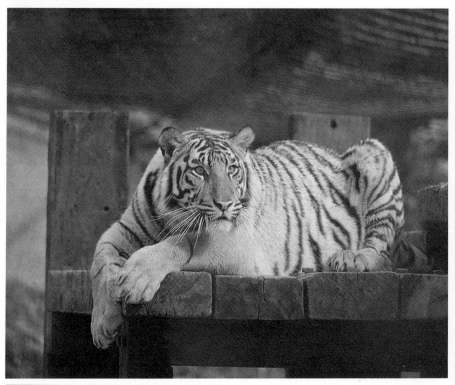

likely to be much more interesting than pictures of animals sleeping or resting.

Zoos are ideal for portraits, although these may need a lens longer than 200mm. The quality of light is likely to be important, but as the animals are in fixed locations you can usually plan the time at which you shoot. For greater interest, spend time waiting for an animated rather than a somnolent facial expression.

Finally, the very artificiality of the surroundings in the zoo can make an occasionally interesting photograph, showing a relationship between the animal and its compound, its keepers and public.

Lighting

While existing light is normally perfectly adequate for the outdoor sections of a zoo, the fishes, reptiles and other small creatures are usually kept indoors. Sometimes, but not often, the artificial lighting may be sufficient for hand-held photography. For tungsten lighting, use Type B film or daylight film with an 85B filter; for fluorescent lighting, use daylight film with a CC30 magenta filter. In either case, a fast (1SO 400) film is necessary. Usually, however, a portable flash unit is the only practical way – but check first whether this is allowed.

If you are shooting through glass, make sure that the camera angle and flash angle are such that there will be no reflection back into the lens. As the light passes twice through the glass on its way to the film, some will be lost, particularly if the glass is thick. TTL flash metering automatically compensates, but otherwise allow an extra half or one stop, and bracket exposures for safety.

Even for a non-active portrait, waiting for an alert or different expression makes a considerable difference. Zoo life encourages sluggishness in many animals, so patience is necessary.

For aquarium and vivarium photographs, flash is essential, if allowed by the zoo. Aim the flash from an angle to avoid reflections in the glass.

An increasing number of zoos provide naturalistic settings for some species. Although the viewpoints may not always be so clear, this is generally more than compensated for by the lack of bars and other artificial elements. This kind of zoo is the best for photography.

Index

Main entries and definitions are given in bold figures.

Acknowledgements

SPECIAL THANKS TO:

The Department of Wildlife Conservation, Sri Lanka.

Keith Johnson Photographic, London.

Paulo Colour, London.

Jamie Wood Ltd, Polegare, East Sussex.

The United States Department of the Interior,
Geological Survey.

Fred Bruemmer